THE
YEAR
TIME
STOPPED

THE GLOBAL PANDEMIC
IN PHOTOS

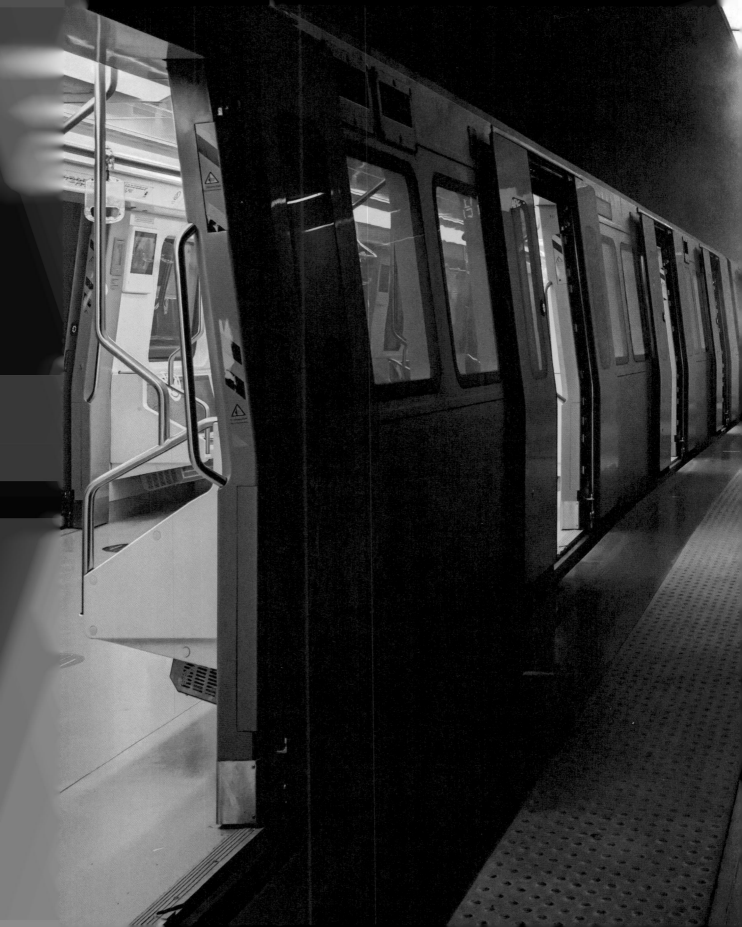

O.S.B. 23 Dk. 00 41
_IĞINİZ İÇİN SARI C‌

THE
YEAR
TIME
STOPPED

THE GLOBAL PANDEMIC
IN PHOTOS

CHRISTINA HAWATMEH
and NOUR CHAMOUN

HarperOne
An Imprint of HarperCollinsPublishers

HarperCollins books may be purchased for educational, business, or sales promotional use. For information, please email the Special Markets Department at SPsales@harpercollins.com.

FIRST EDITION

Photograph on pages 2–3 by F. Dilek Uyar
Photograph on page 251 by Marwan Shousher

Library of Congress Cataloging-in-Publication Data has been applied for.

ISBN 978-0-06-315951-8

22 23 24 25 26 WOR 10 9 8 7 6 5 4 3 2 1

CONTENTS

FOREWORD

This book is about you, and it is also about all of us. You are looking at pivotal moments that people around the world experienced in 2020—moments from lives that were completely uprooted. This is the year time stopped.

When someone captures a unique moment in time just right, it seems all too familiar, even when you look at it with a stranger's eyes. You may see yourself in that image too. You see the gripping highs and lows, the loneliness, and the togetherness.

We started an online platform called Scopio, with a clear vision in mind: to be a home for photographers and artists of different identities and geographies to tell unique stories through visual mediums like photography, illustrations, and graphic art. There are important stories the world needs to hear and see on a daily basis, and no one can tell those stories more authentically than the people experiencing them.

Inspired by the social movements demanding justice from oppressive systems in the 2010s, Scopio emerged as a platform to help people search and find protest photos being shared on social media platforms. People protesting for change were at the time equipped with new technologies such as smartphones that connected them to new social platforms for sharing their stories, and we created Scopio to aggregate all these images and make them easy to find and use, with the consent of the photographer. Today, we see widespread issues of representation in visual media. People of different identities and from different parts of the world often don't see themselves in the images around them. Creating a platform and safe haven where anyone, anywhere can share their images instantly, and have those stories used by the world, is where we wanted to make the biggest impact.

This book was a decade in the making—we just didn't know it. The nature of the platform we've created is part of the unique story of the pandemic, a year when we could be so isolated yet so connected through our devices.

A platform like Scopio was positioned to connect everybody who has a camera and wants to share their story. Pandemics of years past were so different precisely because they lacked the advanced technologies to document everyday experiences.

We've gathered 200 photos from photographers everywhere, leading different lives, that allow us to see, through the lenses of others, the common emotion we all felt together through the year 2020, and all of the challenges the pandemic threw at us.

Although people's experiences through the pandemic have been vastly different, based on their economic, racial, gender, and geographic contexts, what we witnessed is a collective sense of limitation and confinement throughout this year.

The images in this book tell the story of what it was like to live through the first year of the COVID-19 pandemic. It's through sharing the stories that we can begin to grasp the injustices faced by communities everywhere. What happens when a global and highly connected society retreats into itself? What happens when we are forced, like never before, to examine who we are? To answer that, looking deeper into what exactly happened is key. So in this book we will look deeply into the stories people were telling through their images, highlighting 2020 in two parts:

Part 1 tells the story of finding ourselves more alone than we have ever been—and many of us feeling this for the first time in our lives. The images show changes in our lifestyles, emotions, and habits, and the personal transformations many of us experienced.

Part 2 tells the story of our coming together, despite all the obstacles and hardships. We come together out of necessity for survival, not out of the luxury of choice. The images capture the authenticity of long-overdue movements and protests, and the explosive energy that bubbled to the surface.

Although seemingly opposite, these two human experiences are fundamentally connected, and in fact part of the story of humanity. As we faced a new reality of introversion and introspection, revealed in part 1, seeds were planted and then grew rapidly into the connectedness and momentum illustrated in part 2.

The images taken during this time are historic. The collection represents a microcosm of our global world from its most privileged to its most underserved populations and the injustices that naturally arise as a result. The year 2020 uncovered a lot of deep-seated injustices that already existed and proved to us that there is little that can stand in the way of people's demands for dignity and basic needs, not even a global pandemic.

Although all of us were forced into isolation, we were never truly disconnected, in part because of the technology that helps us share our experiences with one another. This book is dedicated to the individuals and communities fighting for basic rights, and to the photographers and everyday people who captured these historic moments.

—CHRISTINA AND NOUR,
COFOUNDERS OF SCOPIO

P A R T 1

Although it was not the same for everyone, we all experienced some type
of isolation in 2020. When the COVID-19 pandemic hit, everyday life as we
knew it was completely transformed.

The images included in this part show the fear, the hesitation, even the
excitement that this new way of life ushered in. They tell of mass hysteria at
grocery stores, as we stockpiled enough food to feed our families, preparing
for the worst. They tell the story of the hospitals that were overwhelmed
and the healthcare workers who turned into unlikely heroes. A lot of us had
to say goodbye to our loved ones over a video call, as they died alone in the
hospital. Some of the stories told were of creativity in a time of isolation.
Many couples found themselves having Zoom weddings when they had
initially planned to see hundreds of guests congratulate them in person. A
lot of us picked up new hobbies at home and discovered interests we never
knew we had as we felt more and more alone in our journeys.

These images are snapshots of inner workings. What was going on inside
people's heads? The collective trauma being experienced took its hold in
unique ways. People showed their care for their loved ones in new ways.
They mourned and grieved for those lost as well as for the lives they were
missing out on.

ALONE

The images that came pouring in from all around the world showed the array of locations, ages, genders, races, and classes that illustrated the vastness of the human experience. Although we were all far apart from one another, miraculously people found ways to stay more connected than ever.

The global internet infrastructure and the advancement of mobile devices we had been developing for decades were put to the test like never before. The pandemic tested those who were equipped for the shift as well as those who were not. It created a disparity between the populations with devices and internet access and those without. It left storytellers who didn't have internet access or mobile devices unable to share their stories with the world. Those who could not get online navigated a disconnection from the outside world, in a time when we're dependent on technology.

We relied on one another in these dark times and used our latest tools to do so. The human tendency to stay together did not go away during the pandemic; it took on new shapes and forms.

THE WORLD

The year started like any other for many people, who would later see their world turned upside down. The sudden shift to a population experiencing a rampant pandemic was jarring and shocking. These photos depict the nostalgia that was soon felt, even within the scope of the same year.

BEFORE

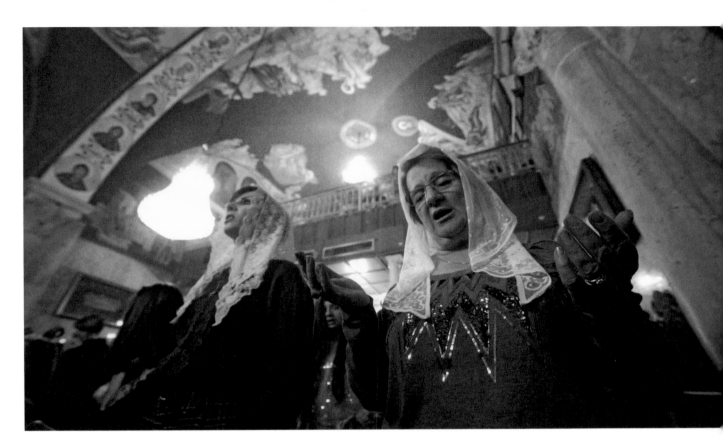

I took this on January 7, 2020, only a few months before the spread of COVID-19 around the world, as Gaza's Christian worshippers celebrated Christmas in the city's Orthodox Church. In the first year of the pandemic, as the world stood still and underwent a crushing lockdown, I felt like many countries got to experience a fraction of the daily life that Gazans have to endure under Israeli military occupation. As a photojournalist, I got to document the daily confinement of my people over the years that has been more restrictive than any pandemic. The Gaza Strip is known as the world's largest open-air prison.

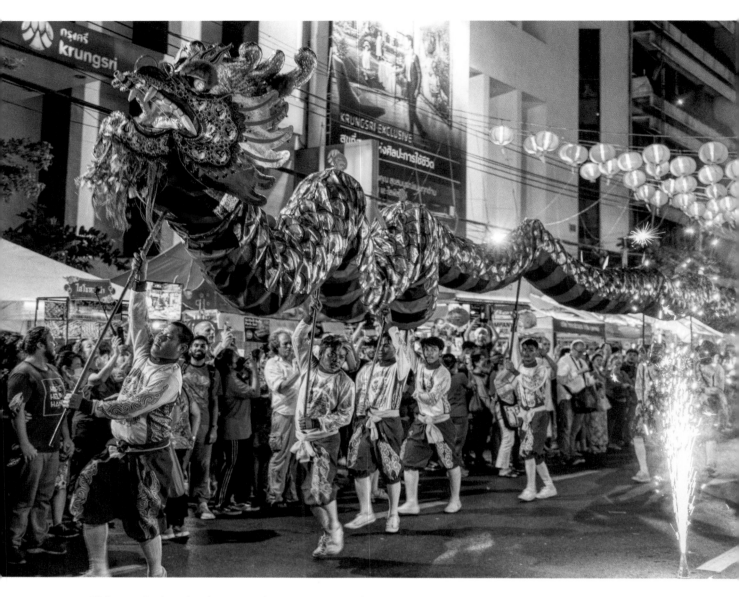

This was the last time I went to a large celebration right before the start of the pandemic: Chinese New Year 2020. I was living in Bangkok, and Chinatown hosted one of the largest Chinese New Year celebrations in the world. There was so much love and excitement in the air. Not one of us had any idea that this would be the last big celebration in Thailand for over a year. Looking back at this photo makes me appreciate life so much, as the pandemic made the world realize how much we take for granted.

C.J. CATHERN BANGKOK, THAILAND

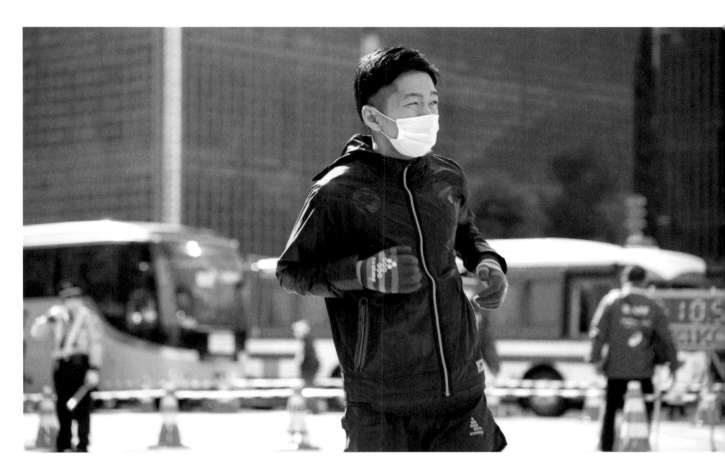

This was the day of the Tokyo Marathon 2020 (March 1). On this day, the person in the picture competed as an amateur, running the original Olympic Games marathon course.

We were going to exhibit this picture in a gallery in Tokyo during the Olympics, but one month later it was announced that the Games would be postponed till 2021 due to COVID-19, so we had to postpone our exhibition as well.

I was deeply disappointed by the news because I really wanted to do an exhibition during the Olympic Games. But later I finally understood that the situation was much more severe than I had assumed.

AYUMI NAKANO TOKYO, JAPAN

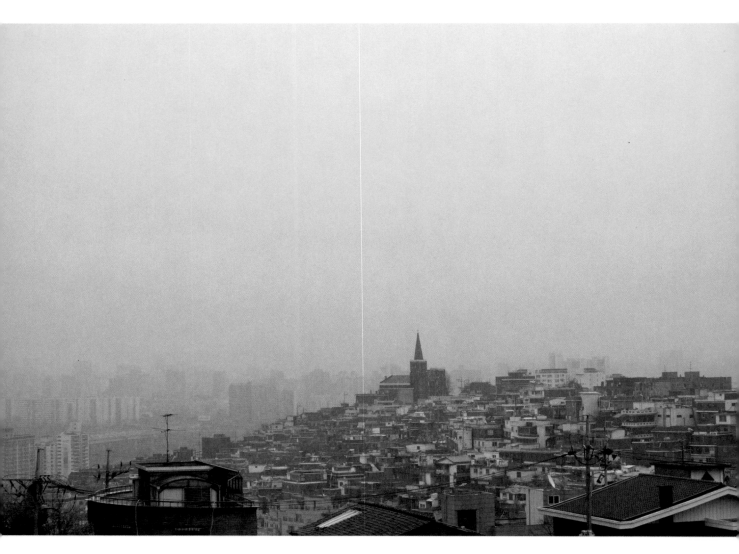

Seoul is suffering and will continue to suffer due to a high concentration of "fine dust" [particulate matter in the air]. As COVID-19 slowed down everything that aggravates air pollution, the concentration didn't rise as high in the air as it often does. But before the pandemic, we were regularly faced with "fine dust fog," which can slowly kill us.

E M P T Y

Photos capture how things may have looked, but there are few ways to describe the eeriness of the abandoned places most of the world saw so often in 2020, with widespread lockdowns and social distancing in full effect. Millions of people saw what once were bustling squares, streets, and public spaces become empty with only essential workers putting their lives at risk to serve the rest of the population staying home. Until all public spaces could safely be occupied again, their emptiness was a reminder of how far the world was from returning to normalcy.

S P A C E S

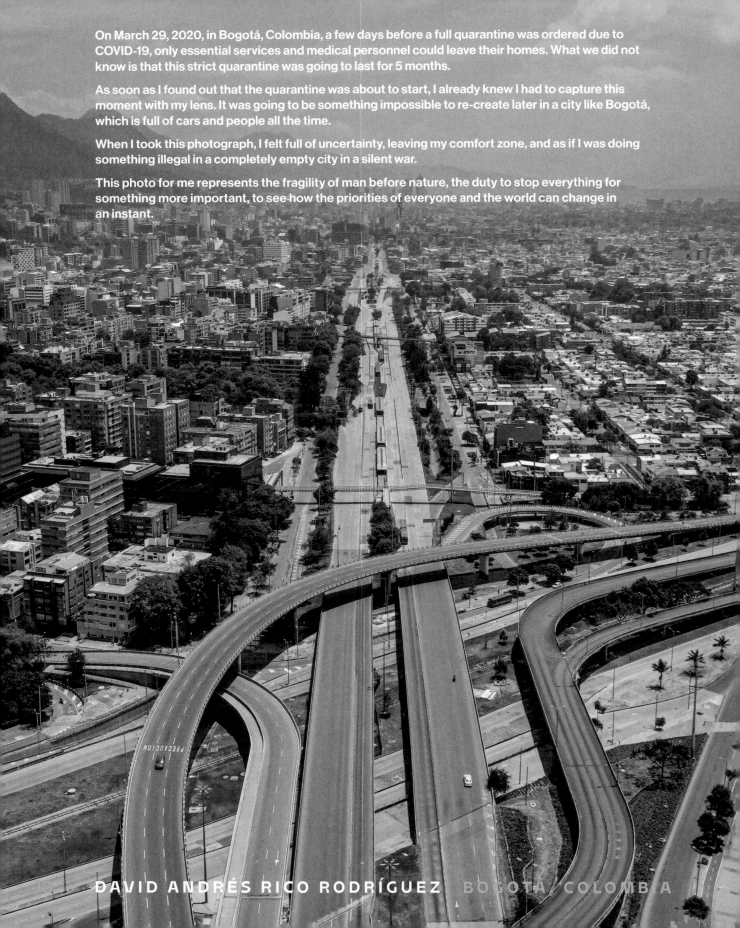

On March 29, 2020, in Bogotá, Colombia, a few days before a full quarantine was ordered due to COVID-19, only essential services and medical personnel could leave their homes. What we did not know is that this strict quarantine was going to last for 5 months.

As soon as I found out that the quarantine was about to start, I already knew I had to capture this moment with my lens. It was going to be something impossible to re-create later in a city like Bogotá, which is full of cars and people all the time.

When I took this photograph, I felt full of uncertainty, leaving my comfort zone, and as if I was doing something illegal in a completely empty city in a silent war.

This photo for me represents the fragility of man before nature, the duty to stop everything for something more important, to see how the priorities of everyone and the world can change in an instant.

DAVID ANDRÉS RICO RODRÍGUEZ BOGOTÁ, COLOMBIA

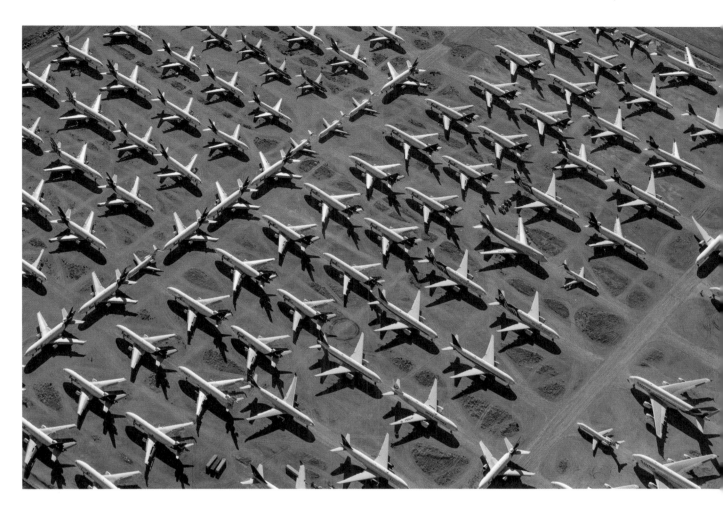

Last year was a difficult and tragic time. As I am a concert violinist, my music career suffered greatly; all of my performances and recordings had to be canceled. I am very concerned that the pandemic will have a long-lasting negative impact on all artists. Since I was unable to perform, I focused my energy on photography. I captured landscapes, documented events, and explored numerous remote areas.

California's Victorville Airport turned into a large parking area for hundreds of retired and furloughed planes due to COVID-19 and the decline of air travel. I took this aerial image while flying my plane.

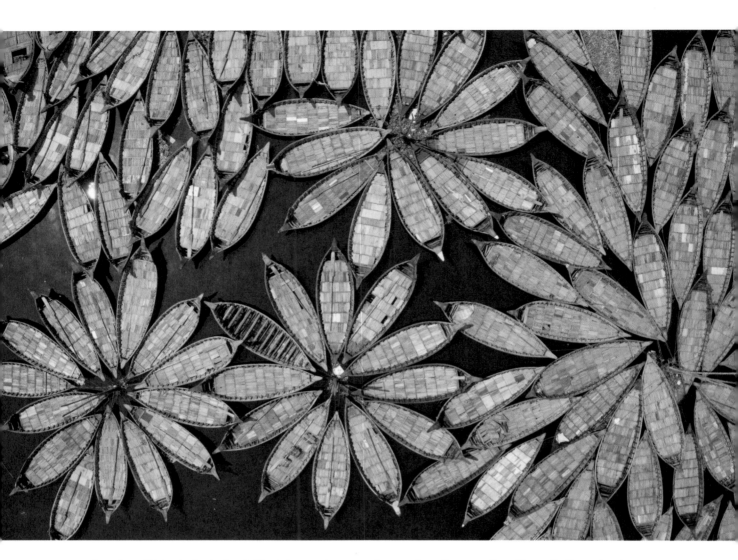

I captured this photo during full lockdown when people were in self-quarantine. Normally these boats are so busy carrying passengers, but now they rested there. Like these boats, I was also in quarantine—with my family at an apartment in Dhaka, Bangladesh. Gloomy, dark clouds of fear had been created by the coronavirus. On that evening, it felt like midnight. Only a few people were out there. The chaos of people, the dazzling lights of different shops, the never-ending gossip in the tea stalls, the buzzing restaurants— all were absent and were becoming unfamiliar.

Hundreds of wooden boats were arranged in flower shapes, ready to carry workers from the outskirts to their jobs in the center of the city. The enormous groups of boats are in the Bangladeshi capital of Dhaka, which is the third most densely populated city in the world, home to 17 million people. The picture was taken in the Sadarghat area, on the banks of the Buriganga River, which is used as a route into Dhaka for millions of workers.

AZIM KHAN RONNIE DHAKA, BANGLADESH

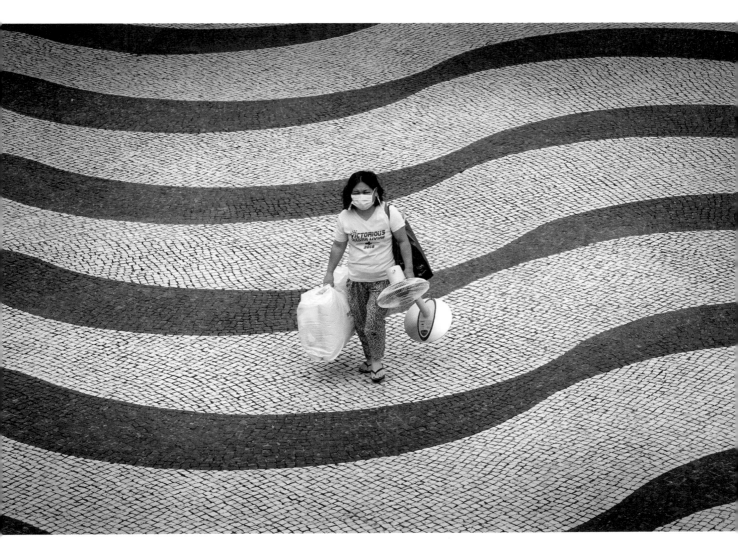

As a photojournalist, I had to go out in the middle of the pandemic in order to photograph what was happening in Macau, a territory that as of this writing has had only 53 cases of the SARS-CoV-2 infection. This photograph is part of a set taken of single people walking on the immense sea of Portuguese-style pavement in Macau, something rare to see, since in normal circumstances these streets are full of hundreds of people. It's almost impossible to take a picture of this sidewalk with a single person walking there.

GONÇALO LOBO PINHEIRO MACAU, CHINA

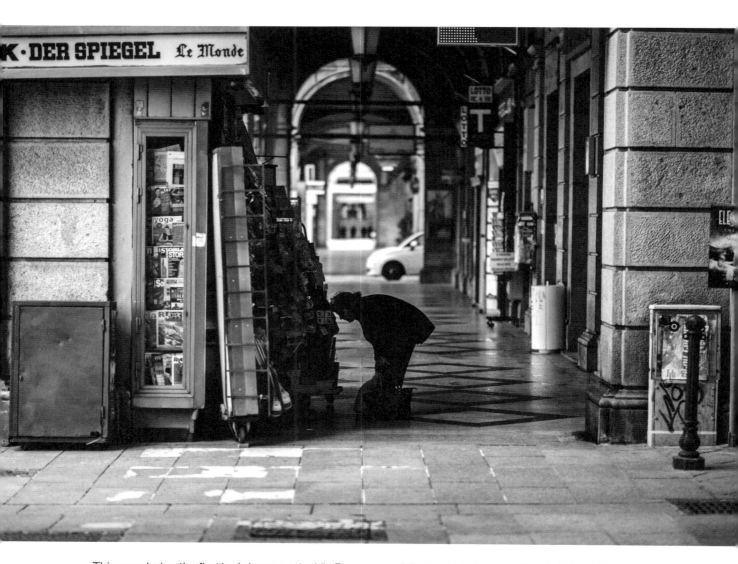

This was during the first lockdown, on the Via Roma, one of the busiest streets in Cagliari, Sardinia, usually filled with pedestrians all day. Seeing it practically empty, with only one person, bending down to read an article on the newsstand, left me stunned. I wonder what he was reading. Who knows—an article about the times, a puzzle to lighten up his day? I will never really know.

LUCA AZZENA CAGLIARI, SARDINIA

Students no longer able to attend courses in person turned to getting their education online. Something previously deemed not an option at many schools—online learning—became the only way for pupils to continue their education.

Being an educator for the last decade, I didn't think it would be possible for parents to get behind online education. However, it was nice to explore the capabilities of technology and the willingness people had to embrace this new form of delivery.

ROBERTO MORENO BEIJING, CHINA

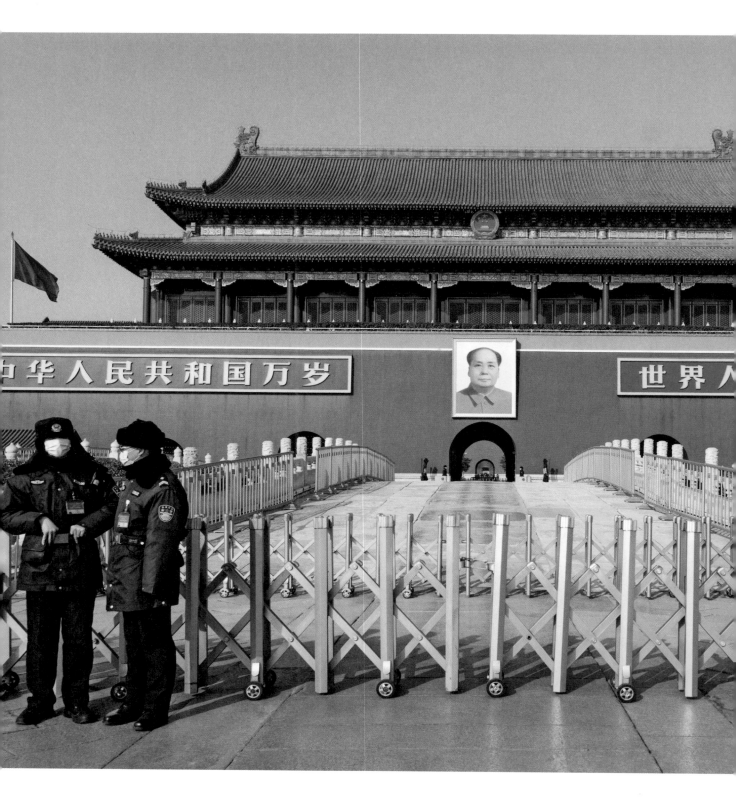

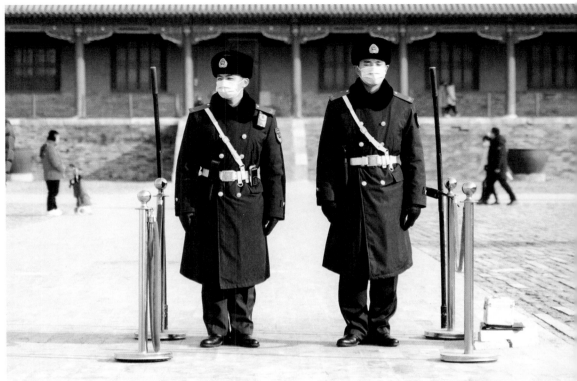

When people talk about China, the Forbidden City is one of those places that always come up. It's been the focus of a couple of movies, and it's a place full of controversy. It's also a source of pride for the local people.

To me, the Forbidden City, in a way, serves as a symbol of power and unity. If you stand in front of the Tiananmen Gate to the palace, you will see a giant painting of Mao Zedong, commonly credited with uniting China during the Cultural Revolution.

Having been relocated to Beijing, I decided to venture out and see what this place was all about.

During COVID-19, sightseeing in China was a bit more pleasurable, because you didn't always have thousands of people in the same place. Instead, you could see the finer details in the buildings, take photos like this one (*left*), capturing the architecture and the character of a building without having people in the shot.

This made it such a treat to walk in the city and see how architecturally diverse it is. Though the city mostly contains Chinese architecture, a couple of structures show Neapolitan influences.

I'm sure the guards at times need to relax their eyes for a minute or two before opening them again to realize nothing is happening in front of them. Unless a spectator like me is there to capture that moment. There are guards everywhere at the palace, with rotating assignments. I'm sure this (*above*) was one of those seconds.

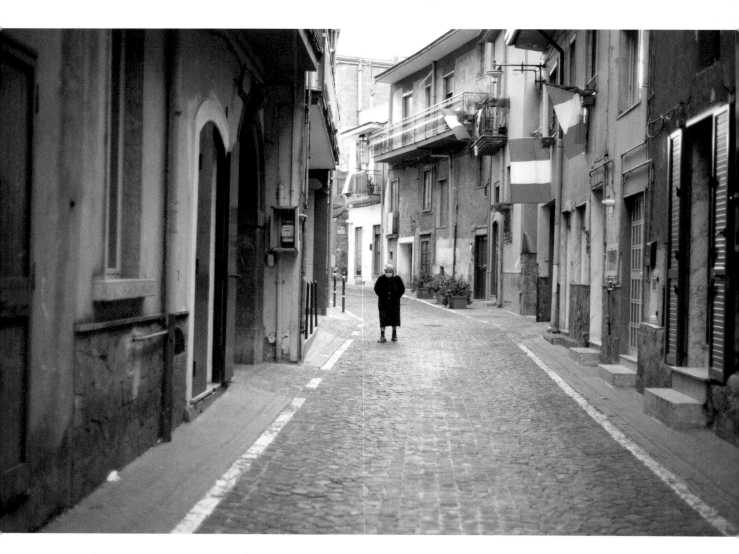

The year 2020 challenged all of us. For me, being a huge fan of photography, this meant trying to tell what was happening in the best possible way. For example, going out just to visit the supermarket with the fear of being infected was not easy—it felt like being in a movie. Or seeing the loneliness in the streets, which a few months ago had been full of people, was really bad. I felt bewildered. I, like all of us, did not know what was really happening.

On March 13, 2020, I took this photo as part of a reportage to show this difficult moment in our community.

This coronavirus has changed our lives. We are facing a social revolution that has perhaps never been seen before. We have been deprived of our freedom, of our "normal" lives, but we have rediscovered the importance of our dearest affections, those little things we did before, almost without thinking about it, and these things are what we now ardently desire.

After nearly two years, we can finally see the end of this pandemic and remember how Bob Dylan sang "The Times They Are A-Changin'"—and maybe forever.

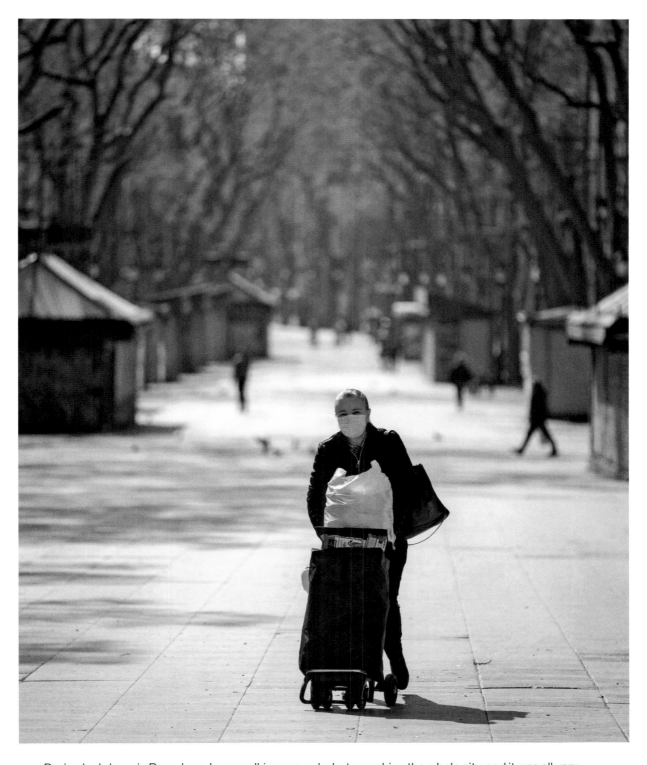

During lockdown in Barcelona, I was walking around, photographing the whole city, and it was all very creepy. I used to live here when it was super vibrant, but now, during the pandemic, almost no one was on Las Ramblas.

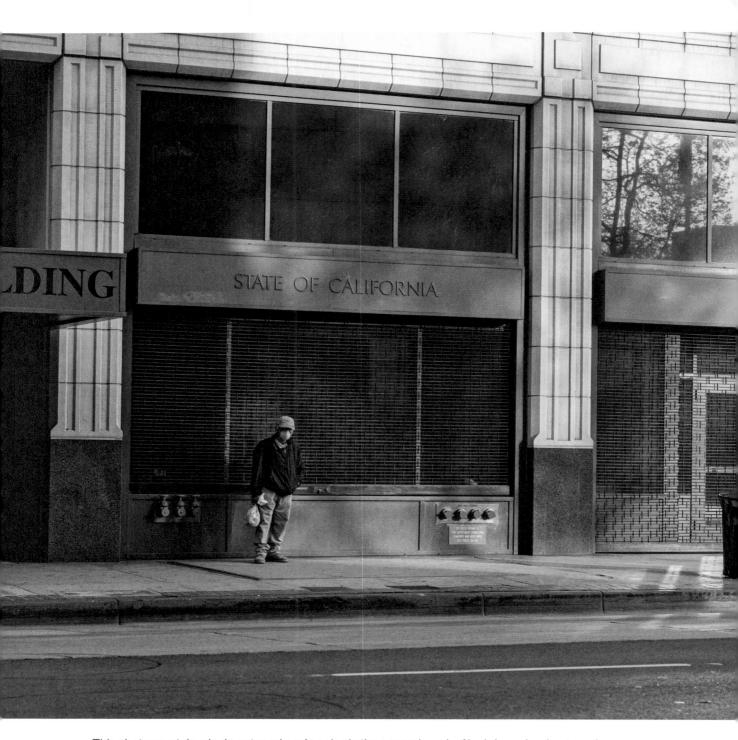

This photo was taken in downtown Los Angeles in the second week of lockdown. I woke up early one morning from the stress of the pandemic and could not fall back asleep. I decided to go for a walk with my Hasselblad 500C/M film camera and capture the empty streets. People were sparse, and the few I did see were all masked up. Then I came across this State of California building with one lone man in front of it, and I knew this photo said so much. After I shot two rolls of medium-format film, I came home to develop and scan the film. Seeing that film on my light table for the first time, I knew I had captured a moment that said so much about what was going on.

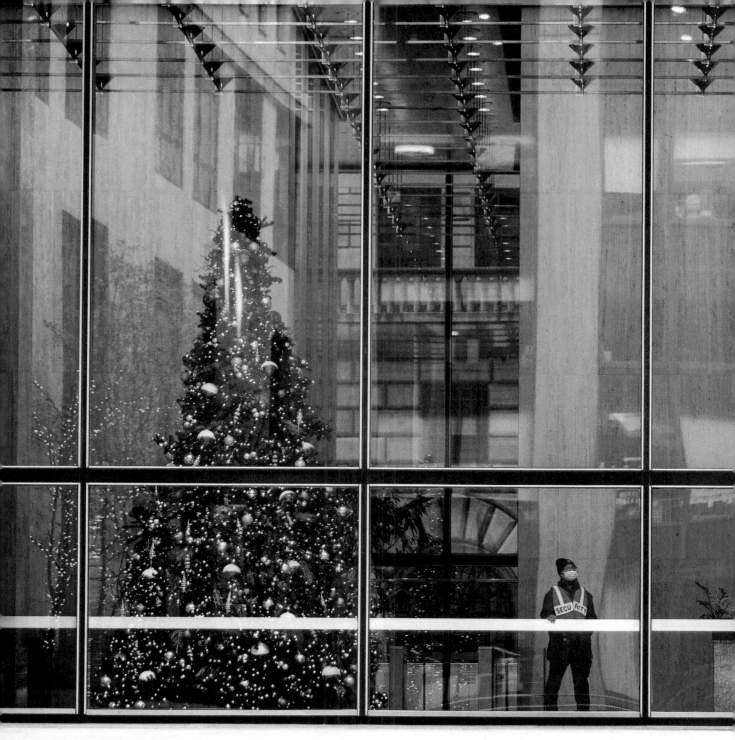

A lone security guard in a mask stands guard beside a Christmas tree in a near-deserted Wall Street building, in New York City, during the pandemic. This was just before Christmas near One World Trade. The plaza I took the picture from is usually bustling, but it was just me and him and the huge tree, with nobody passing in or out. He looked so lonely, it made me stop and capture the moment. If he even noticed me, he didn't give any sign. That solitude, in the middle of one of the busiest cities on Earth, has been such a hallmark of 2020. I hoped that someone would pass and wish him a happy holiday.

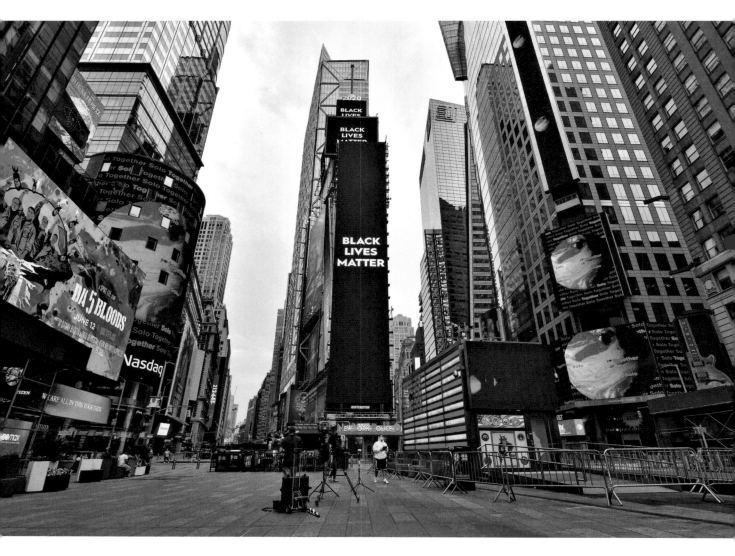

I guess one of the most transforming periods in world history happened to be in this pandemic timeframe. The energy at Times Square always reflects the vibes of the city. It has been still and empty for a while, but during the Black Lives Matter protests, it was filled, and it caused quite frightening sensations. People got to the point where they couldn't be quiet anymore, and some force had to be implemented, which comes with aggression and is never pleasant.

For me and my girlfriend, 2020 was supposed to be a year of great change. We moved to a new city right at the beginning of the year with a clear mind for what was to come, and then the pandemic happened.

It all changed for the worse, and we were abruptly forced to deal with what was happening. With people feeling anxiety and depression, this was one of the hardest times of our lives.

But we were together, found little joys in the changing of everyday life, and we got through it together.

Full lockdown did not happen at Jakarta—it was a semi-lockdown by local government. This shot was taken on a Saturday night on the Jalen Jendral Sudirman thoroughfare, usually crowded with young people in their vehicles. Then only a few motorcycles and cyclists were on this main road, some of them selling snacks and coffee as their main income.

HIDDEN

This is an ode to our heroes, all the professionals and volunteers working during the pandemic, and the ways in which we celebrated them. The essential workers became everyone's heroes. When times got most uncertain, when it seemed like life could be on the line, these hidden heroes did not stop. They made their sacrifices, and they did it for the future of humanity. This pandemic may be one of the most defining battles of our generation, and it was a battle fought behind closed doors. Images can never fully capture all the ways our heroes fought. Yet even though their work often goes unnoticed, these heroes still carry on, as they did before, as they will continue to do.

HEROES

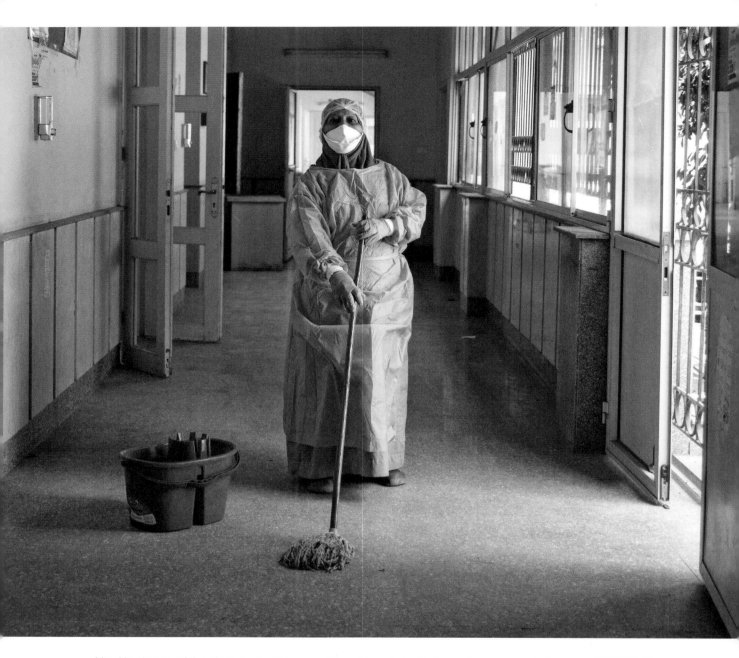

Um Alaa is one of the cleaners in Abbaseya Fever Hospital, which receives suspected cases of COVID-19. I personally believe so much in the importance of the cleaners and garbagemen in this crisis and that their role is as important as that of doctors and nurses. Most of them shy away from being photographed or featured because of how society looks at them even if they appreciate and know the role they are doing, but their families and friends are not proud of that. I asked Um Alaa politely if she would agree to be photographed, and without hesitation she replied yes and answered my fears: "Of course, go ahead. I'm not ashamed of my job. I'm rather proud and I have been teaching my kids to be proud of me because of what I do. Now they are well educated and working because of my job. There is no shame in that, and if I don't do this job, who else would do it? It saves lives."

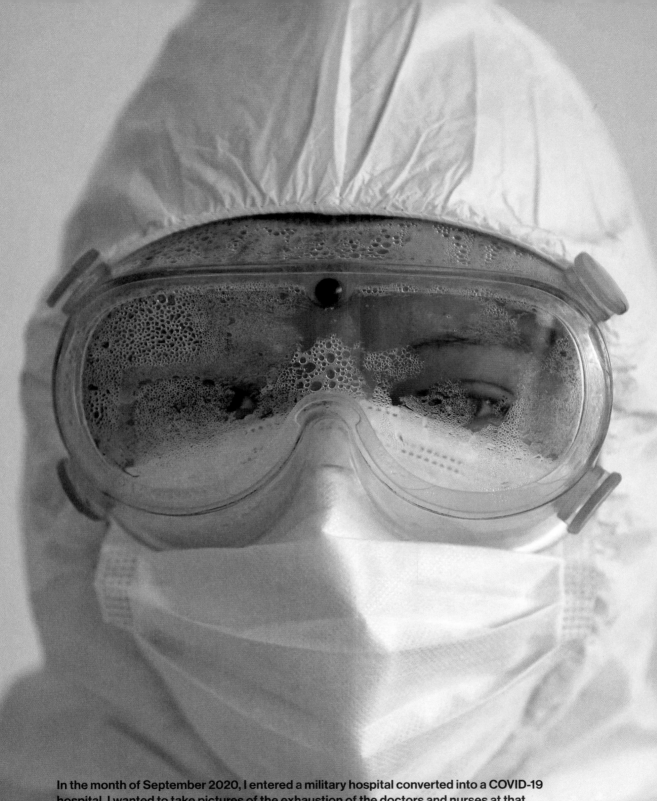

In the month of September 2020, I entered a military hospital converted into a COVID-19 hospital. I wanted to take pictures of the exhaustion of the doctors and nurses at that hospital. I keep looking for a way to show with my images the great battle that doctors and nurses wage daily against this virus.

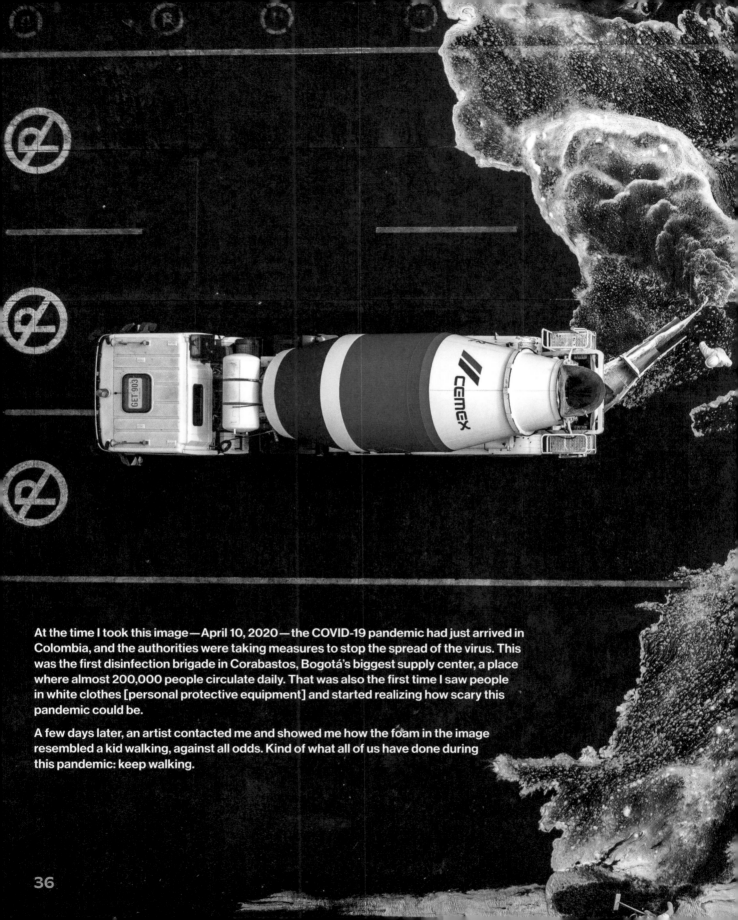

At the time I took this image—April 10, 2020—the COVID-19 pandemic had just arrived in Colombia, and the authorities were taking measures to stop the spread of the virus. This was the first disinfection brigade in Corabastos, Bogotá's biggest supply center, a place where almost 200,000 people circulate daily. That was also the first time I saw people in white clothes [personal protective equipment] and started realizing how scary this pandemic could be.

A few days later, an artist contacted me and showed me how the foam in the image resembled a kid walking, against all odds. Kind of what all of us have done during this pandemic: keep walking.

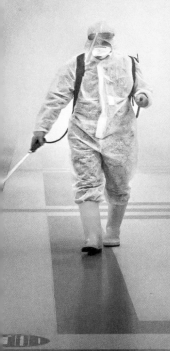

S.B. 23 Dk. 00 41
GİNİZ İÇİN SARI CI

During the coronavirus pandemic, all public transportation in Ankara, Turkey, is disinfected day and night. I took this photo to show people how municipality teams worked while they were at home due to lockdown. Myself, I felt like I was on a dystopic film set.

F. DILEK UYAR ANKARA, TURKEY

A worker disinfects a TransMilenio bus, Bogotá's mass transportation system. To prevent the spread of the coronavirus, since March 2020, when the first case of coronavirus was registered in the country, the cleaning tasks of the fleet were intensified. Hundreds of men and women worked day and night in shifts of approximately six hours to disinfect the buses, since before the pandemic arrived in the country this transportation system mobilized more than 2.5 million people daily. Seeing these buses empty for the first time was as shocking as knowing that the next morning many low-income inhabitants were probably getting the virus in the same place where I was taking this picture with no risk of contagion.

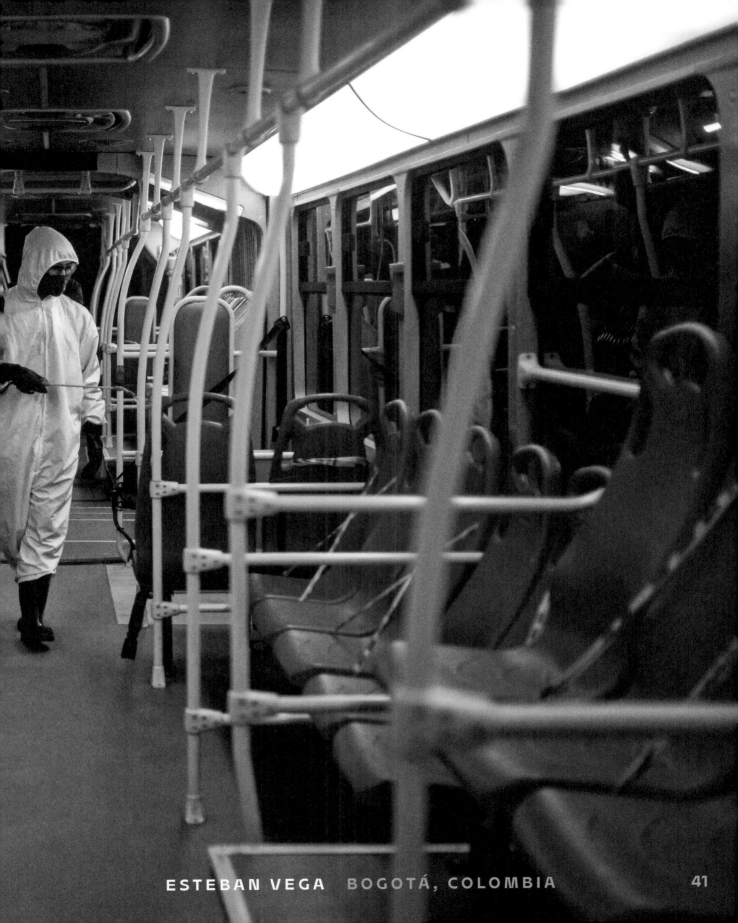

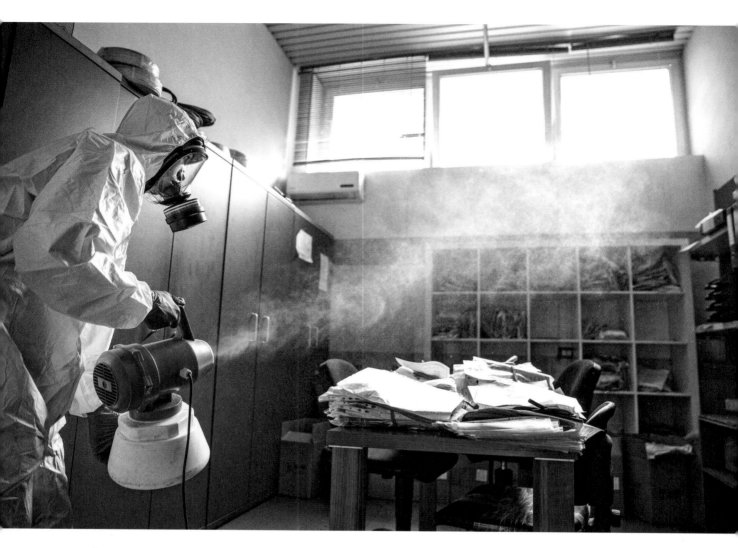

During the lockdown, I followed a group specializing in sanitization. We spent days together behind masks as they sanitized and I took pictures to document the period. I followed the group for a month during their work around Milan. It was my first photographic assignment during the lockdown. I remember driving from the studio to the place to be sanitized, and I was alone in the car. The only thing I could see was birds landing on the highway. It was a feeling of total desolation.

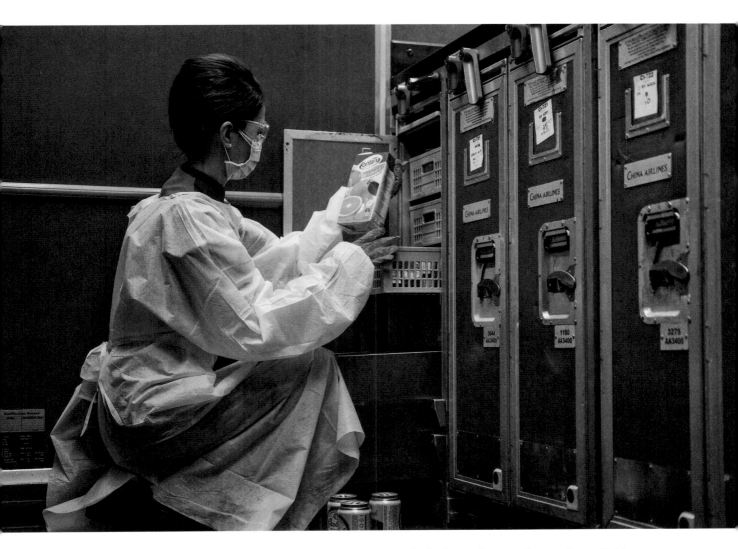

I was trying to document everything on my flight. Things people don't usually see, what work as a flight attendant is like during COVID-19.

For me, the most difficult part is that I have a 3-year-old at home. Every time I go home, the first thing I tell my kid is "Mommy can't give you a hug right now because I'm dirty." The fear of bringing home the virus is definitely hard for me and my family.

In the beginning of COVID-19, nobody knew what it was. It was really scary, especially for the frontline workers. From no protection to full-on suits with masks and goggles.

It's crazy how people used to travel and how much interaction we had with passengers on board. Now there's none.

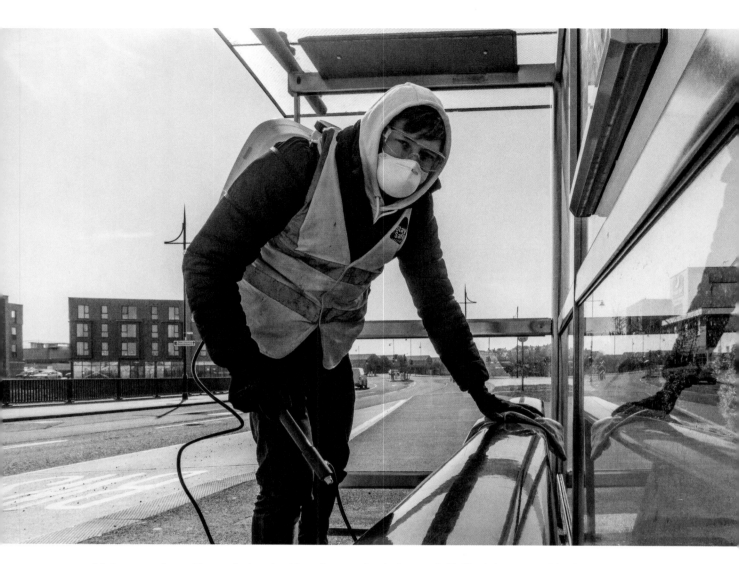

My housemate and I were furloughed for a few weeks during our initial lockdown, so with a lot of spare time on our hands, we got out in our community and started sanitizing and cleaning high-traffic areas. It was really satisfying being able to have something productive to do, and also have the opportunity to help out locally.

JOSH JOSHUA BARRY, WALES

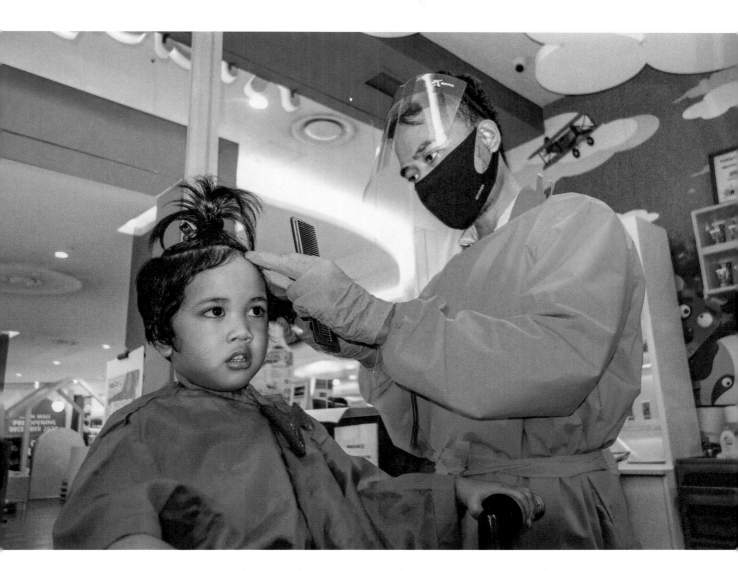

It was our first family weekend when the local government decided to reopen malls and shopping centers. I chose the nearest mall as our destination—besides, Diego (my son) loves to go there. He also needed a haircut. When we arrived at the mall, I was surprised that the place was quiet, unlike a regular weekend before with stores fully open. We headed to the kids' barbershop. Again, it was easy to get an appointment there, and we went straight on to the process. I remembered the barbershop before had been packed with parents and children. We used to wait an hour for a haircut. I sat beside Diego while he was enjoying getting his hair trimmed. We had a laugh and made a small joke to help him stay calm and relaxed. I talked with the barber about how things were going with the current conditions, and he joked about how he looks like he's in a medical hospital with his face mask on. This is the snapshot of that moment.

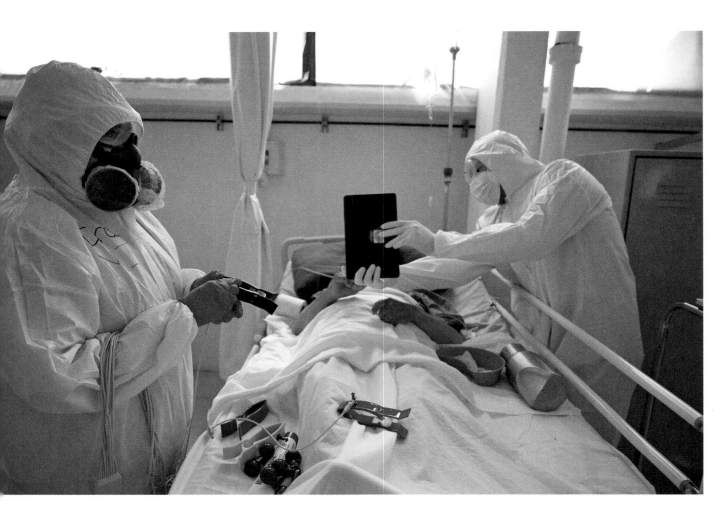

In September 2020, I entered a military hospital converted into a COVID-19 hospital. After equipping myself with all the security accessories to enter the building, one of the images that most moved me and that I took without hesitation is of a nurse showing an iPad to a patient so that he could communicate with his family.

I keep looking for ways to show with my images the great battle that doctors and nurses wage daily against this virus.

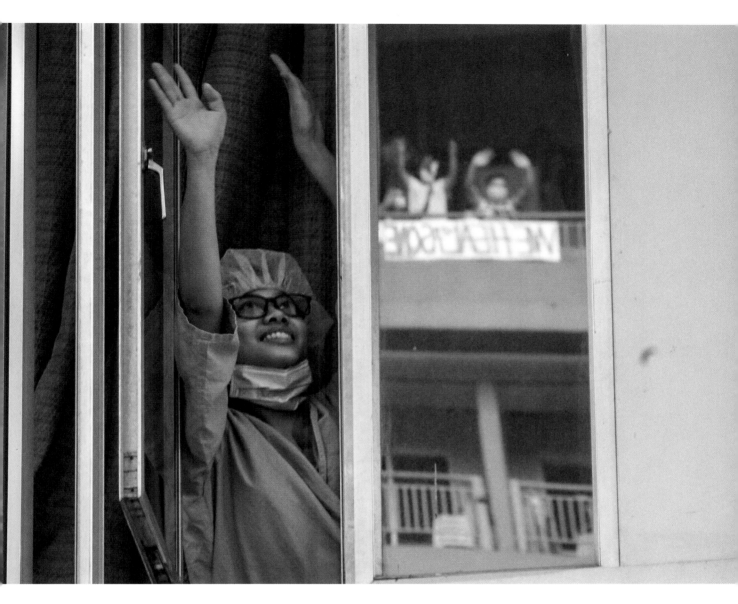

The situation during this pandemic is very different from events in the past. As a photographer, you could go out and come back home safely, but now nobody knows whether they have brought the virus back to their safe space.

This is a nurse waving back to residents of a condominium in front of Adventist Hospital in Pasay, south of Manila. It is one of my favorite photos I took throughout this pandemic, because with these simple efforts, I felt the best of humanity in these trying times.

JANSEN ROMERO MANILA, PHILIPPINES

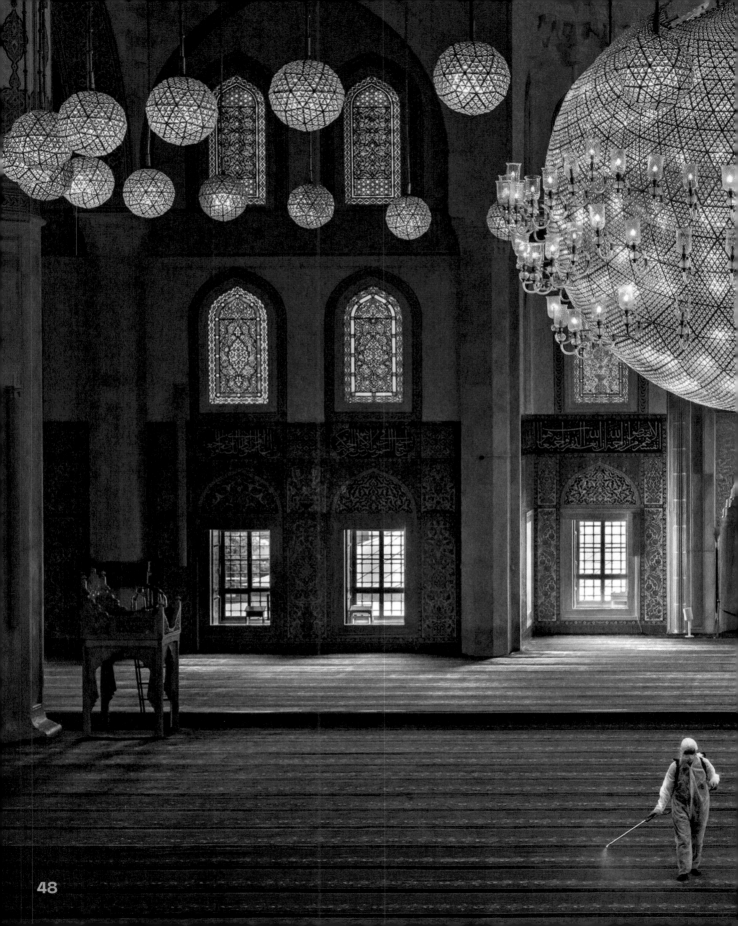

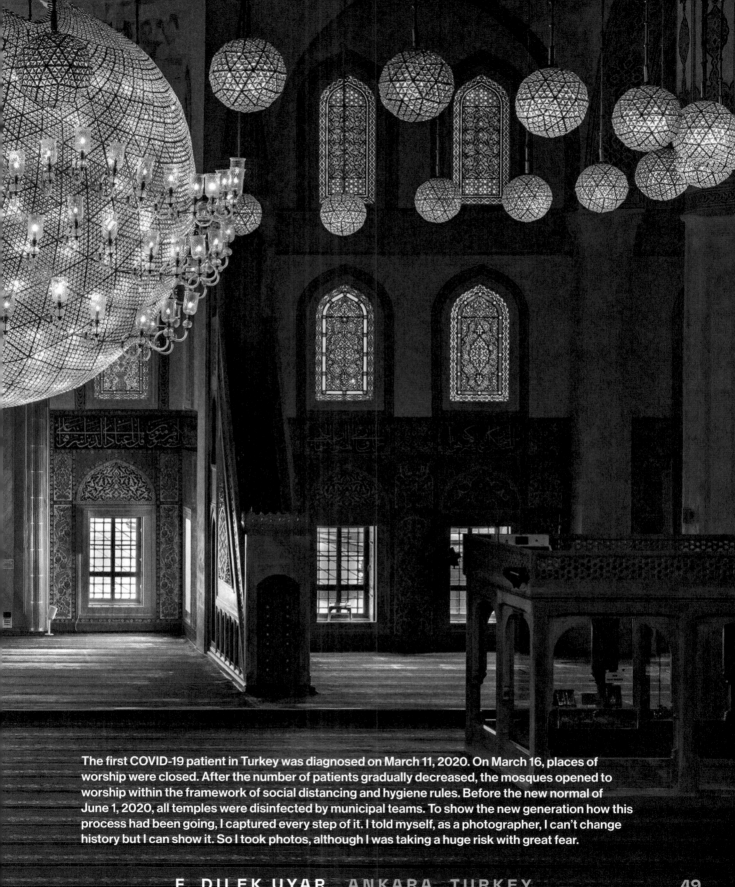

The first COVID-19 patient in Turkey was diagnosed on March 11, 2020. On March 16, places of worship were closed. After the number of patients gradually decreased, the mosques opened to worship within the framework of social distancing and hygiene rules. Before the new normal of June 1, 2020, all temples were disinfected by municipal teams. To show the new generation how this process had been going, I captured every step of it. I told myself, as a photographer, I can't change history but I can show it. So I took photos, although I was taking a huge risk with great fear.

F. DILEK UYAR ANKARA, TURKEY

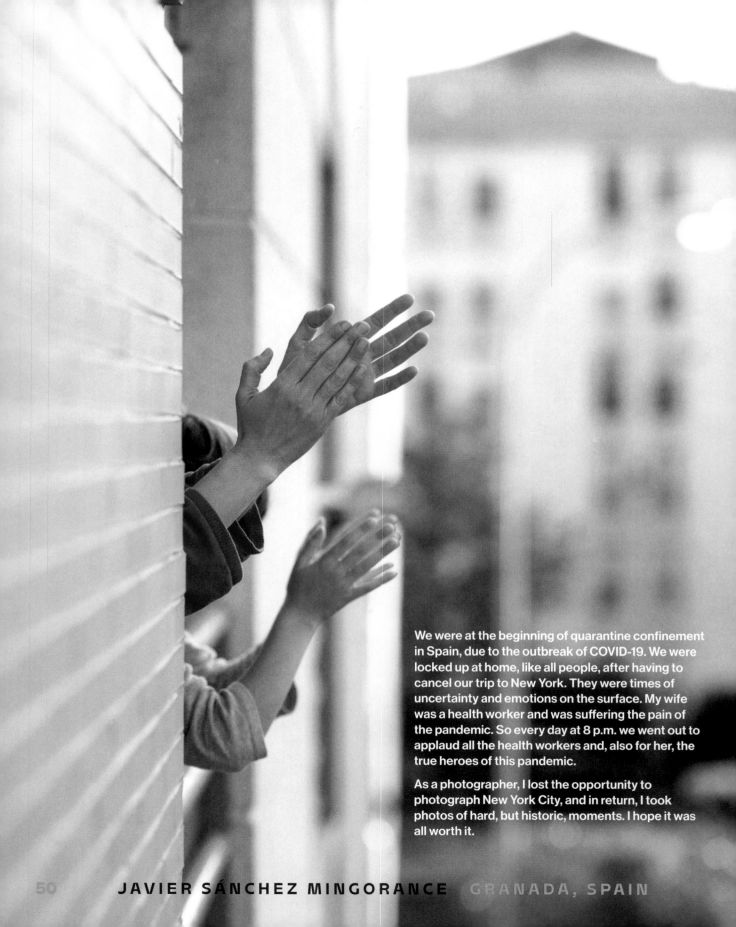

We were at the beginning of quarantine confinement in Spain, due to the outbreak of COVID-19. We were locked up at home, like all people, after having to cancel our trip to New York. They were times of uncertainty and emotions on the surface. My wife was a health worker and was suffering the pain of the pandemic. So every day at 8 p.m. we went out to applaud all the health workers and, also for her, the true heroes of this pandemic.

As a photographer, I lost the opportunity to photograph New York City, and in return, I took photos of hard, but historic, moments. I hope it was all worth it.

JAVIER SÁNCHEZ MINGORANCE GRANADA, SPAIN

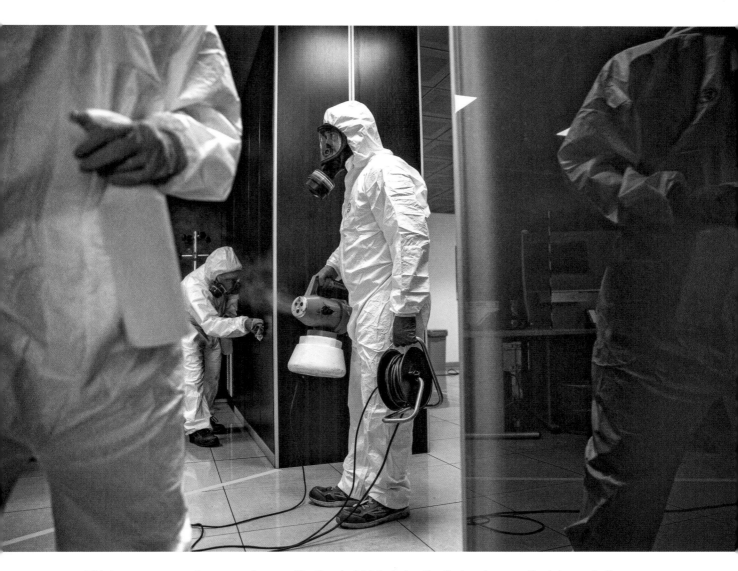

This image represents coronavirus sanitization, in 2020, during the first and second lockdowns in the Milano area.

In the middle of lockdown, I got a phone call: we would need photos to show what was going on. I remember going out of the house to follow the sanitation team: very few people on the street, only long queues outside the stores for basic necessities. We arrived on the spot, in a moment, like ghostbusters, a troupe of boys ready in their suits to go into action. I remember these were difficult moments in which not much was known about COVID-19. People worked with a sense of anxiety and with maximum attention to protecting themselves. It was difficult to shoot with protective masks, fogged glasses, and a sense of desolation. Despite these difficulties, I was able to follow these guys for more than one trip and show their hard work to try to eradicate the virus from surfaces and make the environments safer, in order to allow at least a similar-to-normal life for the less fortunate.

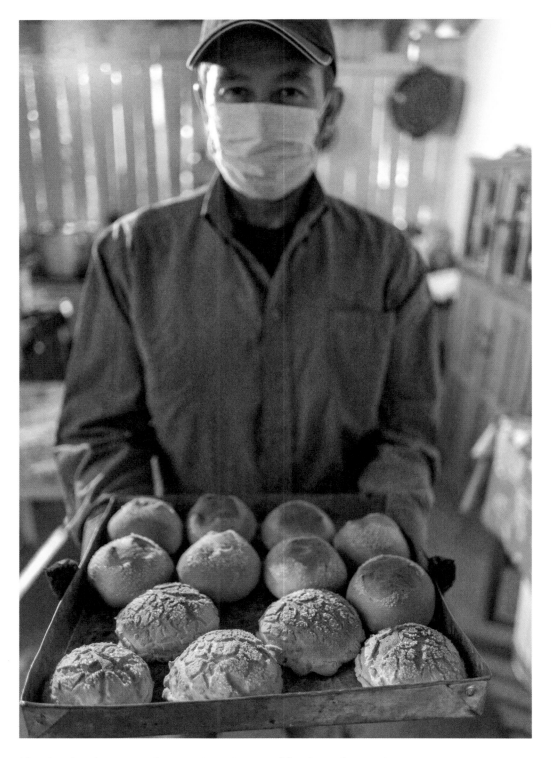

Months after the coronavirus pandemic began, all food suppliers and restaurants started to sell through delivery only. Many people became entrepreneurs in their own communities and cities. This farmer and his family make an iconic type of handmade bread that is addictive and delicious, especially with coffee or a milkshake. They started a family business, with the support of all the family, in the times of COVID-19.

In May 2020, after 2 months without me leaving home, unable to work, due to mandatory confinement because of the COVID-19 pandemic, the government of my country, Spain, allowed professionals to work. Just before it all started, I had been hired to take pictures in a beauty center in Granada, my city, but it had to be postponed due to circumstances. As soon as I was able to go out to do my job, I asked the owner of the center if she wanted to resume the work that had been postponed. The problem was that at that moment the use of face masks was mandatory, so we were not going to be able to produce the images we wanted. It is a beauty center, and it is important that faces are not covered by a necessary but annoying mask. The owner told me to go ahead. It would be a different job, but it would represent the new world in which we were immersed. In this way and with all the security measures, I completed the job. Over the years, this will remain an impressive testimony to what our generation had to live through. Billions of people saw, at the same time, how their lives changed forever.

JAVIER SÁNCHEZ MINGORANCE GRANADA, SPAIN 53

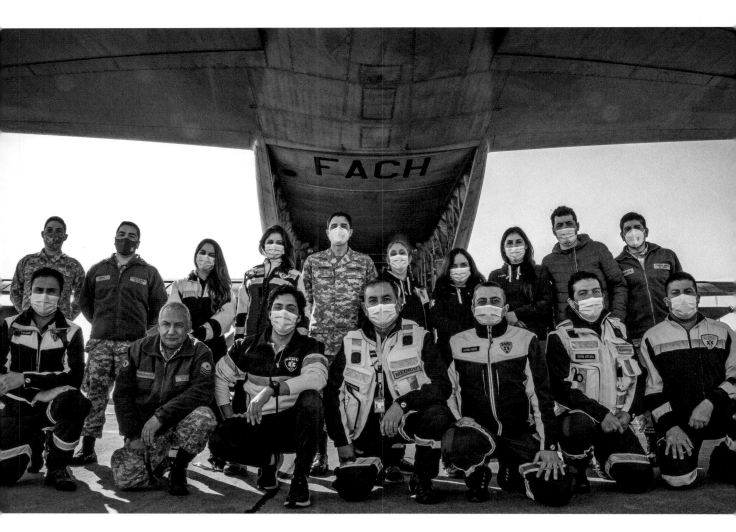

This is the emergency medical team and the Chilean Air Force team in front of a C-130 Hercules plane, a few minutes before starting air transfers of critically ill patients due to COVID-19. At this time, there had been 4 months of quarantine and 3 months of daily evacuation flights of ventilated patients infected by COVID-19 from Santiago to other regions. Hopefully, one day there will not be a need for more.

It has been hard for everyone. Life changed 180 degrees. This is why we have to express the positive things about living in a pandemic, to discover our priorities, to understand how moving away physically has brought us closer to the people we love, and to be more grateful and fair.

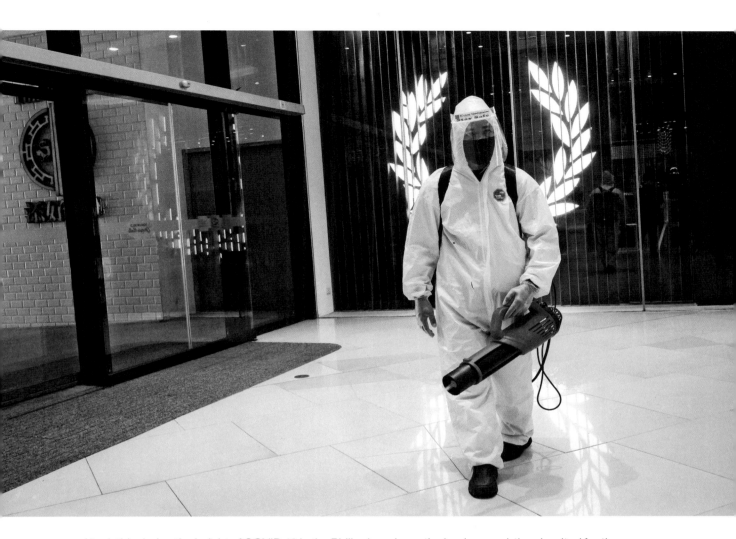

I took this during the height of COVID-19 in the Philippines. I saw the background, then I waited for the mist sprayer to be aligned and took the shot. It means so much to me because during these times, these people were at the front line, battling the virus head-on. I will always be grateful for these people, who became angels in each community. Their stories will become a part of the histories of the world.

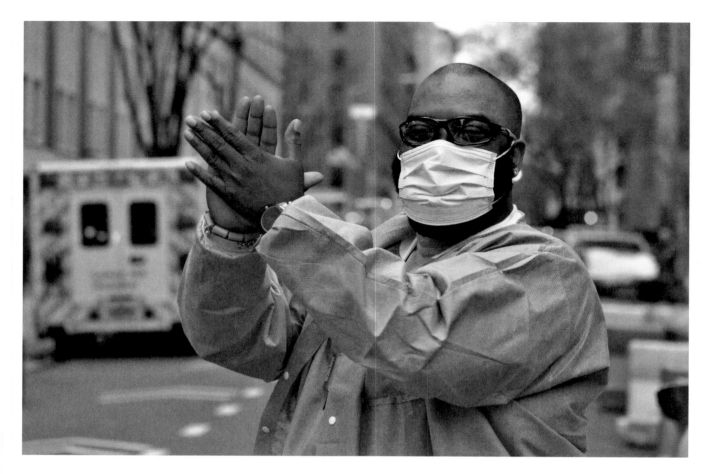

One of the most uplifting and touching moments of the lockdown was when, at 7 p.m., people stopped everything to show gratitude to all the essential workers. Everybody was clapping on the streets or through the windows.

I took this photo next to the Lenox Hill Hospital. The doctors were not only accepting gratitude but also encouraging others by saying that we are all in the same boat.

This doctor has a mission to save lives, and with his clapping, he shows that we are all doing it too, through different manifestations. And that his strength to keep going through this time comes substantially from all the people's support.

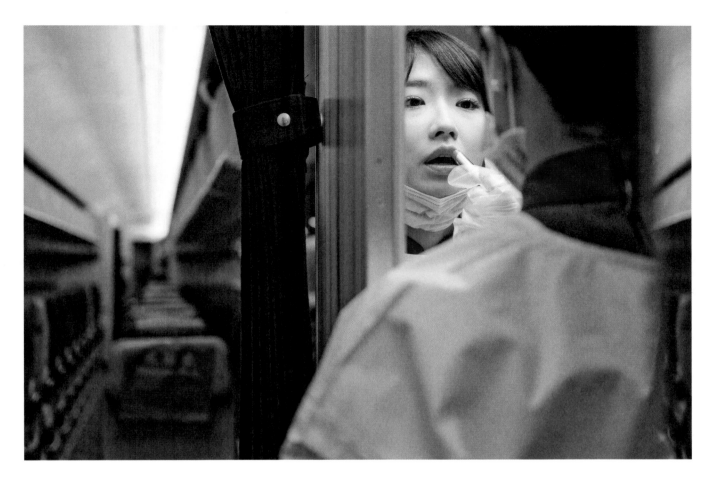

The year 2020 was full of turbulence. As a flight attendant, I felt the pain in numerous ways. There were the months without flying. There was the loss of income and the worry about future employment. As planes began to take off, there were multiple training classes to teach us how to correctly wear our PPE.

For all of our flights, we had to wear a sterilized gown over our uniform, surgical gloves, a mask, and then a plastic face shield. We all understand the importance of taking these precautions, and I fully support any measure to help slow the spread of COVID-19, but we all want to look pretty, even if it's hidden behind all the gear.

For me, this photograph represents that desire to still look pretty and retain a sense of normalcy through these difficult times.

No matter how much it's hidden, everyone should know that there is still a smile under the mask.

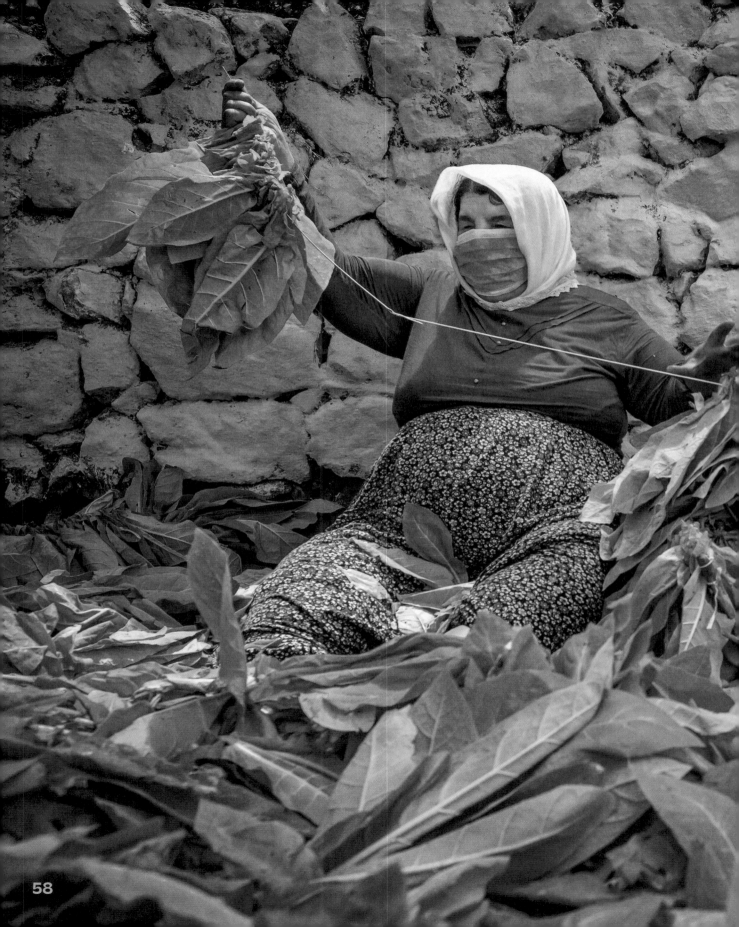

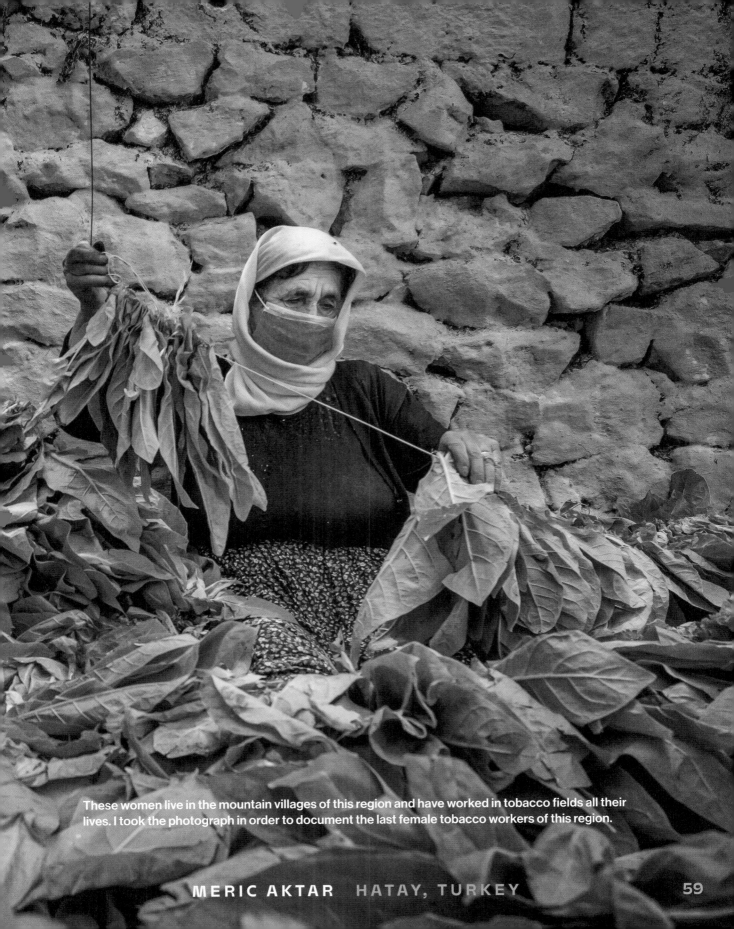

These women live in the mountain villages of this region and have worked in tobacco fields all their lives. I took the photograph in order to document the last female tobacco workers of this region.

MERIC AKTAR HATAY, TURKEY 59

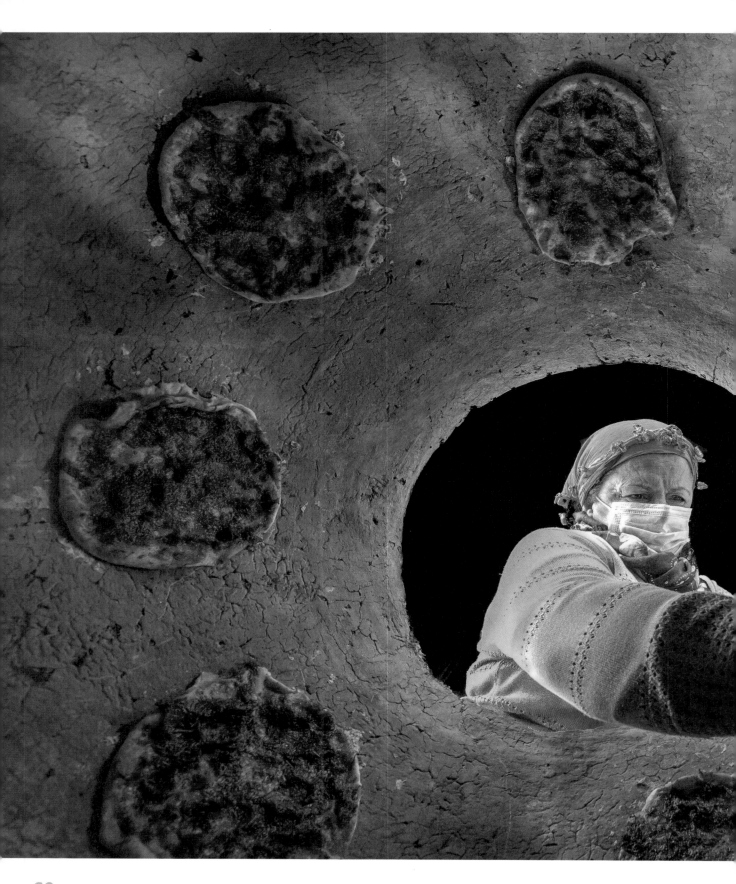

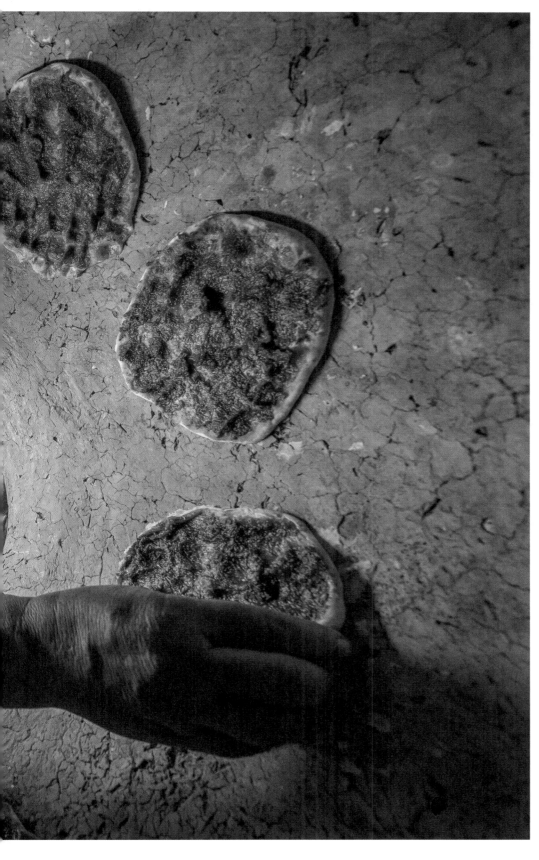

The woman in the photo is my mother. A woman who has devoted herself to the natural life for years. On the weekends, she usually cooks natural and delicious pepperoni bread for us in the tandoor. I wanted to photograph her work from a different perspective during the coronavirus days.

MERIC AKTAR HATAY, TURKEY

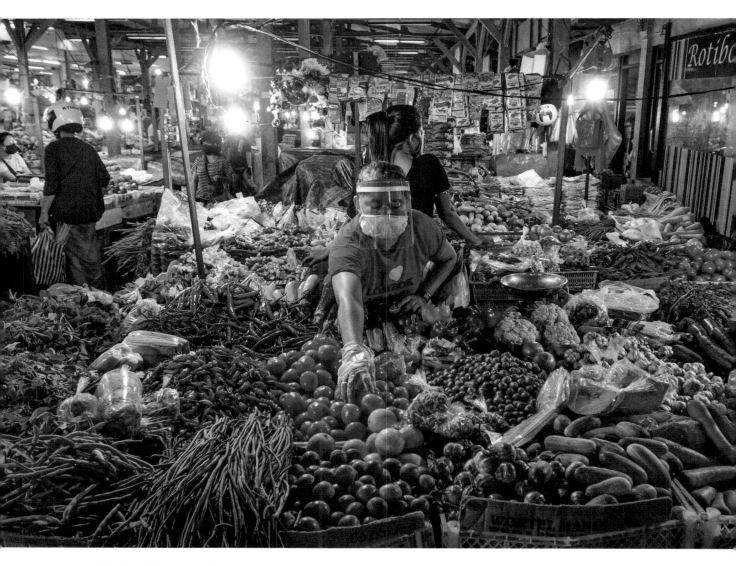

The city of Denpasar implemented community activities restrictions to prevent COVID-19 from further spreading. I feel this changed traditional market habits, especially in Indonesia. In this country, the traditional markets tend to be wet and dirty. But now the sellers are using plastic gloves and face masks. Even though it's just because of the COVID-19 health protocol, for me, these things became a new habit of hygiene, which is better for everyday health.

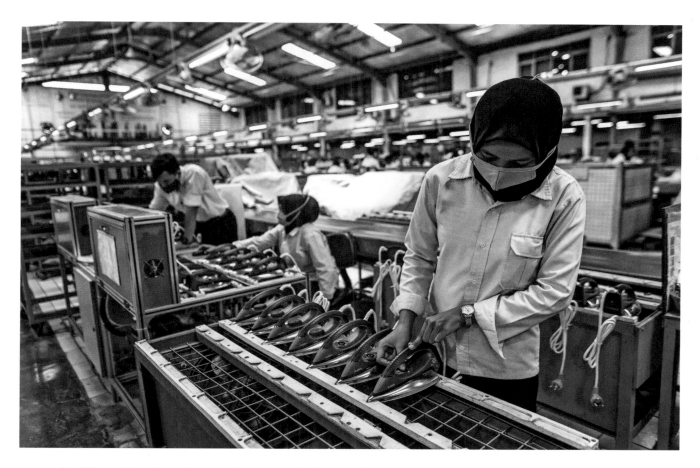

Amid the outbreak, workers wearing protective face masks are seen at a factory that manufactures clothes and blenders on the outskirts of Jakarta, Indonesia, on August 19, 2020. I visited this very large factory to see the life of the workers. Without work, they find it difficult to live.

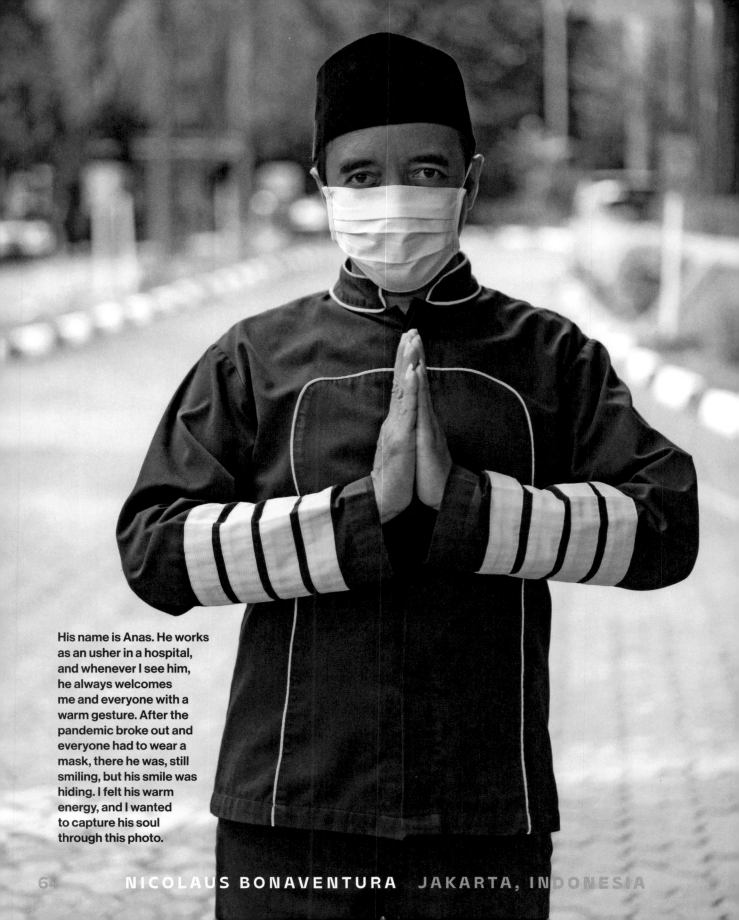

His name is Anas. He works as an usher in a hospital, and whenever I see him, he always welcomes me and everyone with a warm gesture. After the pandemic broke out and everyone had to wear a mask, there he was, still smiling, but his smile was hiding. I felt his warm energy, and I wanted to capture his soul through this photo.

NICOLAUS BONAVENTURA JAKARTA, INDONESIA

SOCIAL

One of the biggest shocks that the pandemic brought most people was the necessity of social distancing, which tore many families and communities apart, away from the socially connected life they knew and into an unfamiliar form of isolation. For a lot of communities and cultures, this new way of life was especially difficult to accept. Physical touch was a main form of communication, where love, respect, and acknowledgment were typically shown through simple gestures that had become taboo overnight.

DISTANCING

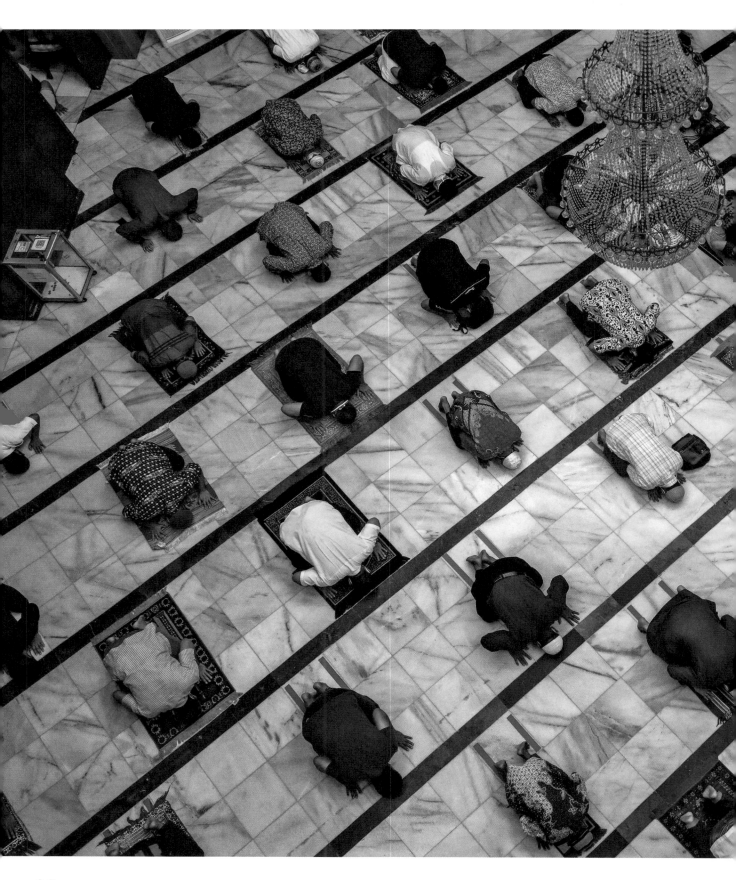

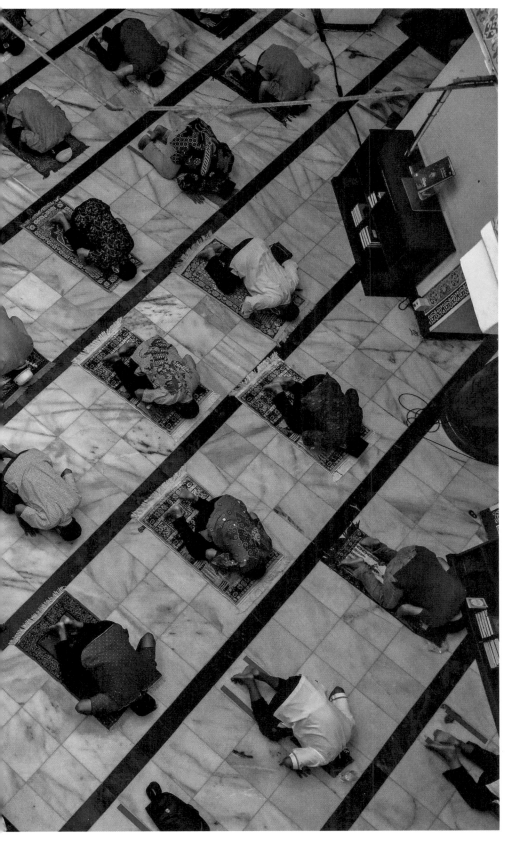

Worship is very important for humankind. During the pandemic, everything has been very limited, and you always must maintain a distance. This can be seen in the photo I took of Muslims performing Friday prayers at a mosque with strict protocols. Muslim men were attending Friday prayers while respecting social distancing, as the government eased restrictions despite concerns over the spread of COVID-19.

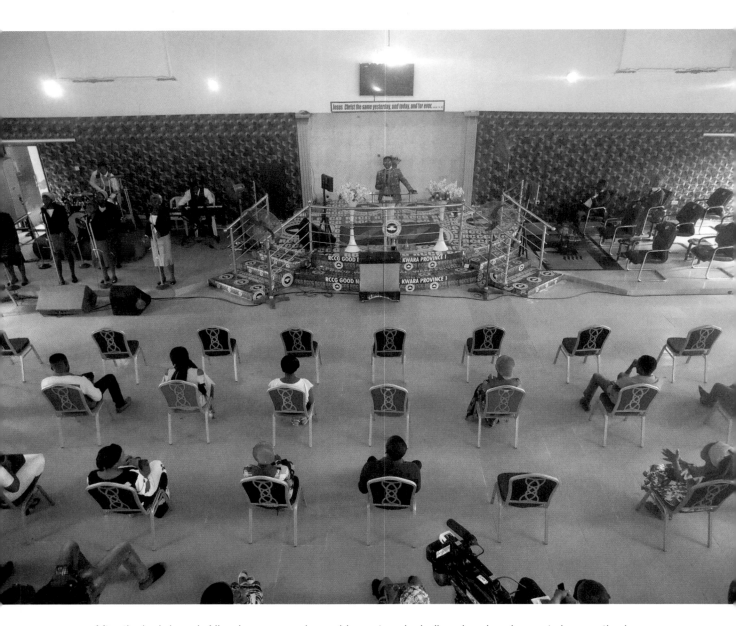

After the lockdown in Nigeria was eased, worship centers, including churches, began to have gatherings in small numbers—such as the ongoing worship session in Redeemed Christian Church of God. Chairs were arranged with space in between to avoid body contact during church services, unlike a normal service where seats are arranged together and members of the church can receive handshakes. This was to reduce the spread of COVID-19.

As a visual storyteller, I believe these moments are unique and ought to be remembered in history books. And as a Christian, I haven't ever experienced this kind of change in a church environment. I felt the need to freeze these moments, knowing I might not get to experience any similar changes in the future.

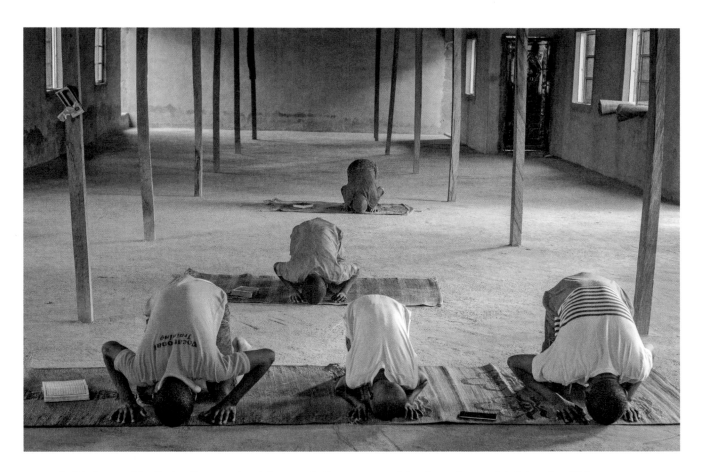

In this image, Muslim brothers and a sister pray in the mosque while observing social distancing. This is unlike other years in which they all would have come to pray in groups. This image is an excerpt from the project *Ramadan in COVID*, in which I documented the activities of Muslim youths during the fasting period. The key activities of Ramadan include Tefsir teachings, Iftar, and Jakar, among others. The project intends to see how Muslim youths in my environment cope socially with the change in their usual religious activities even with the restrictions due to COVID-19. The project was done in the Alase Community in April 2020.

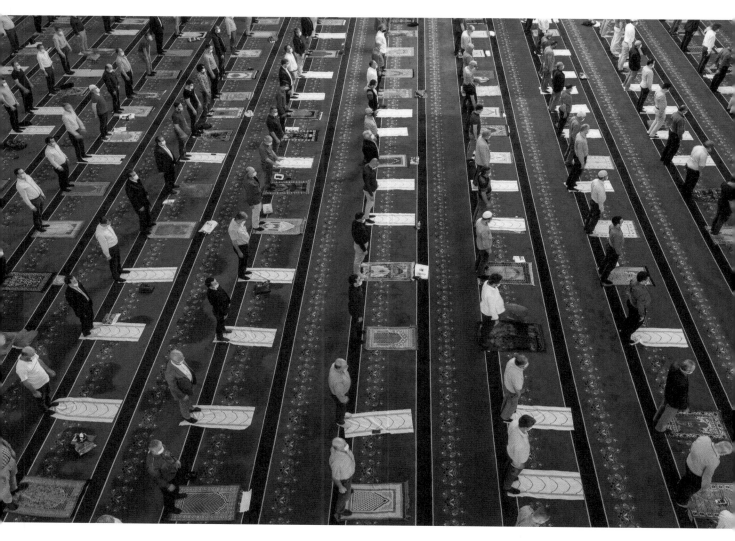

This is Ankara's Kocatepe Mosque. A new normal started after June 1 in Turkey. Mosques were crowded but people praying had to obey social distancing rules and wear masks. . . . I took this photo to show what happened during the pandemic in my city to the next generation.

F. DILEK UYAR ANKARA, TURKEY

A visit to Macau's only mosque during Ramadan resulted in a handful of photographs. A Muslim executive removed his tie and began to pray during salat (prayer) time. This photograph is part of a work I carried out at the end of 2020 about the Islamic community in Macau during a time of pandemic. Ramadan was somewhat affected by the pandemic because the only mosque in Macau was closed for two months, as were all other places of worship, for Christians, Buddhists, and Taoists. For this project, I spent a few hours in the mosque during salat time. I tried, as much as possible, not to interfere with Muslim prayer, going unnoticed while I photographed and captured the possible moments, within the existing restrictions, both at the religious level and at the pandemic level.

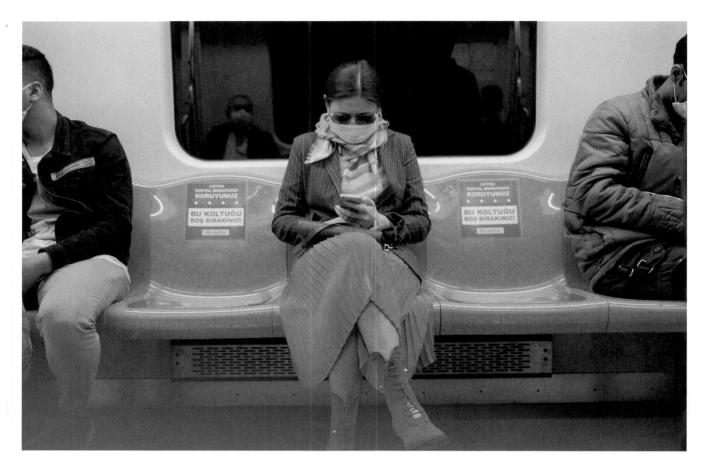

Isolation even in public ...

I was taking the metro that morning. Passengers were anxious because of COVID-19, but they must still go to work. At that time, COVID-19 was spreading fast in Istanbul. Despite masks and glasses, you can see everyone suspicious of others.

I felt like I was in a sci-fi film. In the metro, an invisible enemy was among us. But life continues, and people go to work, and I was thinking, *It's a weird contrast of a situation.*

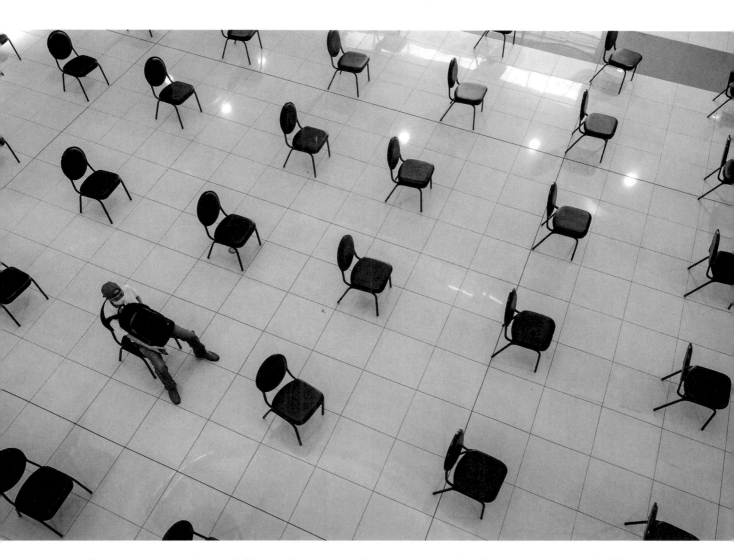

Only one person per household was given a quarantine pass to go out, but that one person worried that they would be the one to catch the virus. There was always a thought like, *What if I've already got the virus? I might pass it on to a family member.* But being able to leave the house was a sacrifice for the family, to help them continue living a good life.

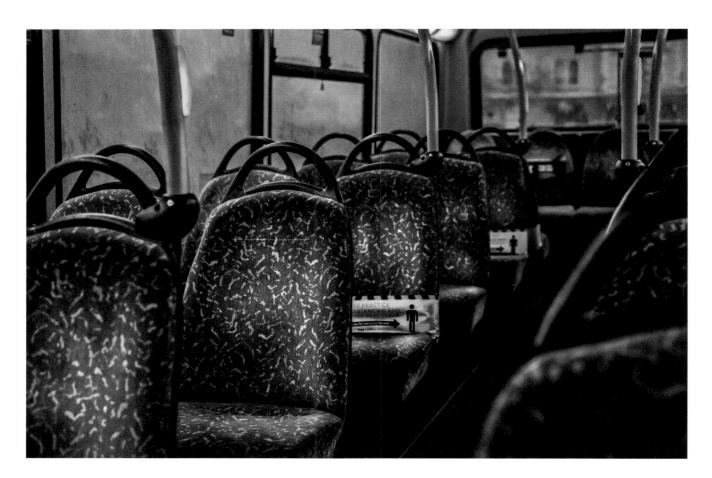

When I'm not photographing, I'm a healthcare assistant in a residential home. During the lockdowns, as key workers we had to carry on working like everything was normal. I remember I just got my new camera, so I took it to work, and after the shift I was doing a little photo documentation for myself.

Usually in the mornings, the buses are full with overly loud children going to school with their worn-out and equally loud parents. Honestly, I have always been overwhelmed with the noises on my way home. This photo represents so many things I never thought I was going to miss. This was my reality during the lockdowns: keeping distance even on the buses, making sure we don't sit behind or beside each other, having no loud children in the mornings—just soul-eating, terrifying quiet and emptiness. Even the colors are desaturated.

The whole world had stopped functioning, like a fictional post-apocalyptic scene from a sci-fi movie. I was scared when I looked back at this photo. Because I knew this reality didn't only affect Weston, but the whole world. And if I was this lonely, with the freedom of going to work, what did all those people who were stuck in their homes feel?

All these feelings and mainly the loneliness were the motivation to create this memory—to give back something to the community, on which we can look back and say: "Yes, I remember. That was an awful time. Thank God it's over."

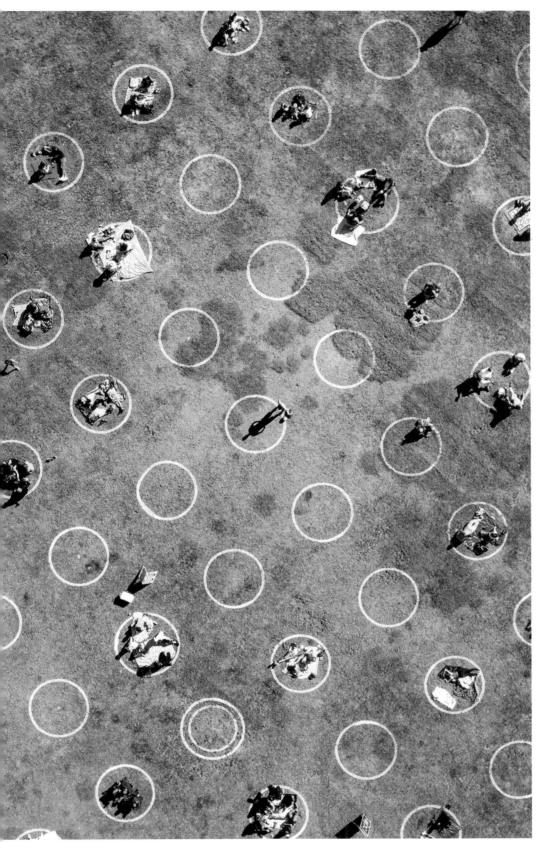

In the early stages of lockdown, it was an odd time to shoot photos. Very few people were on the street, and it felt somewhat like being on the moon. I shot this drone image as people started venturing outside again in May. It was odd, and compelling, to see one of San Francisco's main parks transformed with such a visible mark of COVID-19.

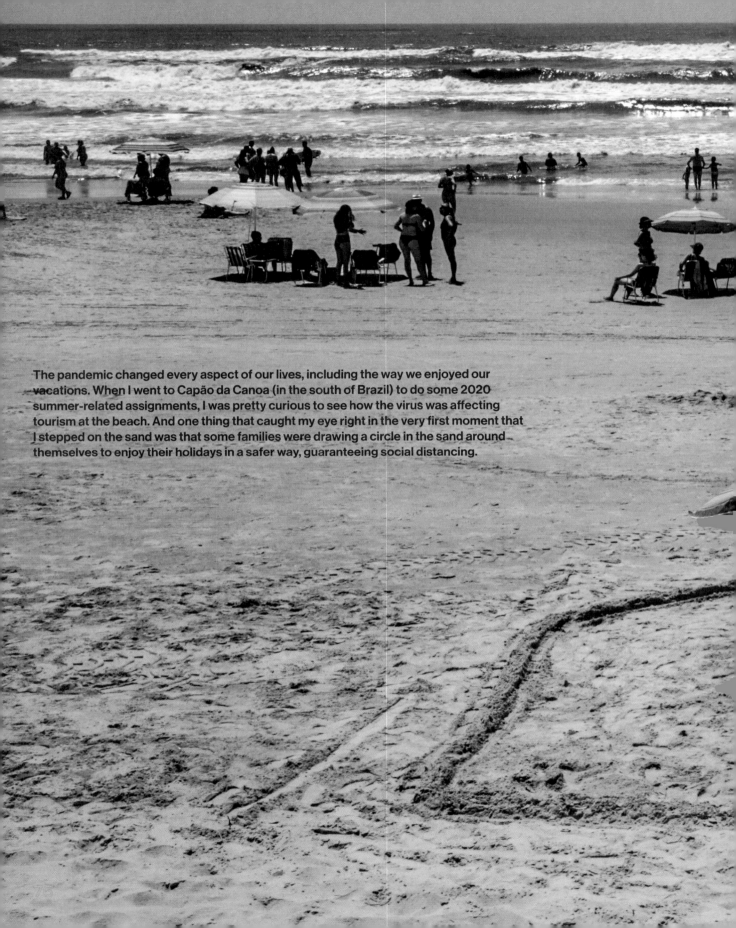

The pandemic changed every aspect of our lives, including the way we enjoyed our vacations. When I went to Capão da Canoa (in the south of Brazil) to do some 2020 summer-related assignments, I was pretty curious to see how the virus was affecting tourism at the beach. And one thing that caught my eye right in the very first moment that I stepped on the sand was that some families were drawing a circle in the sand around themselves to enjoy their holidays in a safer way, guaranteeing social distancing.

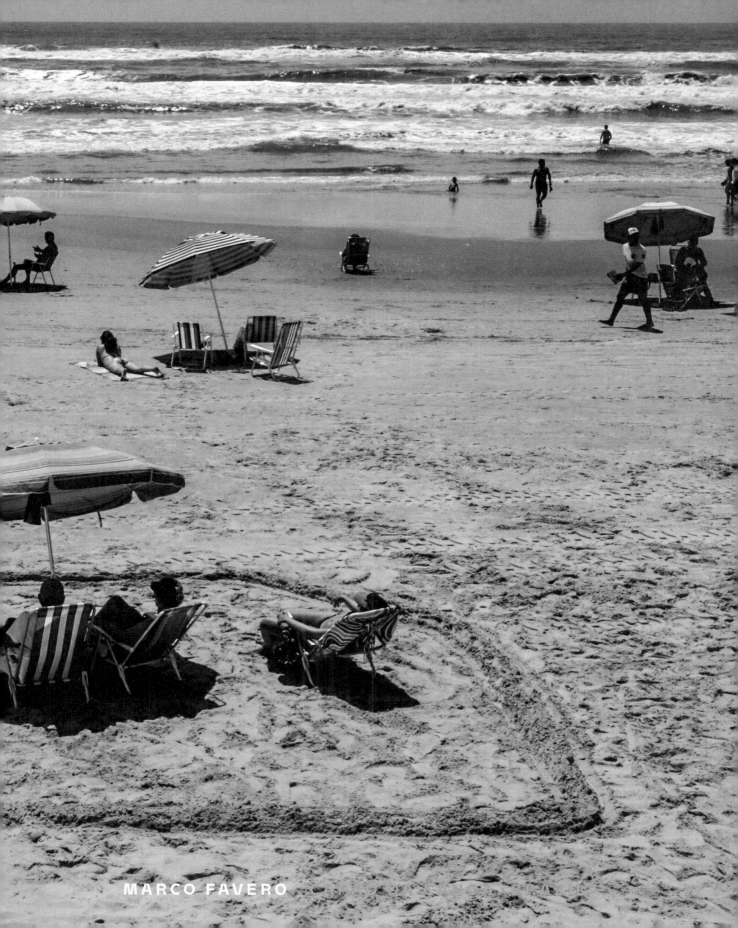

MARCO FAVERO

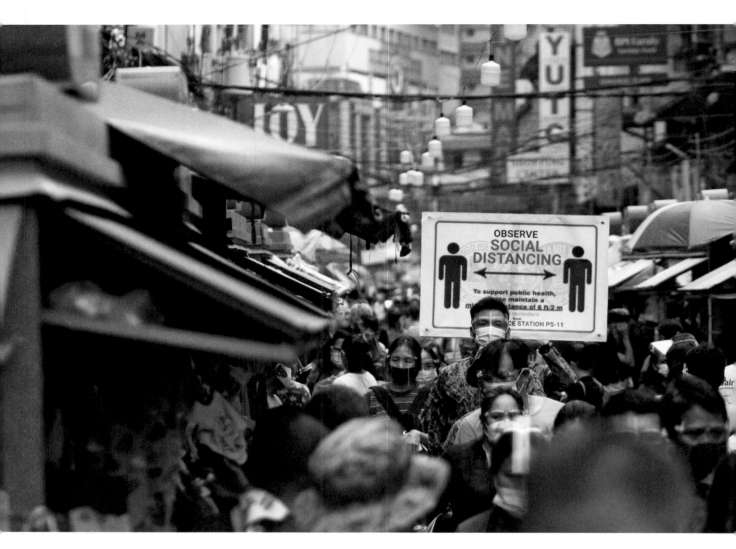

As COVID-19 cases in the Philippines rose and Filipinos faced numerous lockdowns, I took this photo of market-goers scrambling to do their Christmas shopping on a narrow street in Divisoria, a famous thrift market in Manila, despite the danger of getting the virus due to a lack of social distancing. I get anxious whenever I look for human interest in crowded areas such as this one. This virus made a huge impact on my photojournalism journey.

JANSEN ROMERO MANILA, PHILIPPINES

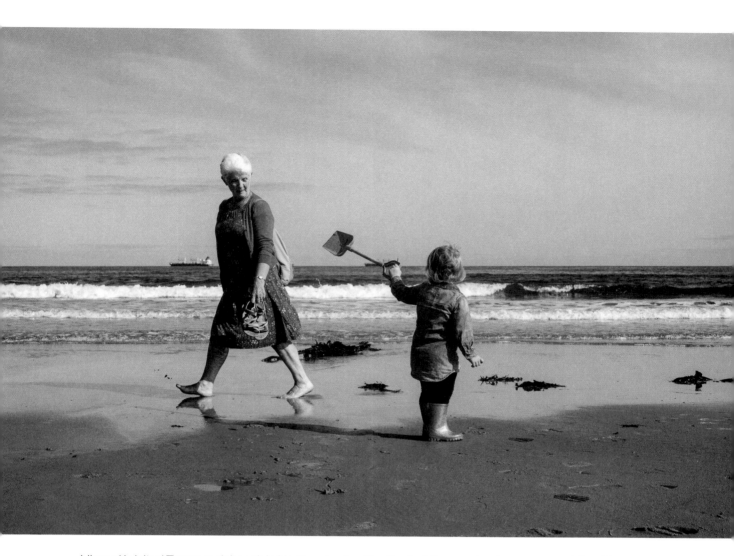

Lily and I visited Tynemouth beach in Northumberland for the first time as simply mummy and daughter. I used to take my little boy to the beach all the time. But due to continuous lockdowns, I hadn't been able to visit with my little girl. In fact, half of her life has been spent enduring this pandemic. She has not known shops without masks, playgroups, singing groups, dance clubs, baby gymnastics, regular visits from friends or family. She has mostly known the confines of home! So even a trip to the beach with Mummy became a momentous occasion. Yet the "Get off my beach" moment still arose—perhaps because she had become so accustomed to not being around too many people. I observed as Lily would watch intently any individual who would cross her path on a mostly deserted beach. Clearly the miles of open sand were not enough for her. She wanted the whole place to herself, and she was happy to chase off any old dear with a spade who intruded on her space!

CLAIRE BATEY NORTHUMBERLAND, ENGLAND

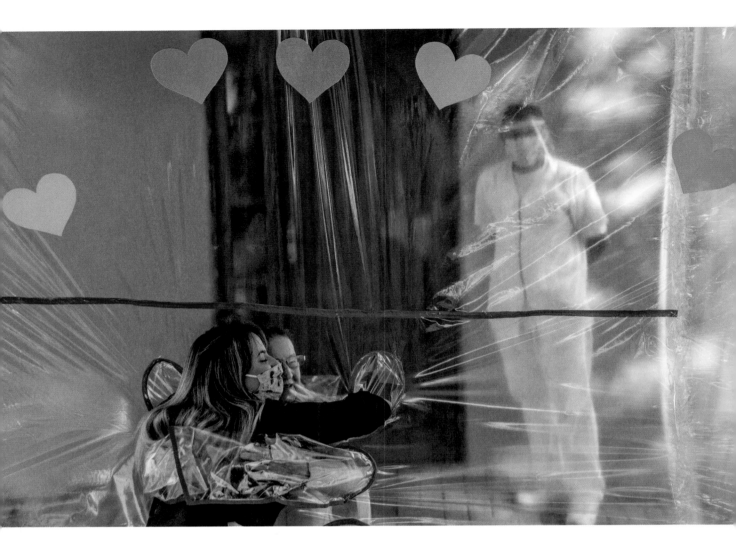

With social distancing as a way to protect the most vulnerable, the elderly especially feel the weight of loneliness. With that in mind, this nursing home in Gravataí (in the south of Brazil) installed a "hug tunnel" so that residents and visitors could exchange hugs through a plastic curtain. I took this photo as part of an assignment for my newspaper (*Zero Hora*, based in the city of Porto Alegre). We had heard that this nursing home installed this plastic curtain so residents and visitors could exchange caresses. This picture shows a 23-year-old hugging her grandmother, 93, for the first time since the beginning of the COVID-19 pandemic. The picture is one of my favorites of the whole pandemic coverage because it shows humans trying to overcome obstacles to show love to their loved ones. It's a scene that is, at the same time, sad and full of hope. Obviously, hugging a granny through a plastic curtain isn't the same and shows the other side effect of the disease: keeping people apart. But at that moment (way before a vaccine was produced), it was one of the most clever solutions offering people an opportunity to see each other and share affection. Personally, I kind of saw part of myself in that. I'm currently living 900 kilometers away from my parents, and since the pandemic started, I saw them once, for a week during my holidays (after staying in quarantine for a whole week). In a way, it was painful to watch this hug in the nursing home, knowing that I didn't have a plastic curtain for my own family.

MARCO FAVERO GRAVATAÍ, BRAZIL

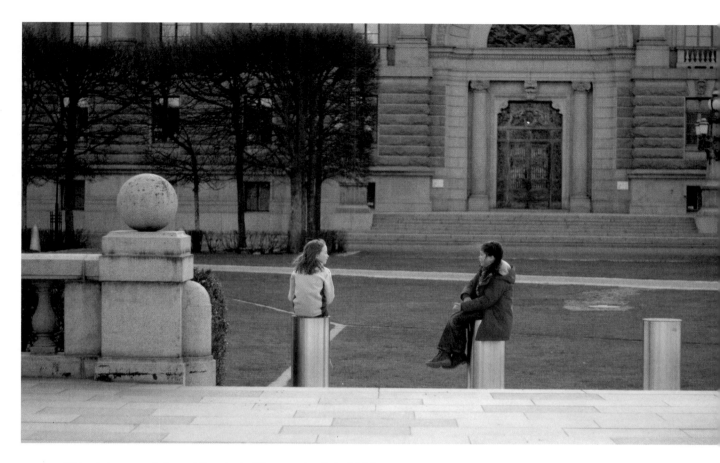

This picture was taken at the start of the pandemic in 2020.

While I was doing my internship as a photographer, my boss came up to me with the rest of the management team to tell us to go home, that a big situation had begun worldwide. I'm a 22-year-old woman, and I had traveled alone far from home—from Venezuela to Sweden—just to do this internship, because I was looking for opportunities. Then the pandemic started . . . So when my boss told me about this, I didn't know what to say or do. As you can imagine, I was stuck in another country, in a different culture, with a different language, etc. I had no way to travel back home or to any nearer country to family or friends. I remember that the first month in Stockholm, people were scared. No one was in the streets. I wanted to capture this because it was very shocking to see an empty city. Sweden has a bad reputation for its pandemic actions, but what I have learned is that people are still aware of what is needed. Perhaps Swedes never did a proper quarantine or never used a face mask. But social distancing is a thing. Or was.

Walking back to my Airbnb, after taking some pictures in the city, I found two little girls playing but social distancing. It made me have mixed feelings. I felt sad and happy. I guess it is sad because we lost contact with our most beloved ones, but also happy since it was really motivational and beautiful. The girls were taking care of each other, and I thought, *Sometimes love is not visible. Sometimes it is just different.*

The image was taken in the most touristy place in Stockholm, called Gamla Stan. The two girls sitting distanced was a story that really shocked me, because I'm from a "third-world country," and we are sometimes not careful or sometimes just forget some rules, but here in Sweden, you can notice how people take seriously the worldwide situation. Perhaps it is not mandatory to wear masks, and perhaps we did not quarantine, but something that I really admire is that people of all ages take social distancing seriously and consciously. These 2 girls were playing in front of the parliament house, having fun even in a bad situation, and they were happy and enjoying the time outside while respecting the minimal national restrictions.

VALENTINA OYÓN STOCKHOLM, SWEDEN

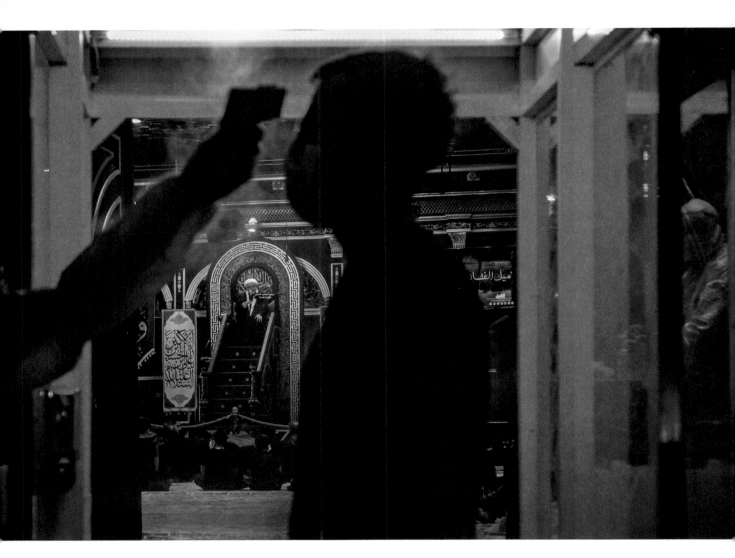

This photo was taken in Karbala, during the month of Muharram. The world was living the spread of the coronavirus. I was trying to get a picture that shows the relationship between preventive measures and people commemorating Ashura.

People don't seem to be interested in all the health measures imposed by the Ministry of Health in Karbala, but at the same time, there is a presence of health personnel trying to prevent the spread of the virus.

ABDULLAH DHIAA AL-DEEN KARBALA, IRAQ

LOCKDOWN

At each new year, we typically make a promise to change up our lifestyle. When 2020 began, it seemed as if many people were taken aback by just how much their lives began to transform. Living in a pandemic brought about extreme lifestyle shifts, as normalcy quickly became irrelevant. Physical changes were apparent as everyone navigated life under lockdown. Masks hung right at the door along with the keys to our houses, friends stayed six feet away, and being a homebody suddenly seemed like the only way to be. Lockdown lifestyle was not a change anyone expected, but it was a change we all had to quickly adapt to.

LIFESTYLE

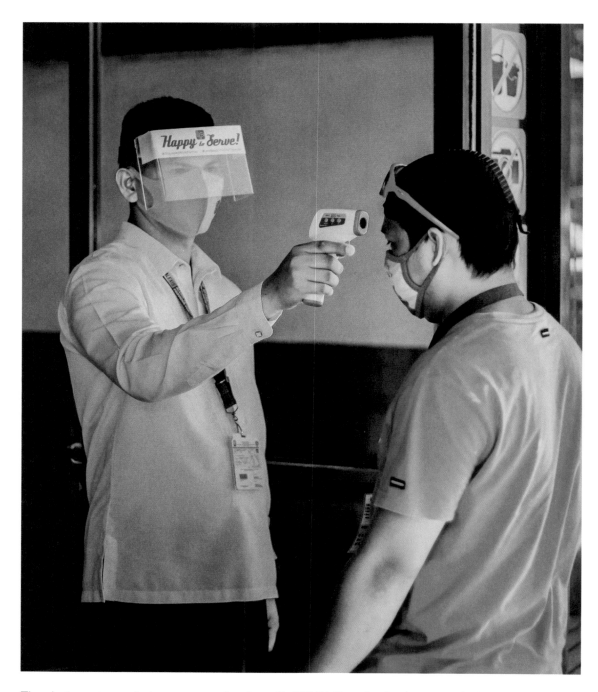

The photo portrays what we are experiencing with COVID-19: authorized personnel taking the temperature of a person who is about to enter a building in Dumaguete City, Philippines.

As a photographer, being able to capture moments that are unforgettable is a blessing, most especially in these trying times. I've been taking photos for quite some time now, and at the very moment of capturing this photo, it came into my mind how it would make an impact on everyone around me. It's very rare to be able to go outside and roam the streets with all the safety protocols being mandated in almost all places around the world. A photo like this gives everyone a chance to witness what it's like in other places and to make future generations understand the struggle we are facing today (present and future).

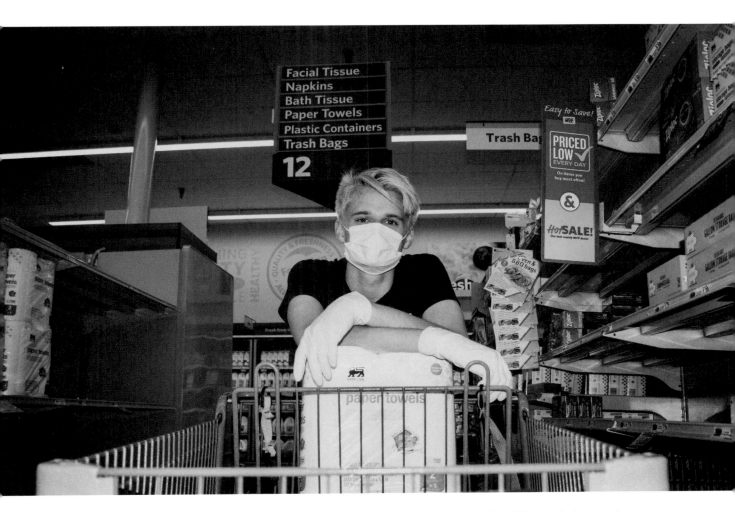

The year 2020 brought with it many adventures. Never did I expect the local Food Lion to hold one of those adventures. COVID made the ordinary things in life (like going grocery shopping) extraordinary. I wanted to capture one of the most basic human activities during a global pandemic.

This photo was taken at the beginning of quarantine when we really didn't know what all was in store for us in 2020. I am a senior commercial photography major at Appalachian State University, and the photo was taken for my editorial photography class. I enjoyed being able to play with direct flash while incorporating some very recognizable items, like the face mask, gloves, and the grocery store. Food Lion was about the only business allowing in customers, so we took advantage of that opportunity! I loved this shoot with my brother, and I will forever have it as a memento from this time in our lives!

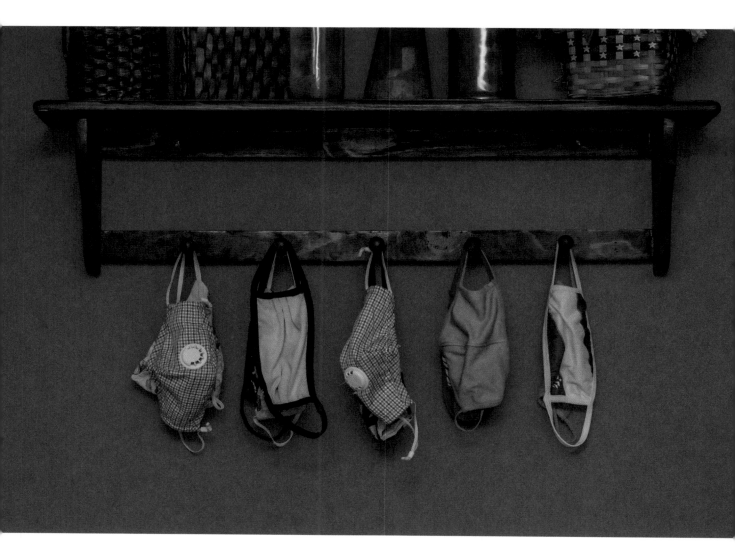

My photo represents the current state of our coatrack, which hangs by the front door. Pre-COVID, our coatrack was used for its intended purpose: to hold coats, sweatshirts, and hats. Since we started wearing masks, my wife, Sally, came up with the idea of transforming our coatrack into our mask rack. Everyone has their own hook to hang their mask on. So every time we leave the house we grab a mask. This photo is a reminder of how our lives have changed and how a mask is now a part of our everyday lives.

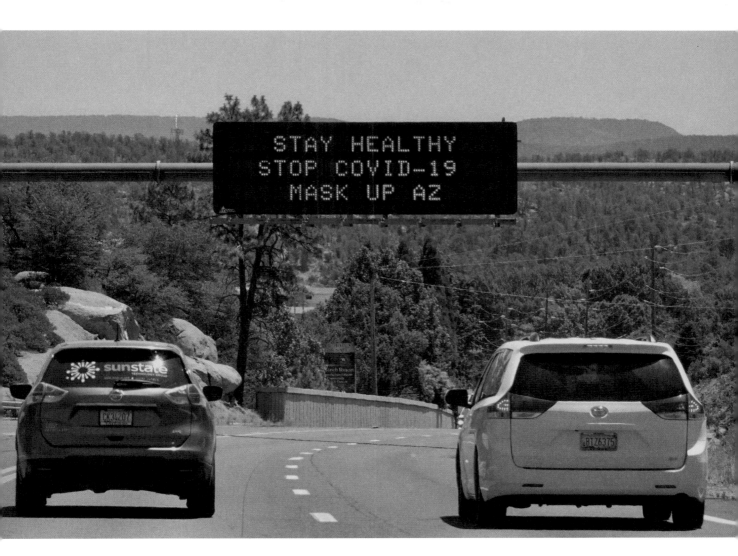

A simple drive from southern to northern Arizona is a beautiful route through the mountains. You are usually greeted by catchy messages along the way, like "Glad to have ya" or "Have a nice day." Now travel is limited throughout the state, and the beautiful views are marred with messages reminding us of how serious this COVID-19 pandemic is.

As a photographer, I usually travel the Southwest looking for unique photo opportunities, fantastic sunsets, and the beauty of the open road. This past year, it was quite a struggle to get out and about with travel restrictions, mask mandates, and separation from friends and family. I had to document the effects of the pandemic, so I hit the road, isolated to the car. Not long into my drive, the signage started to appear, but it wasn't until a "Stay healthy, mask up" sign beside a road in beautiful northern Arizona, with forests of ponderosa pine, that this new-normal signage during the pandemic truly hit me. The open road, a car, windows down, with good music playing—this has been an escape for so many people over the years, including myself. The sign was a bitter reminder that there would be no escape from COVID-19 until full vaccination was implemented. Until then, I will keep breaking out the map and looking for new roads to explore.

EUGENE LOWER NORTHERN ARIZONA, USA 87

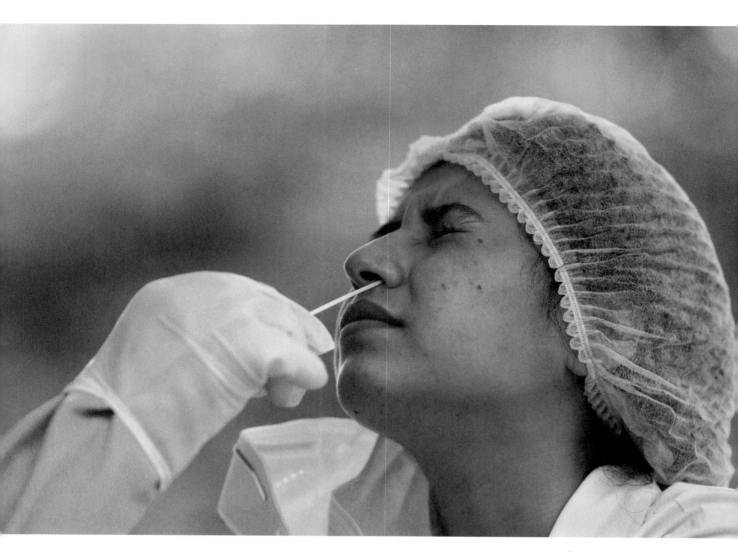

This facial expression was captured during the moment of a COVID-19 test. It was July 29, 2020. The clock was about to hit noon. Eager to take the COVID-19 test, I arrived at Plaza Salvador del Mundo, where the Epidemiological Containment Team of the Ministry of Health offered the tests free to anyone who came to the plaza in San Salvador, El Salvador. These were the first mass concentrations, where the ministry had installed booths. But they had only 300 of those COVID tests. And when I arrived there, only 5 tests remained. These would be used by health personnel. Seeing the expressions on their faces, in the face of the unknown, in the face of an unprecedented COVID-19 outbreak, and with the uncertainty of a positive diagnosis, I captured photographs of before and after the test. This image represents a lot, because I think this is how we all felt in 2020—how unknown the coronavirus was and the uncertainty of what could happen to us in the not-so-distant future.

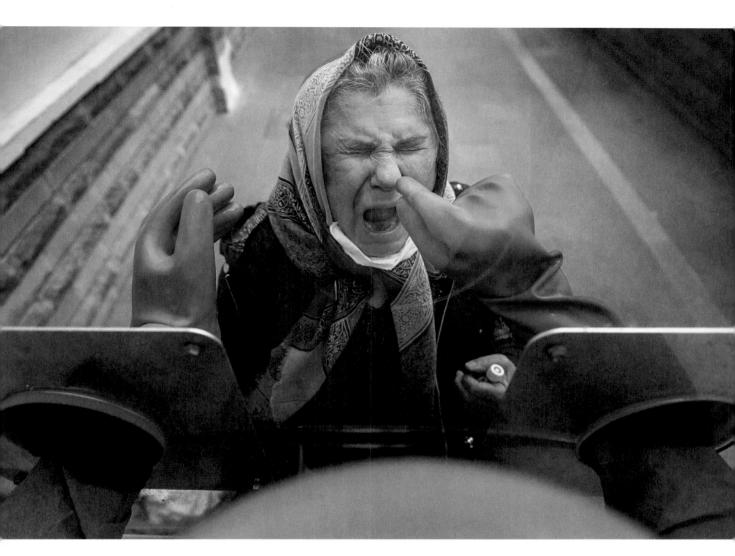

Here is the first place where patients come if they have COVID-19 symptoms: COVID-19 testing. For testing, samples are taken from the throat and nose by healthcare professionals working in an enclosed space. Photography is the eyes of those who aren't there. I just thought that I had to show what was happening to people in hospitals and document the process even though I was in fear during those first days of the pandemic.

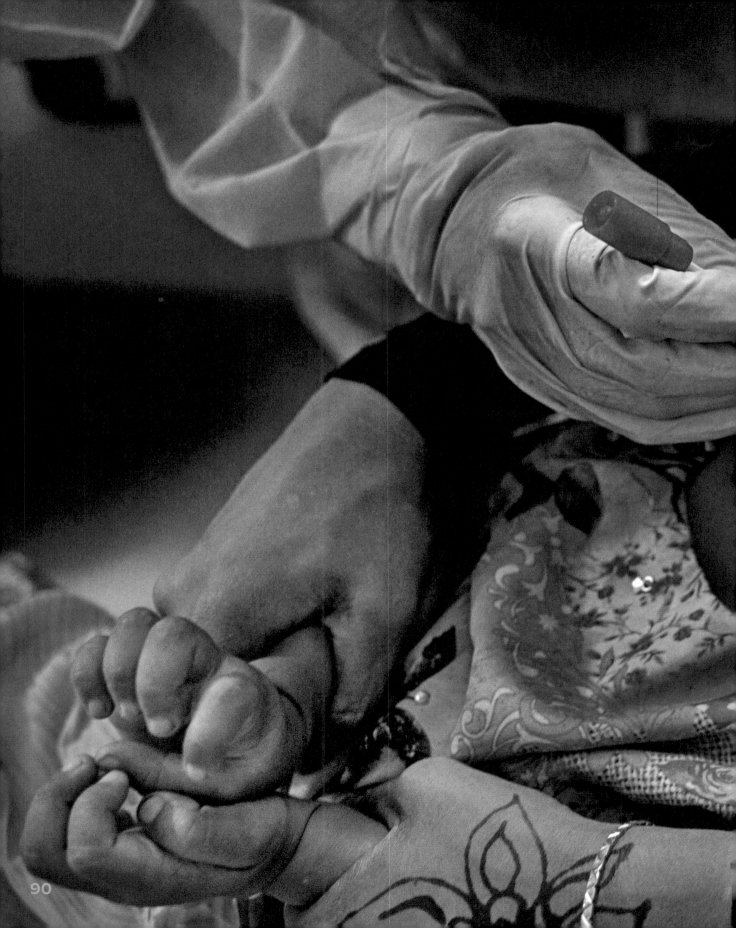

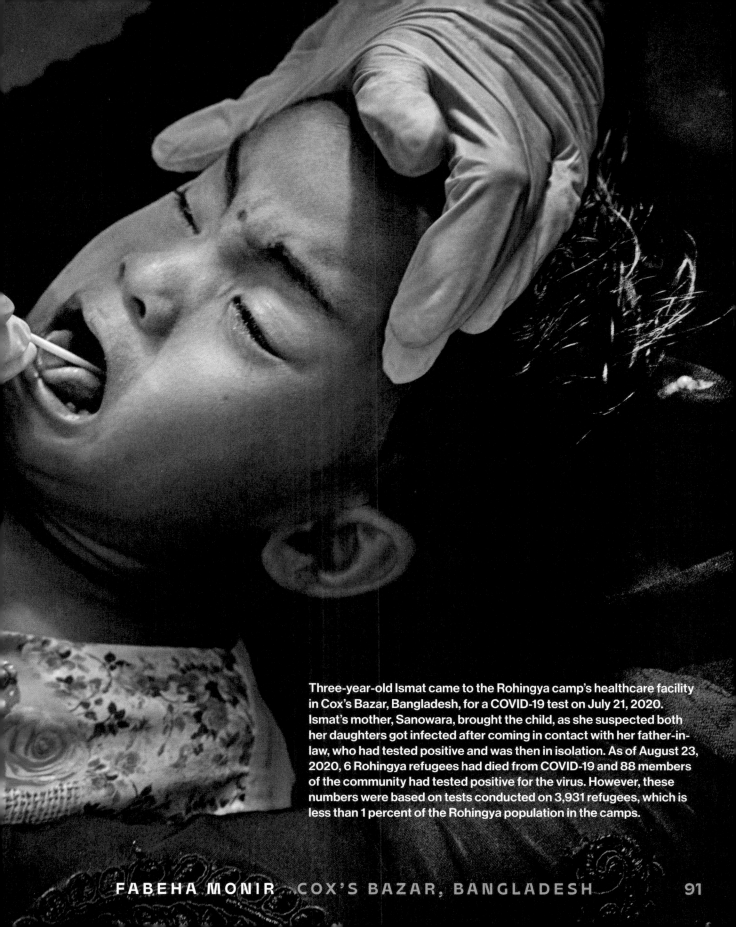

Three-year-old Ismat came to the Rohingya camp's healthcare facility in Cox's Bazar, Bangladesh, for a COVID-19 test on July 21, 2020. Ismat's mother, Sanowara, brought the child, as she suspected both her daughters got infected after coming in contact with her father-in-law, who had tested positive and was then in isolation. As of August 23, 2020, 6 Rohingya refugees had died from COVID-19 and 88 members of the community had tested positive for the virus. However, these numbers were based on tests conducted on 3,931 refugees, which is less than 1 percent of the Rohingya population in the camps.

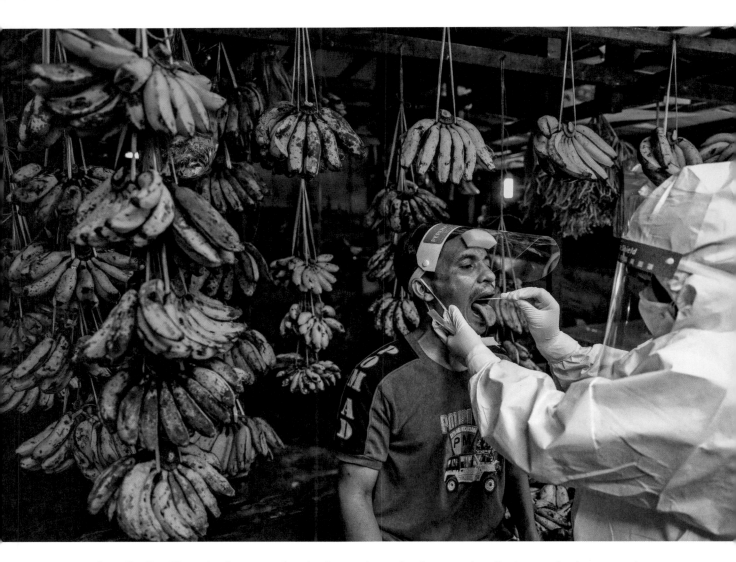

A medical health worker in personal protective equipment, using a swab, collects samples from a vendor at a traditional market to test for COVID-19, amid the spread of the disease in Jakarta, Indonesia. I visited this traditional market during the pandemic for the first time, and I saw vendors still selling but wearing masks. At that time, there was also a swab test for vendors in the market. I hope they are always healthy and able to fight on.

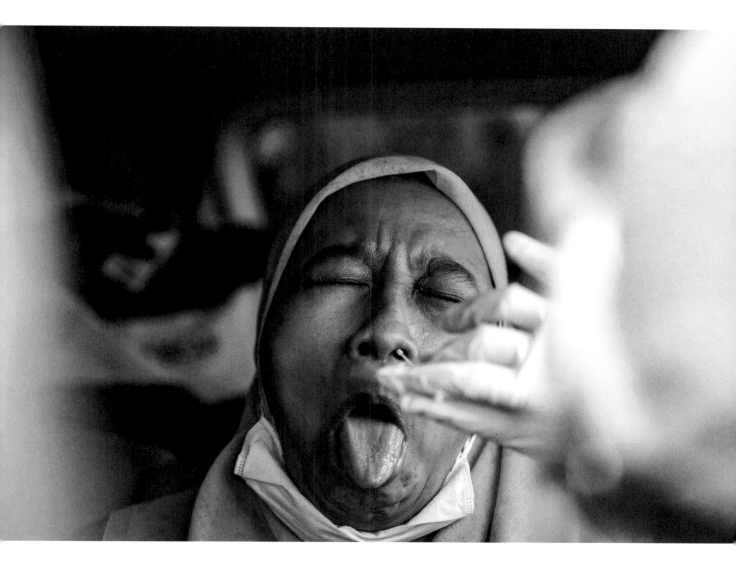

I took photographs of residents as they drove their own vehicles to get tests performed by a healthcare worker. People at this time needed to be more orderly to maintain their health and prevent getting COVID. This woman reacted as a healthcare worker took a nasal swab sample for a COVID-19 test in Jakarta, Indonesia.

GARRY LOTULUNG JAKARTA, INDONESIA 93

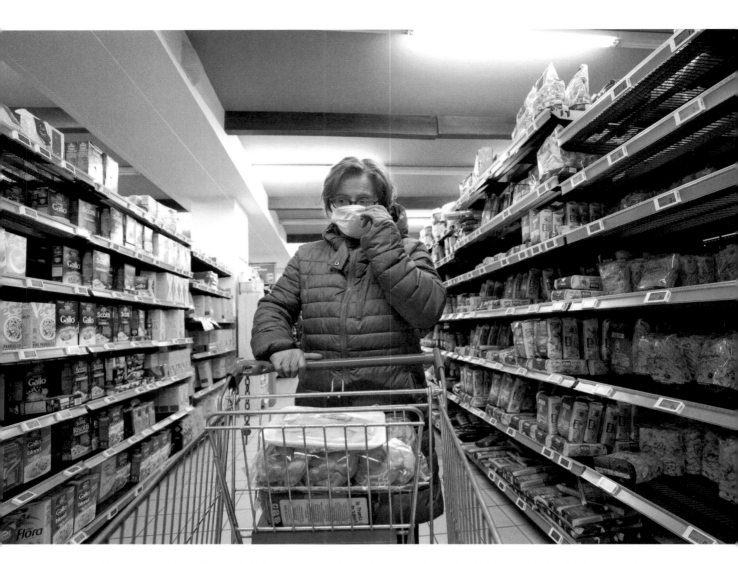

The year 2020 challenged all of us. For me, a huge fan of photography, this meant trying to show what was happening in the best possible light. For example, going out just to go to the supermarket with the fear of being infected was not easy. It felt like being in a movie. Or seeing the loneliness in the streets that, until a few months ago, were full of people, was really bad. I felt bewilderment. I did not know (as indeed all of us didn't) what was really happening.

MARTINO LEO SIANO, ITALY

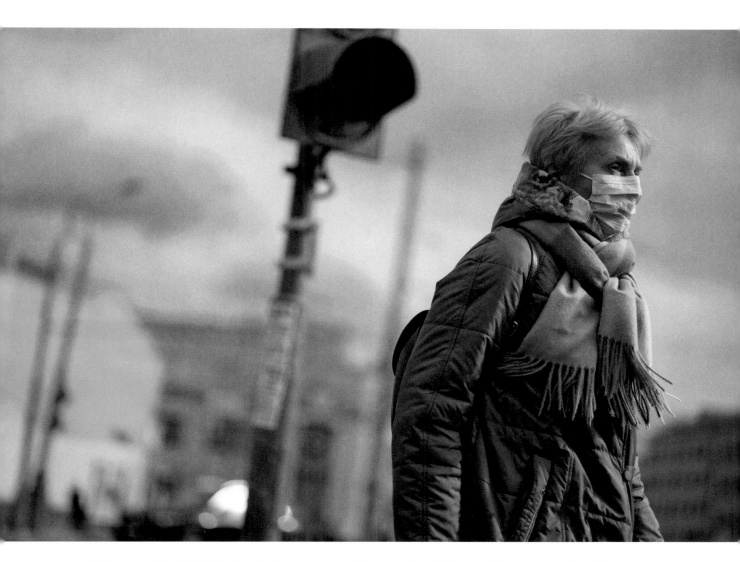

At the end of March 2020, when the quarantine had already started, Moscow became empty, as it never was before. During each of my rare walks through Moscow's streets, I tried to capture the feeling of danger in the air and the unusual emptiness on my familiar routes. This photo was taken when I walked to visit my friends, and on the way I managed to catch a piece of the pandemic atmosphere. A few days after this, I was far away from Moscow, spending the 3-month lockdown at home.

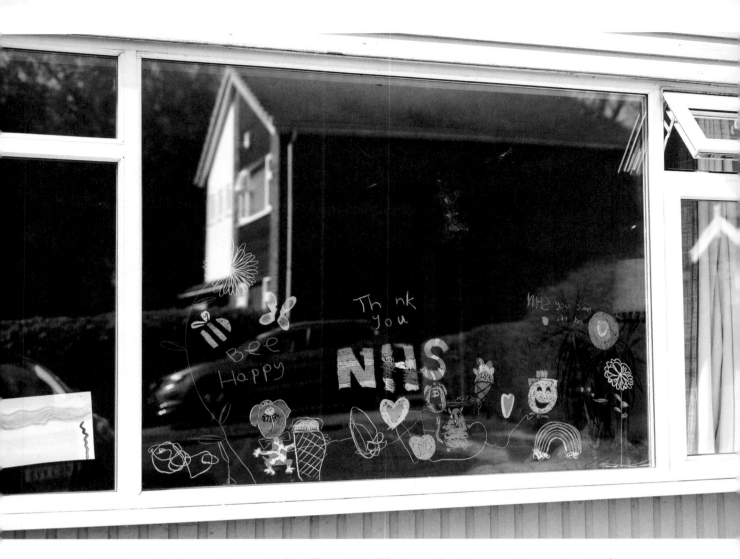

I photographed some girls as part of my *Through the Window* project. It seems they spent most of Lockdown 1.0 painting their windows—something that was common in the UK. Rainbows everywhere to show solidarity with the National Health Service and to give us hope. At the same time, a few shots show the toll the lockdown was taking on the children. Days are long for young ones—months feel like years, and they miss their friends, their family, their freedom.

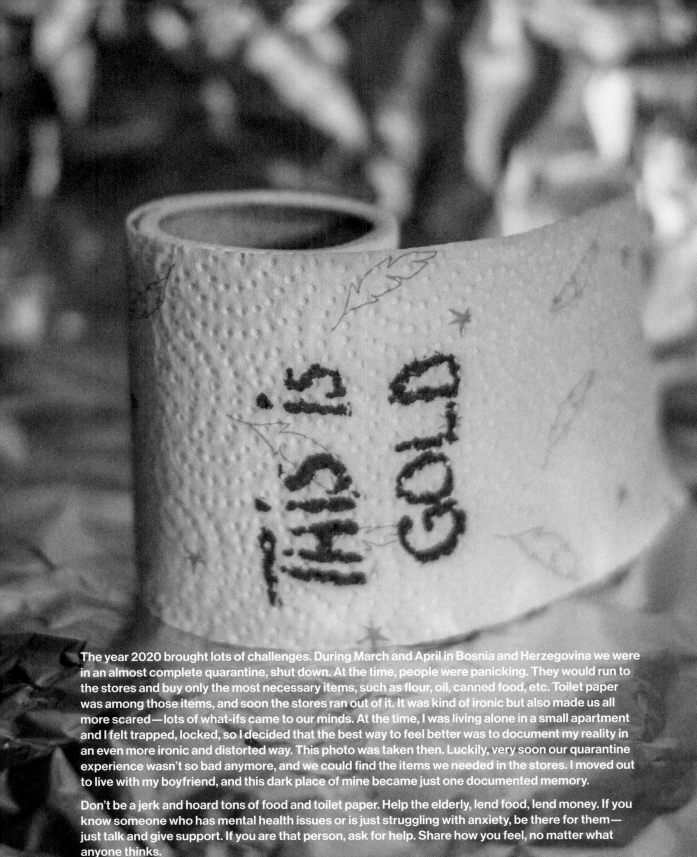

The year 2020 brought lots of challenges. During March and April in Bosnia and Herzegovina we were in an almost complete quarantine, shut down. At the time, people were panicking. They would run to the stores and buy only the most necessary items, such as flour, oil, canned food, etc. Toilet paper was among those items, and soon the stores ran out of it. It was kind of ironic but also made us all more scared—lots of what-ifs came to our minds. At the time, I was living alone in a small apartment and I felt trapped, locked, so I decided that the best way to feel better was to document my reality in an even more ironic and distorted way. This photo was taken then. Luckily, very soon our quarantine experience wasn't so bad anymore, and we could find the items we needed in the stores. I moved out to live with my boyfriend, and this dark place of mine became just one documented memory.

Don't be a jerk and hoard tons of food and toilet paper. Help the elderly, lend food, lend money. If you know someone who has mental health issues or is just struggling with anxiety, be there for them— just talk and give support. If you are that person, ask for help. Share how you feel, no matter what anyone thinks.

TAJANA DEDIC STAROVIC BANJA LUKA, BOSNIA AND HERZEGOVINA 97

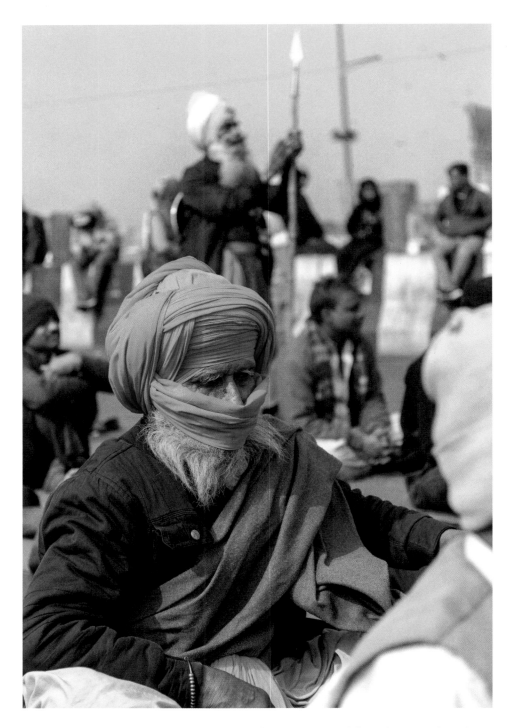

It was a very tough time to fight against an unknown enemy, while at the same time also needing to work toward financial support for myself. I covered farmer protests in late 2020 in Delhi, India, and participated in food distribution for those in need during the pandemic. It was winter in India, when Sikh farmers were protesting against the new farm bills during the COVID-19 pandemic. An old man with an orange turban was sitting between the people. The man attracted my eye even among the huge crowd, to capture through my lens.

ABHISHEK MITTAL DELHI, INDIA

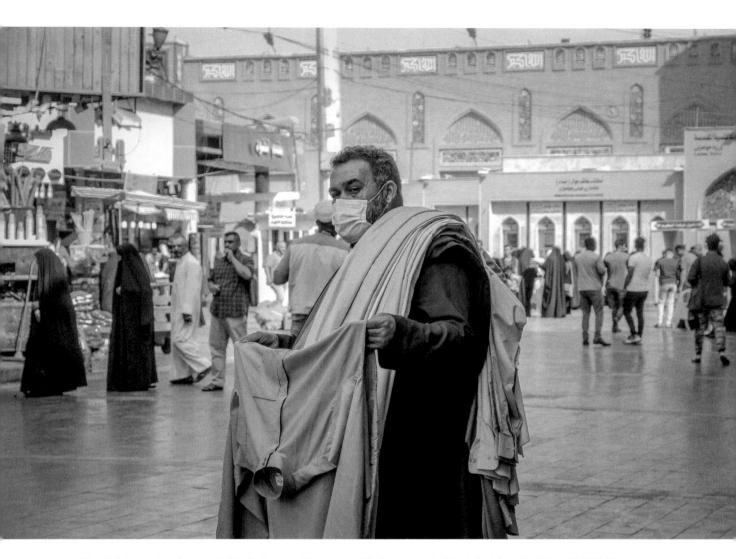

I took this photo of a man in his forties walking around in the street in Baghdad, Iraq, in July of 2020. The man is wearing a mask and he is carrying men's clothes to sell. Although it is dangerous and risky to go out and do this job the whole day because of COVID-19, he has to keep working, to make sure his family survives.

This photo was just right there, waiting to be captured. The man was quietly standing, holding some clothes to sell. I saw boredom, sadness, and loneliness in this photograph, and it touched my heart, like all the photographs I've taken.

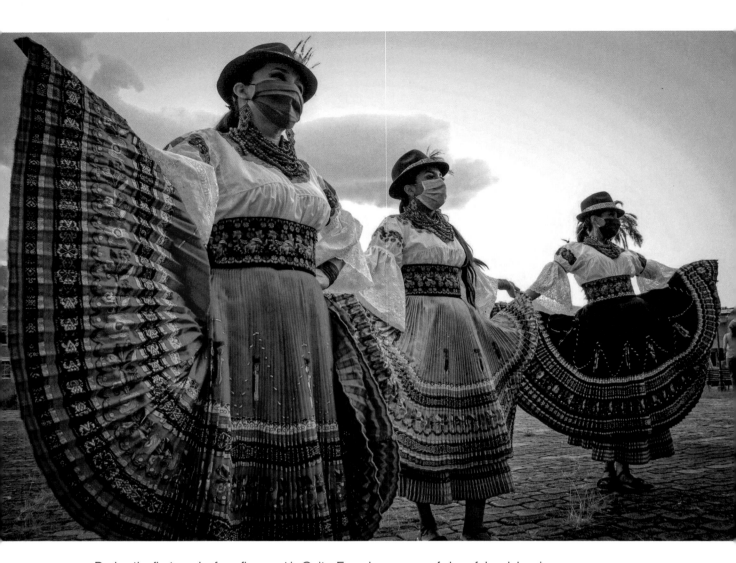

During the first week of confinement in Quito, Ecuador, a group of cheerful and dancing women—*warmis*—took to the streets, bringing happiness to every balcony of the Quiteño people. This took place in the capital of Ecuador, where the inhabitants of the area smiled despite the confinement. I was a spectator. This dance was done after curfew, but I broke the rules and covered it photographically because I was making a documentary in quarantine. It was super intense since they were imprisoning those who went out after curfew. This photo is very meaningful to me—two great arts coming together, both dance and photography.

After a year of reflection, from my point of view as a photographer, to be on the front line is to appreciate life. Apart from learning and working, the first thing should always be our health and well-being, taking care of others, and being there for them.

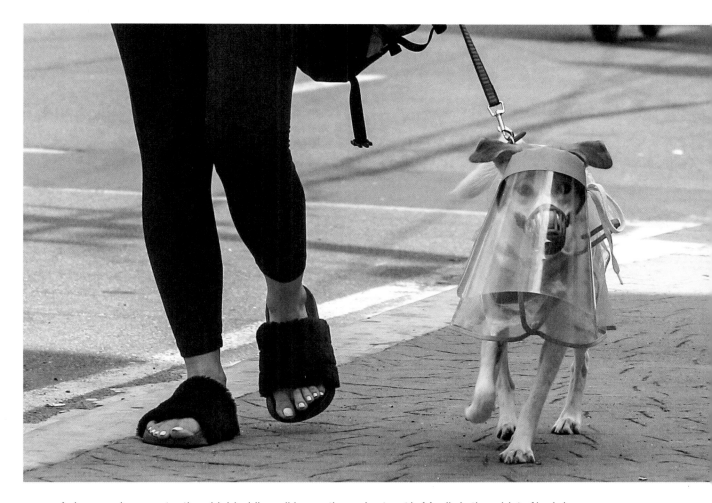

A dog wearing a protective shield while walking on the main street in Manila in the midst of lockdown brings a candid and light moment amid the dreadful mood brought by COVID during that time. Working as a news photographer in the Philippines in 2020 really brought a change in my work attitude. Unlike before, where I would just go to assignments, now (prior to my vaccination) I assess first whether it's too risky or it's safe for me and my household.

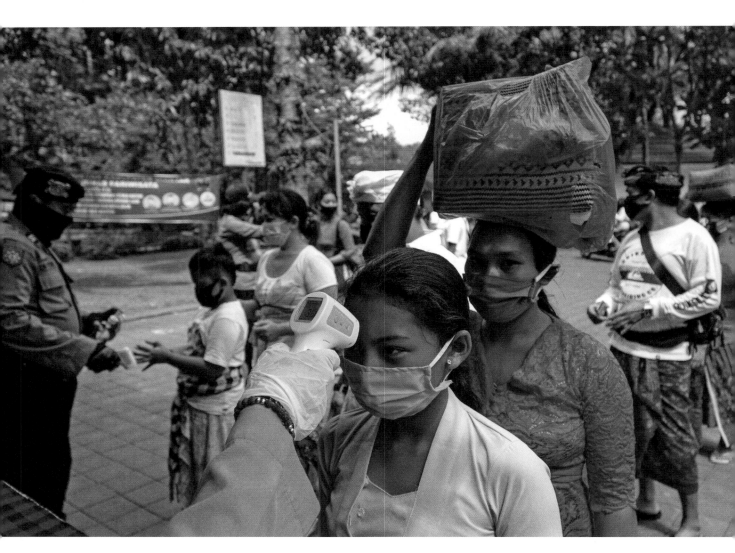

Banyu Pinaruh is a Balinese Hindu tradition in which people cleanse themselves in the sea or a holy spring on the day after the Saraswati day of knowledge. This image was taken at a Banyu Pinaruh cleansing ceremony at the holy spring at Tirta Empul Temple with health protocols, in Gianyar, Bali, on July 5, 2020. The image will be part of history, showing there was a pandemic that changed how people live their lives, including religious aspects. In this case, Balinese Hindus get their body temperature checked by police officers with thermometer guns before their praying session.

The most challenging part of photojournalism now is the virus itself. Photojournalists need to get close to dangerous locations, like hospitals, burial grounds, etc. Because of that, we have one of the most risky jobs amid the pandemic.

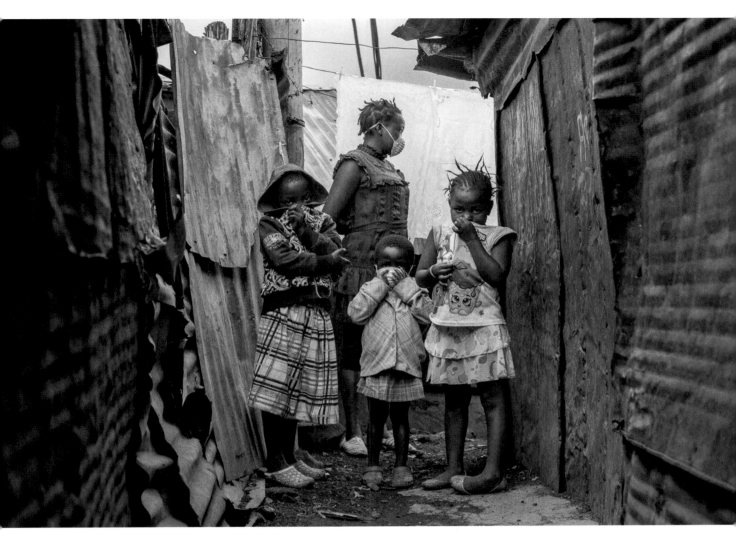

Family members wait outside as the area around their house is fumigated by Kenyan Army officers in Kibera slums, Nairobi. The fumigation process is being done in a bid to curb the spread of the coronavirus.

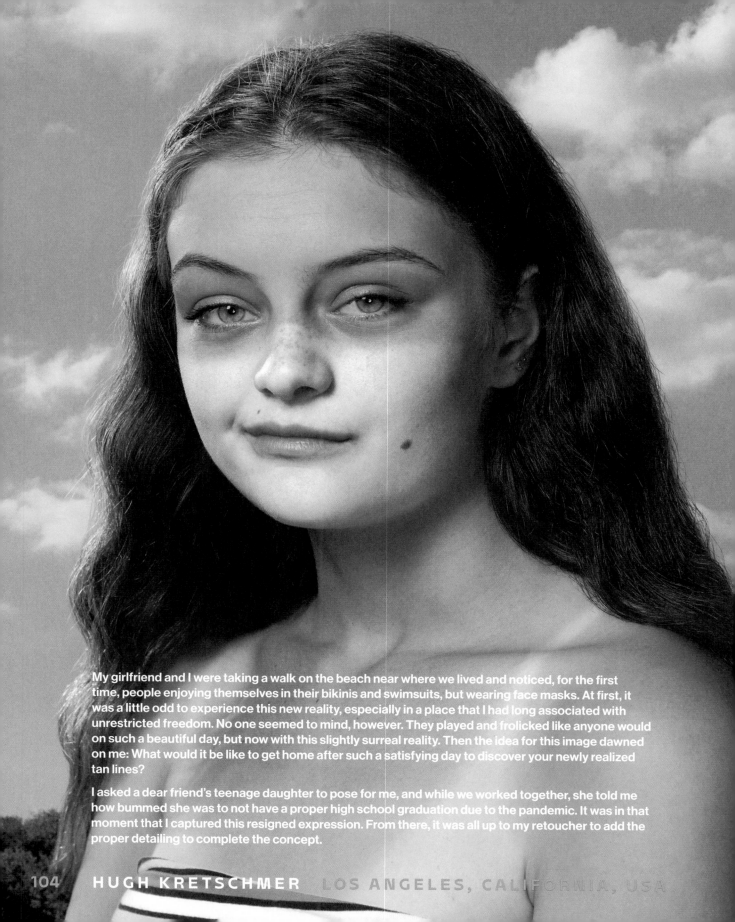

My girlfriend and I were taking a walk on the beach near where we lived and noticed, for the first time, people enjoying themselves in their bikinis and swimsuits, but wearing face masks. At first, it was a little odd to experience this new reality, especially in a place that I had long associated with unrestricted freedom. No one seemed to mind, however. They played and frolicked like anyone would on such a beautiful day, but now with this slightly surreal reality. Then the idea for this image dawned on me: What would it be like to get home after such a satisfying day to discover your newly realized tan lines?

I asked a dear friend's teenage daughter to pose for me, and while we worked together, she told me how bummed she was to not have a proper high school graduation due to the pandemic. It was in that moment that I captured this resigned expression. From there, it was all up to my retoucher to add the proper detailing to complete the concept.

104 HUGH KRETSCHMER LOS ANGELES, CALIFORNIA, USA

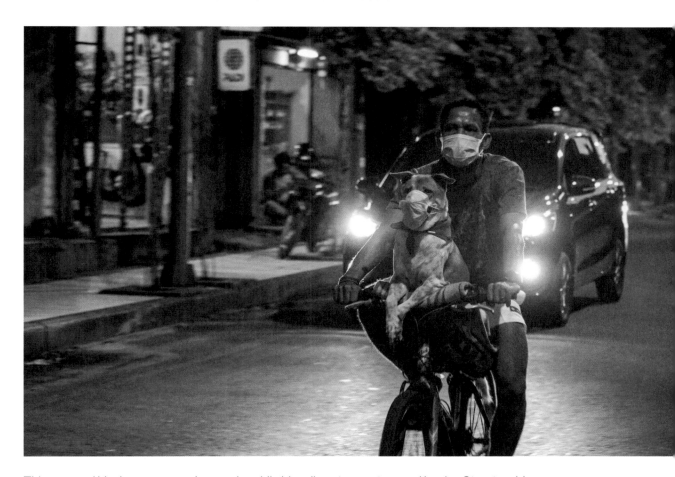

This man and his dog were wearing masks while bicycling at sunset around Legian Street amid concerns about the coronavirus outbreak in Bali. Personally, I found this moment to be a reminder of the hard times of the COVID-19 outbreak. The most challenging part in Bali is that Bali runs on international tourism. Since the pandemic began, all the tourism businesses are closed.

It really is different. Before, millions of tourists always filled Bali. Now, since international flights have stopped, Bali has become something of a "dead" city, especially in tourist areas. Empty, closed, for sale, for rent, for lease. That's all the property posters we've got everywhere.

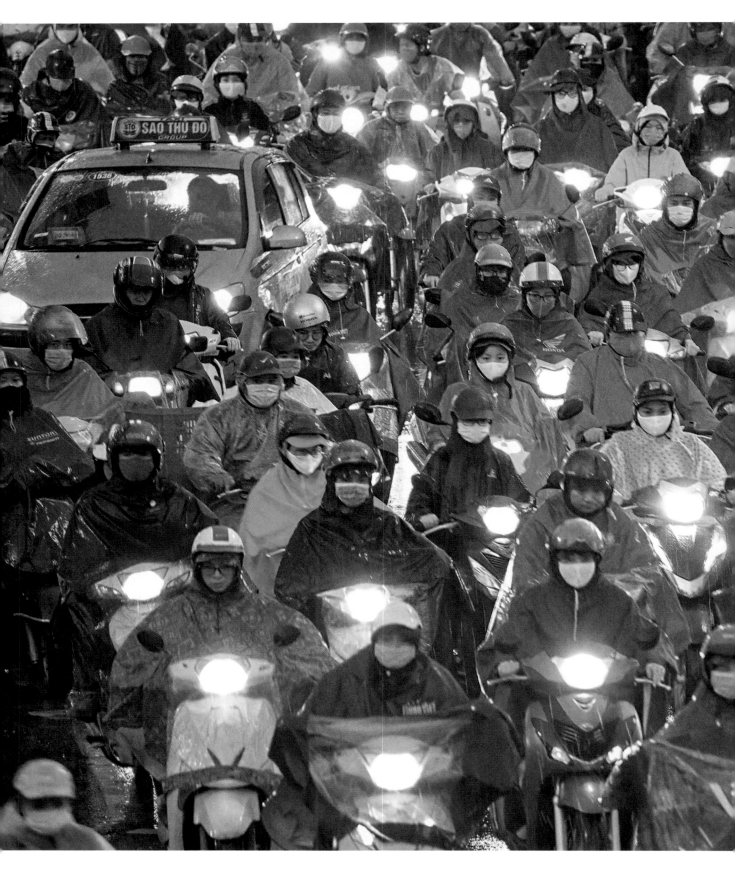

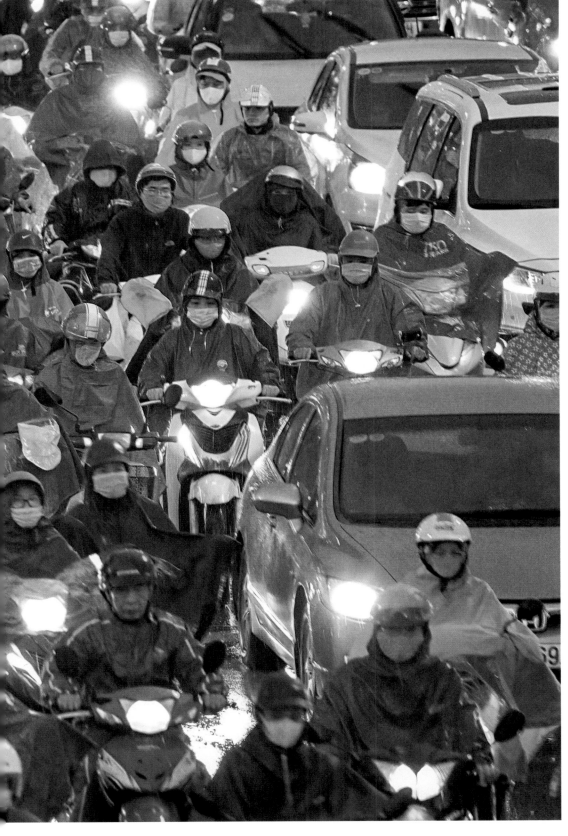

In March 2020, in Hanoi, Vietnam, at the beginning of the COVID-19 outbreak, I noticed this scene of people wearing masks and driving motorbikes during one of my evening walks and thought I should record this. My aim was to find an overpass near the traffic signal from which to capture this scene, and I'm glad I got this. Being in Hanoi for almost 10 years, I noticed a few things during the COVID-19 outbreak that I had never seen before, like people wearing masks, empty Hanoi streets, and so on. I have been photographing life in Vietnam, and this is a new Vietnam, one I hadn't seen before. The COVID-19 cases in Vietnam were very much under control from the beginning since the government took steps to prevent the spread and people followed the protocols. Though I felt safer in Hanoi, it's not easy as an expat thinking about family back home, as I had lost my father a few months before the outbreak. This project of capturing life during COVID helped me to divert my mind as well.

PRABU MOHAN HANOI, VIETNAM

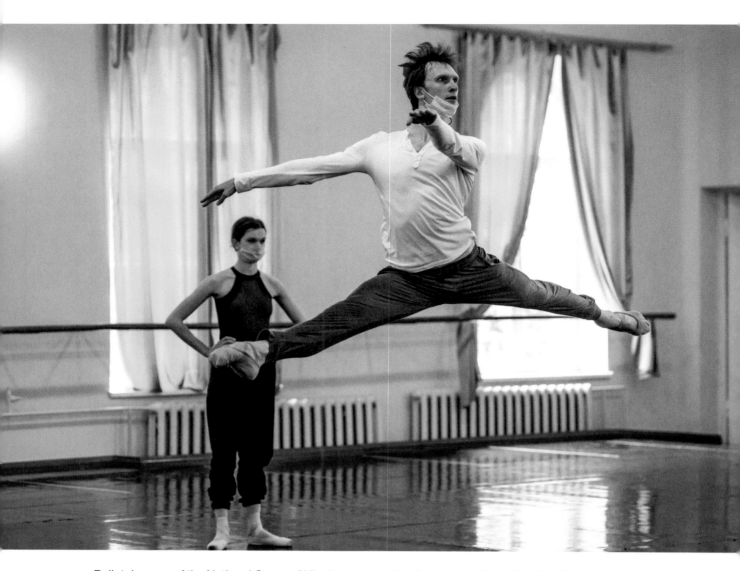

Ballet dancers of the National Opera of Ukraine wore protective face masks during their first rehearsal in the theater, observing quarantine rules, after easing in Kyiv, Ukraine, on May 19, 2020. The coronavirus outbreak changed everyone's life. Ballet dancers were no exception. All this was very unusual, both for the photographer and (especially) for the artists. The need to wear masks on their faces and avoid closer contact made their rehearsals very difficult. But an artist is always an artist, and they worked at full capacity.

And I was just lucky to document this unusual situation.

VLADYSLAV MUSIIENKO KYIV, UKRAINE

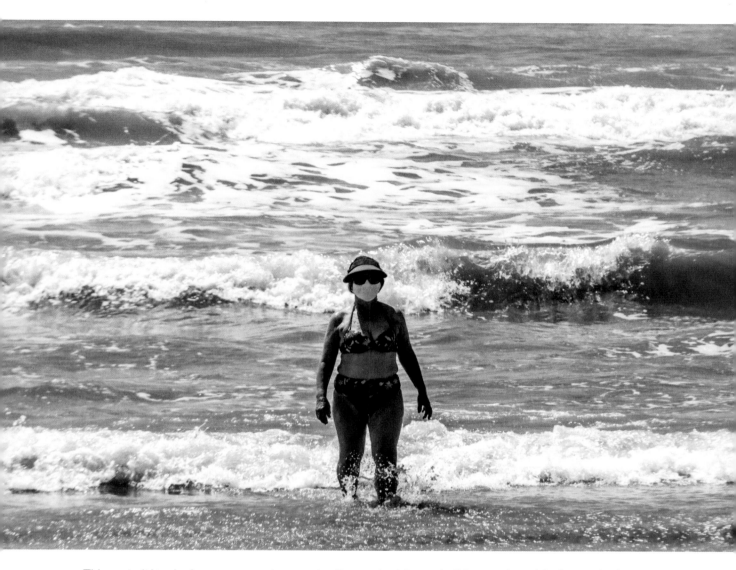

This portrait I took of a person wearing a protective mask while sea bathing on a beach in the south of Brazil translates a little of what I saw during this historic summer.

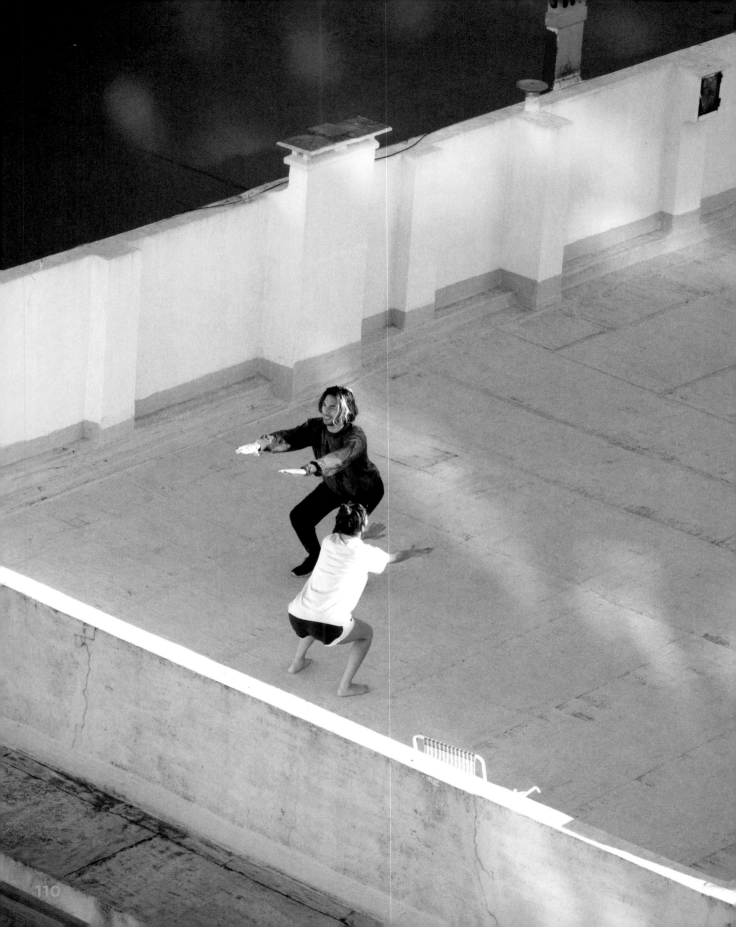

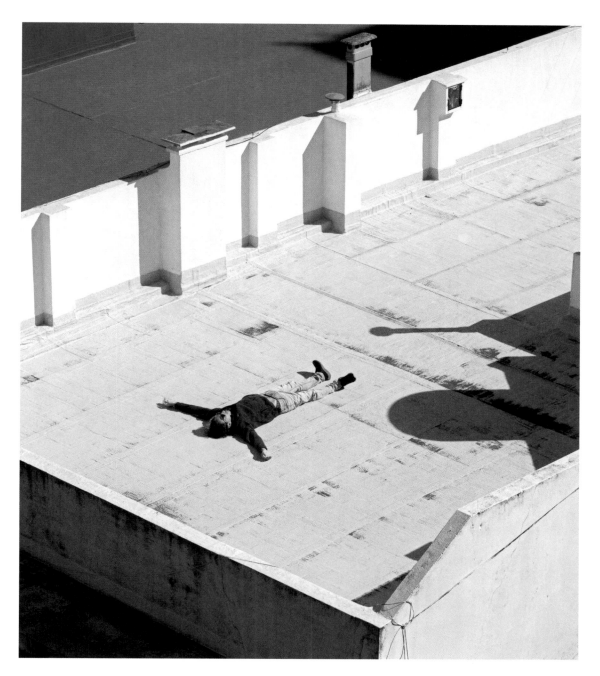

At a time of introspection, when we're presented with a huge challenge to find ourselves, both our light and dark sides, a door to transformation opens for many of us.

From the openings offered by an apartment in the middle of the city, I discovered stories that came from windows, balconies, and terraces. Stories of adaptation and rediscovery of our spaces and all their possibilities, of introspection, of assuming new cleaning and disinfection habits, of protection, of connection, of new codes of love, of loneliness and companionship, to meet again with our partners by our side and keep in touch with those who are farthest away, of discovering our own resources to cope with fear, uncertainty, and confinement. Faced with the challenge of reinventing my own photographic gaze in isolation, identifying, recognizing, and shooting small bits of neighboring stories gradually became essential tasks to cope with everyday life.

ELEONORA LAUFER BUENOS AIRES, ARGENTINA

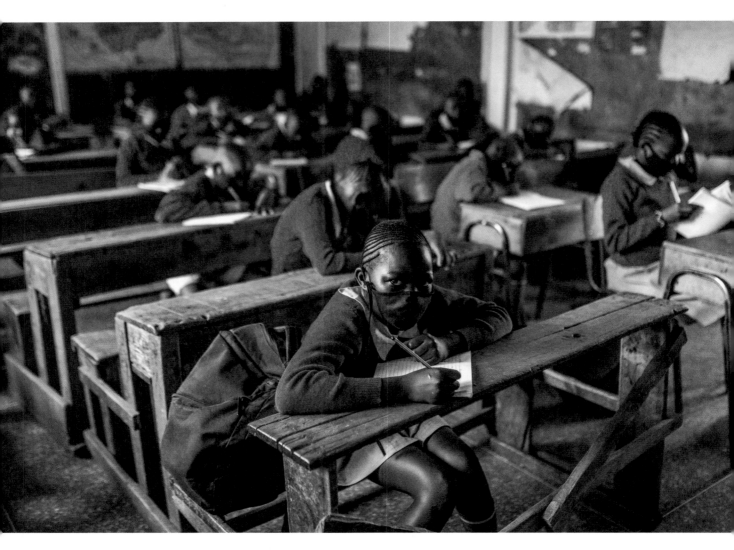

This photo was taken in the context of the pandemic in Kibera slum located in Nairobi, the capital city of Kenya. Students wearing face masks sit in a class on October 12, 2020, after the partial reopening of schools amid the COVID-19 pandemic in Kenya. I took this photo to show how schools were prepared to combat the pandemic after being closed by the government for a period of 9 months.

BRIAN OTIENO NAIROBI, KENYA

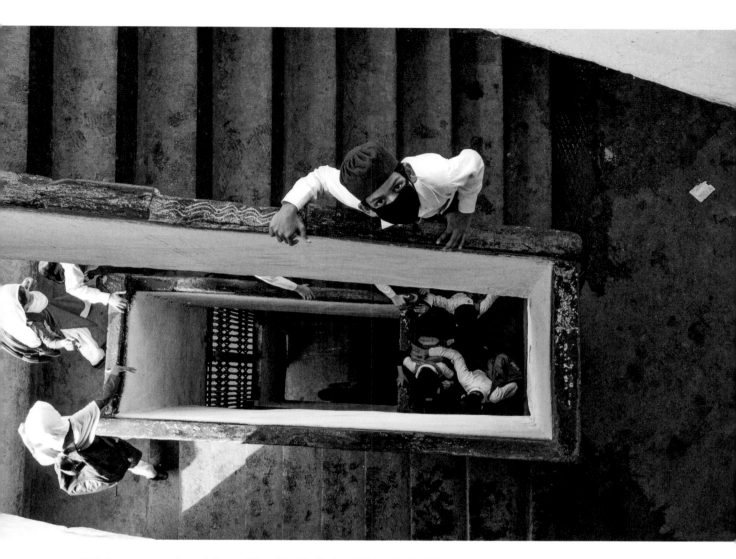

This image was taken at Green Wood Public School, Talaq Mahal, Kanpur, established in 1978 to provide an education to poor children who cannot afford an education anywhere else. I shot this on March 12, 2020, right before schooling was suspended in India due to COVID-19. The reason why I shot this was because education is the last priority in my locality. From the very beginning, profit was never the motive behind this profession. It isn't even today. The real driving force is the passion to educate children in any way possible.

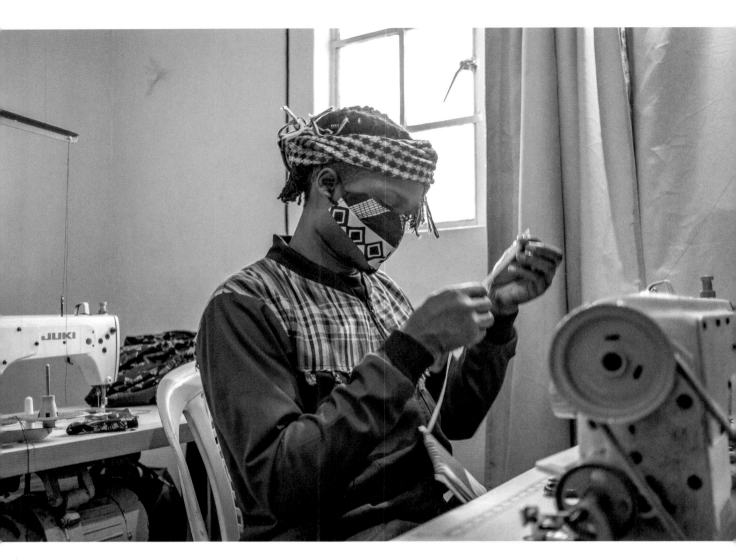

In this photo, fashion designer David Ochieng, also known as Avido, works on a face mask he is making from fabric scraps at his house in Kibera, a slum located in Nairobi, Kenya. Avido distributes the masks to the people of Kibera for free to wear as a preventive measure against the spread of COVID-19. What motivated me to take this photo is the individual initiative that David took to make sure that the people of his community were keeping safe from the pandemic.

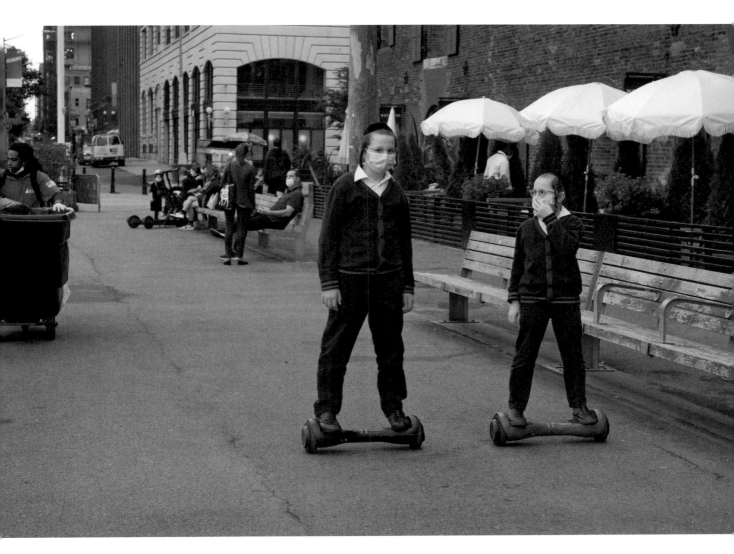

This was a pure moment of brotherhood that goes beyond world circumstances. Two Jewish boys riding hoverboards as a symbol of the young generation balancing between the techno world and deep family values. Their minds are open and flexible to adjust to the pandemic realities. You can literally feel that "new normal" mindset.

VIRTUAL

If the COVID-19 pandemic had happened twenty years ago, what would have been different? There are many ways to answer that, but what stands out about 2020 was our expanded reliance on the virtual. Systems crashed and overloaded as usage suddenly skyrocketed to previously unimaginable numbers. The images in this section of the book show that whether you were a seasoned pro at freelancing from home, attending your first online class, or just figuring out how to call your grandkids using your computer, nobody could avoid what was inevitable. The idea of a complete shift to online communication was predicted to happen eventually, of course. Little did we know that over the course of one life-changing year we would all quickly become faithful citizens of the global online village.

LIVING

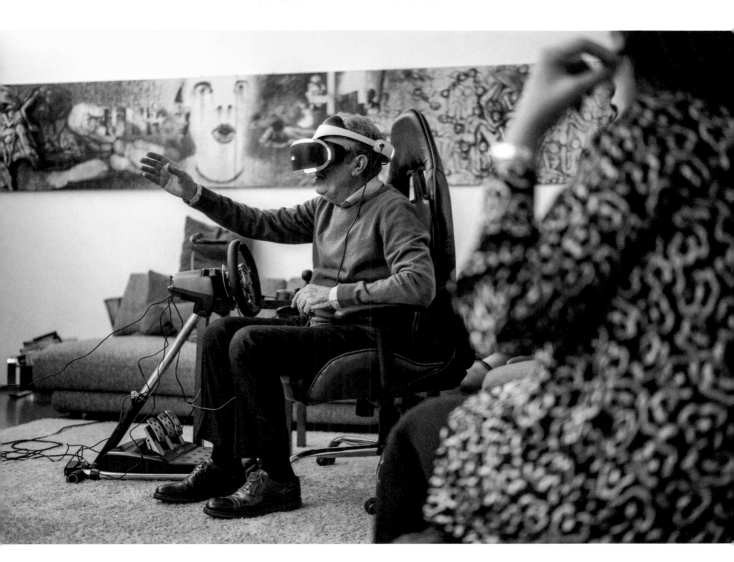

There are many ways of being a family, from the most traditional to the most original versions. There are also families united by the passion for a sport, for a profession, for a place, or for any reason that can push us to live together, even for just moments. Every family has a lot to tell, and I like to tell their story in pictures, by becoming one of the family for a few hours, capturing their best and truest moments with my photojournalist's eye.

On this day in 2020 I turned up to take a lockdown portrait of my friend Jacquie. She was not up for it. It looked like she was going to shut the door on me. As a Kiwi (New Zealander) living in Australia, she did not know if she would have any financial support from the Australian government. She was not permitted to have students in her beloved studio, where we danced and did photography so many times before. She didn't even have the money to pay the studio rent. She was angry, sad, and trying to set up an online class. She spent months dancing in front of her little laptop screen, keeping her students moving, giving them the incredible support she always does. At one stage she was not even allowed to go into her studio. She and her business partner continued teaching from their living rooms, with husbands, kids, and pets in the background. Their students came right back in as soon as the studio was allowed to reopen. But the stress and nonstop work, with no time to actually let herself go and dance, took its toll.

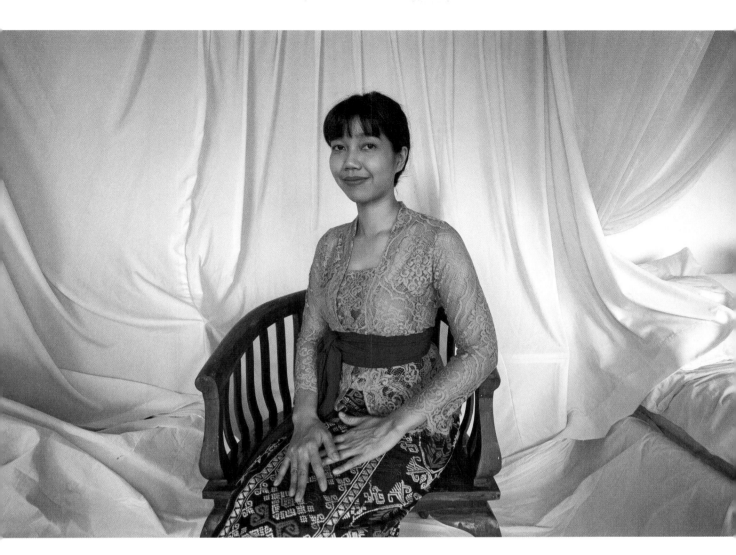

Rachel was getting ready for her sister's wedding in Prague. She couldn't fly over from Bali because the border was still closed amid the pandemic. She felt joy and sadness because she could only attend the wedding via Zoom/video call. During that time, I knew I had to immortalize the moment by taking a picture of her. This photo is taken inside my bedroom, using a curtain and anything we could find in the house.

Before the wedding, Rachel and her family and friends made a video about how much they loved and missed her sister, and how they couldn't make it to Prague, yet they were together in spirit from Bali. We all burst into tears when we saw her sister's reaction. A simple moment that sometimes we took for granted before the pandemic hit, but this time we will certainly remember it and cherish it forever.

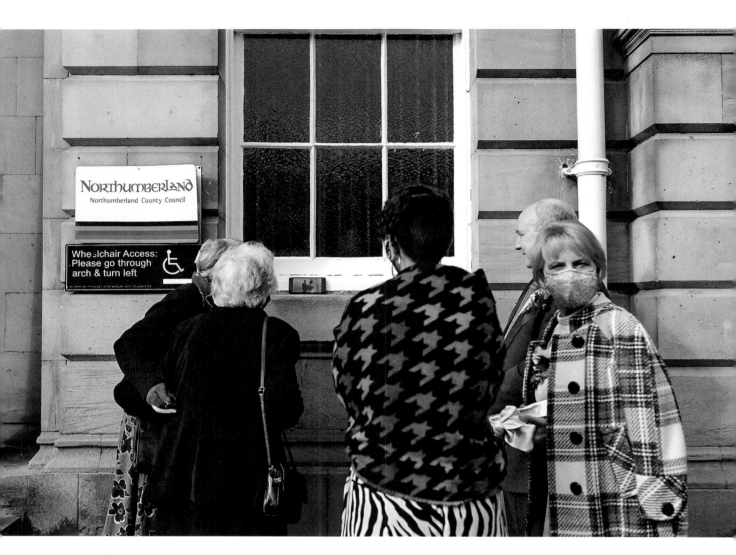

Philippa and David had planned to marry in October 2020. They had to postpone their dream wedding till 2021 due to the restrictions. Up until the last minute, we were unsure if the wedding would be able to take place, but luckily for the couple it did, although most of the guests had to watch the wedding on their mobile phones from the street outside, which sadly included Philippa's dad, who was not allowed to walk his daughter "down the aisle" due to restrictions on the number of people allowed inside.

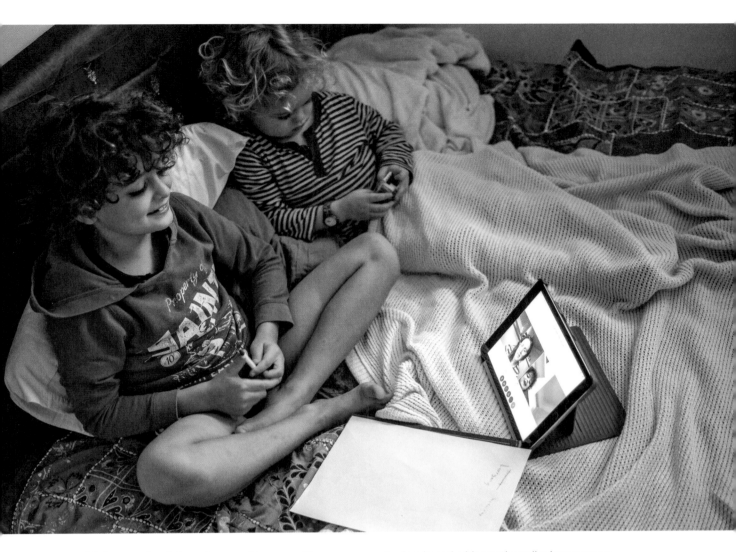

Melbourne Lockdown in a small house with an even smaller backyard with our three lively sons was challenging on a whole new level. Every day. The bunny, 2 green tree frogs, 3 chickens, and a cat got a big workout every day. They played hopscotch, hung out in our cubby house, sat on the boys' laps during online learning … Our youngest's fifth birthday party was Pepino sitting on a chair on the pavement in front of our house, sharing cake with a couple of the neighbor's kids while keeping 1.5 meters social distancing. He was happy.

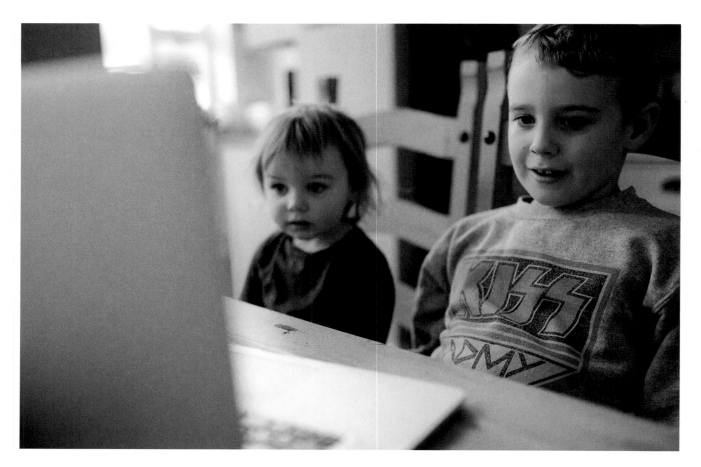

I never dreamt that a 2-year-old could become familiar with the idea of online meetings, mute buttons, and falsifying their background. For almost a year now, the majority of social activity with friends and family has taken place online. It has been heartbreaking to watch. I also worry that this is becoming "normal" for so many of our younger ones. Although it pleases me greatly that my little Lily (2 years old) still asks to cuddle her grandparents. We can only hope that the physical meetings will take place again soon. In the meantime, they sit, they watch, they unmute to speak, they make frantic hand actions to say hello and goodbye, and they even disco online. Here Harry was attending an online class meeting with his school friends. Desperate for interaction of any kind, Lily jumped at the chance to join in and see some familiar faces.

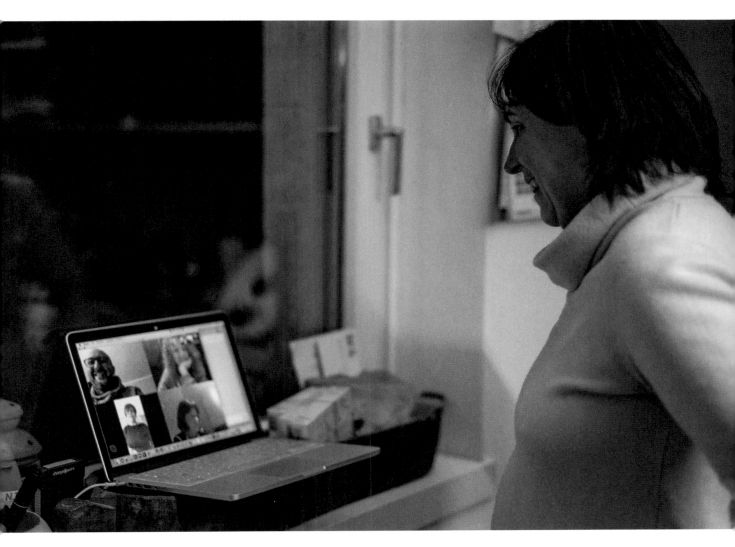

It was March 13, 2020, exactly. We were at the beginning of the first lockdown, and our freedom was put to the test. We found ourselves scared, locked up without yet knowing anything about what was going on and what was coming. As a photographer, I have always shot and documented my life, my family, from holidays to every moment spent with my wife and children at home. I remember well: it was a Friday night, one of those that, normally, we would have spent with friends, chatting, laughing, and joking in some club in the city. But no, here we were at our first online "aperitif" session. We met in front of a monitor connected to one of those platforms that allow virtual meetings, uncorked a good bottle of wine, and virtually toasted. Our first aperitif on the web, as an Italian, accustomed to contact, to being with company, was not easy. The shot portrays my wife, otherwise amused, in a situation of absolute novelty. Who would have thought? Well, this night went on for a long time. This too served as an outlet in a difficult 2020 when both we and our children, in full adolescence, found ourselves living within the walls of the house and temporarily deprived of freedom. I could title this shot *Virtual Cheers*, with the hope of a rebirth, as fast as possible, and with the hope of returning to being free citizens of the world, overcoming the economic and psychological difficulties that this, fortunately past, year 2020 has inflicted on us.

ALESSANDRO CASTIGLIONI MILAN, ITALY 123

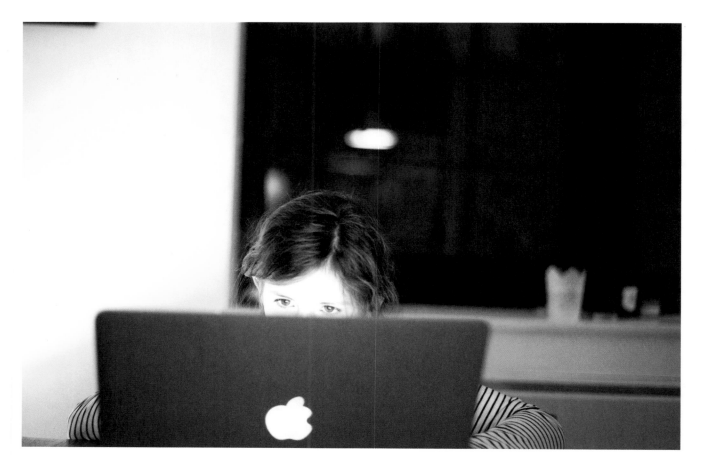

My daughter adjusted to studying at home on Zoom during the COVID-19 lockdown. As so many here in New York City and worldwide have, we've gone from offices and schools and a daily routine to four people almost 24/7 in a very modest apartment. I hope and believe we will look back and appreciate the time spent together. I know I will.

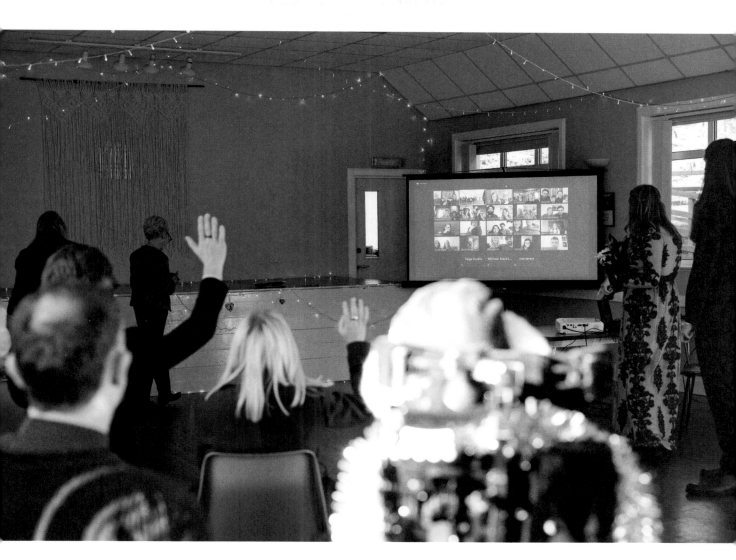

I had the pleasure of photographing the wedding of Molly and Billy, in College Valley, Northumberland. Molly, from the USA, had already been forced to postpone their wedding from the summer to December and managed to marry Billy one day before their license expired and before Lockdown 3.0 was announced. So incredibly lucky. Molly's family were unable to attend except for via Zoom and a big screen. And we celebrated with socially distant cake in zero-degree weather with a sprinkling of snow on the ground.

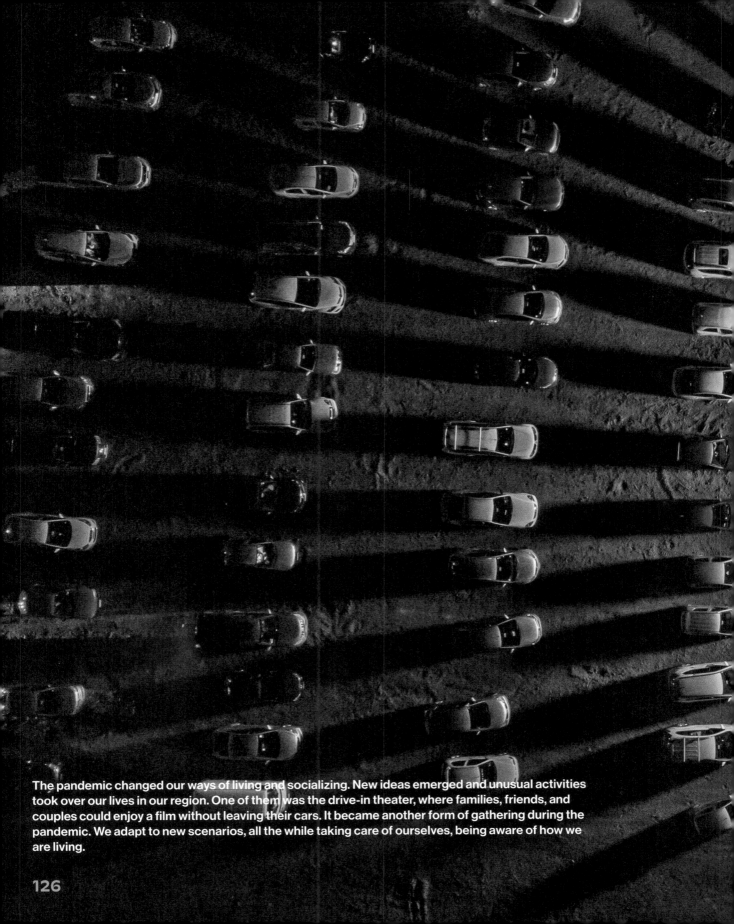

The pandemic changed our ways of living and socializing. New ideas emerged and unusual activities took over our lives in our region. One of them was the drive-in theater, where families, friends, and couples could enjoy a film without leaving their cars. It became another form of gathering during the pandemic. We adapt to new scenarios, all the while taking care of ourselves, being aware of how we are living.

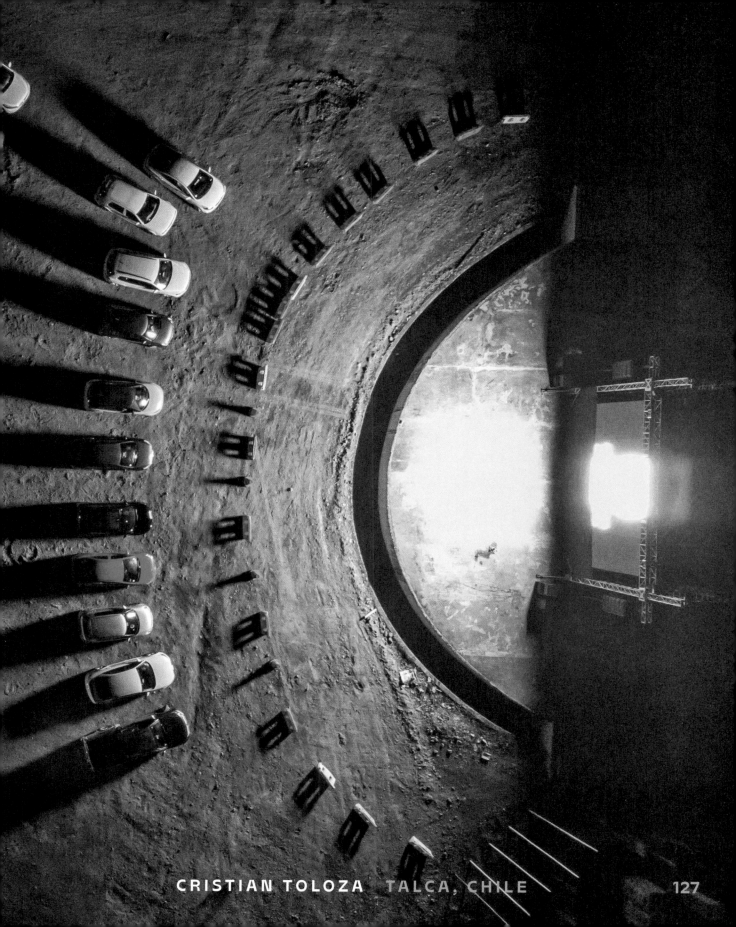

CRISTIAN TOLOZA TALCA, CHILE

LIVING IN

"Self-isolation," "quarantine," and "lockdown" are some of the words you may have had some alien, far-off association with before 2020, but they soon became a way of life. The images in this chapter reveal what it was like to be alone, and this was a new type of being alone. Although we may have been constantly surrounded by stimuli if we were constantly connected, when we looked away from our screens, there was nobody there. Waves of collective uneasiness flowed. People looked inward. The images in this section depict the shared feelings—the boredom of being home, staring down the barrel of alienation, and the grief and loss, on both a mass scale and a personal level.

ISOLATION

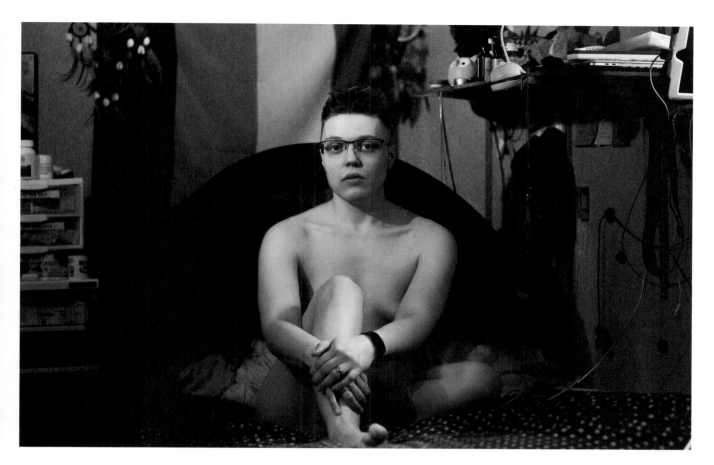

This past summer, my dear friend Arlo reached out to me and shared his self-discovery that he is a trans man. A few months later, he asked me to document his transition.

Arlo and I have been friends since college and have a deep understanding of each other as people and of each other's artistic practices. For this project, we are collaborating: I'm photographing him, and he is writing reflective responses to my images. Here is an excerpt of one of his passages:

> There had always been this deep nagging feeling inside of me that something was wrong. It was like life was a simulation with a very specific rule book and I had been given the rules to another game entirely. I never understood just why I felt this way, only that I did and it was awful.
>
> Once the pandemic hit, I, like many other people, was forced from routine and stuck at home. That was when I first realized that my name was a problem. I didn't identify with my birth name. I felt uncomfortable. It felt like my name had been internally associated with some form of trouble. I was anxious and distraught at the thought of using my birth name but equally distraught about using anything else. This was disturbing to me and did not feel normal. I spoke to a friend about the matter, and he revealed to me that what I was feeling was not nameless. It was dysphoria. As a trans man, he was no stranger to dysphoria, and he began to tell me about his own experiences.
>
> It hit me like a punch to the gut. Everything he was describing, all of it, was my life growing up and even now. It whispered a horrifying truth: I had been trans all along and had tried to convince myself otherwise as a form of protection. Everything I had told myself, all those carefully crafted excuses, came unraveled as lies.
>
> At first, I felt a great sense of grief in my confusion. I kept questioning myself and trying to make excuses. When I first told myself, "I'm a boy," and gave myself permission to be transgender, I felt an enormous amount of relief.

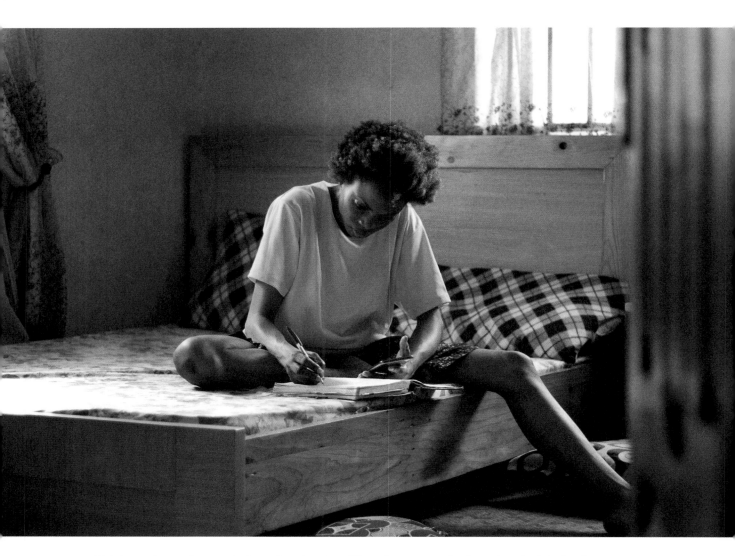

This is one image from a photo series showing different ways people chose to adapt during the pandemic. On one quiet afternoon in May 2020, every member of my family was home. It felt like a family reunion but different. This time it wasn't planned—the lockdown had brought us together. I decided to document how everyone was using their time, going from room to room, looking for inspiration, until I stumbled upon my elder sister jotting down ideas for her fashion business. The photo for me reflects how serendipity can be exploited to one's advantage.

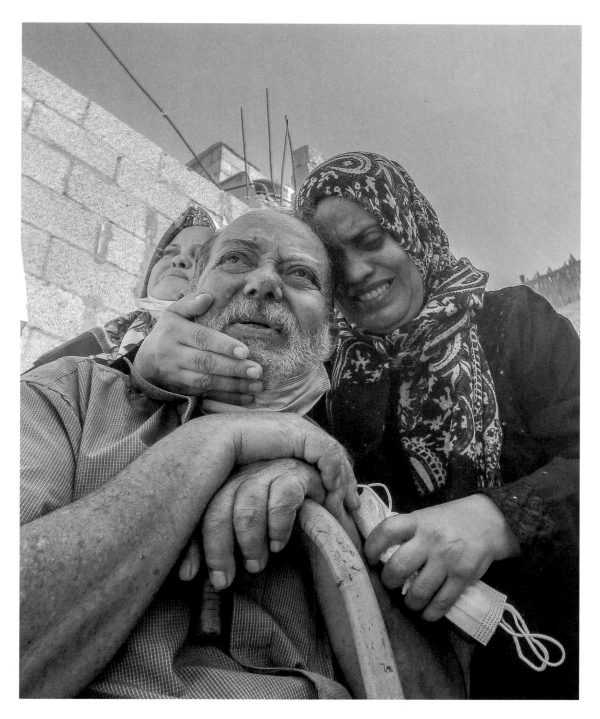

The day before yesterday, two Palestinian fishermen were shot dead by the Egyptian Navy while on their boat. The fishermen had been doing their work south of the Gaza Strip near the sea border of Egypt. Their brother was arrested by the navy. I don't hide from you: I overcame my feelings as a human being, bigger than the photographer's feelings. I cried a lot the moment the picture was taken. This year was the year of disasters for me, the year of the coronavirus, the siege, and the war on Gaza.

ADEL HWAJRE GAZA CITY, PALESTINE

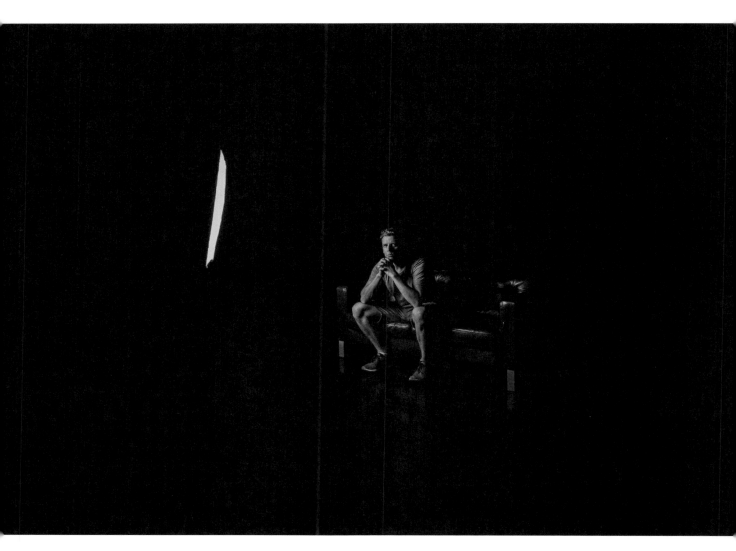

For me, 2020 was a year of being told no. My wife and I had moved to Asia, specifically to travel for a couple of years, and we hadn't been traveling long before everything happened. When flights were grounded, it was like our life plan had been canceled. Of course, that was nothing compared to what followed. No, you can't leave the city. No, you can't leave the house. No, you can't see your family. By June we knew we would be spending the next few months or more apart from everyone. Having recently moved to Thailand, we were isolated by the pandemic but also geographically. We had an overwhelming sense of being alone. I took this photo to highlight that feeling. I wanted the picture to have me with absolutely nothing else in it. The idea was to capture that sense of isolation. When I look back at the shot, I realize it hit the mark. My expression shows no joy at all, and it's a photo that I think is quickly relatable to so many people who have felt the same thing.

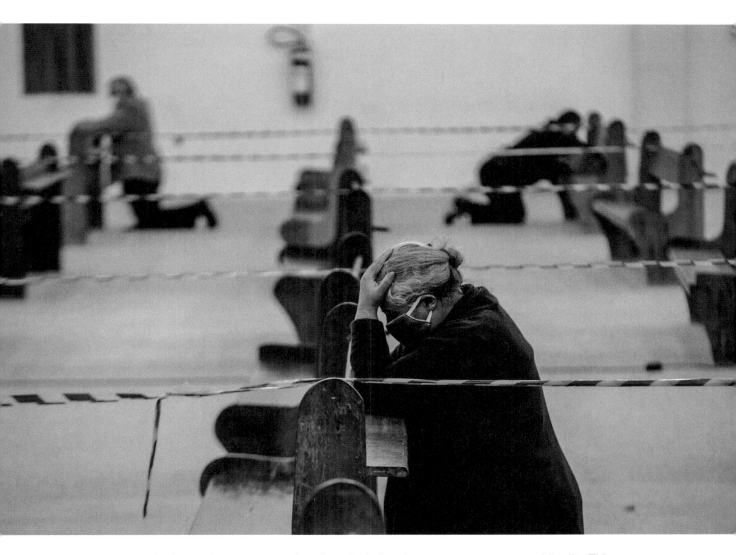

The pandemic changed every aspect of our lives, including the way we express our spirituality. This photo was taken on the first day that the municipal decree in Porto Alegre (in the south of Brazil) allowed ceremonies and masses to resume. There were just a few attendees, but the humbled position of this woman caught my attention, and it was as if she represented everyone in that "God is love" church, praying for help.

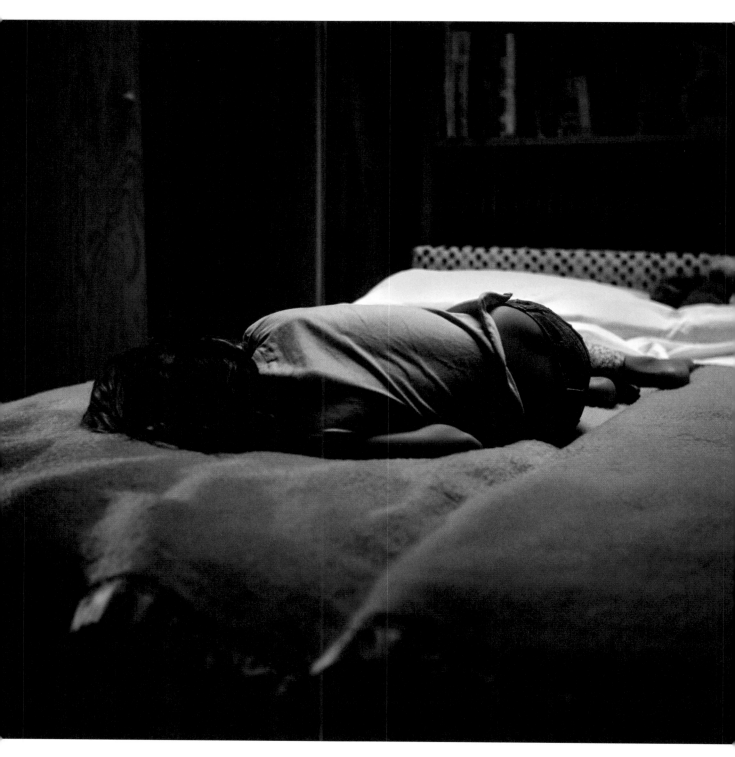

I took this photo while going on about my days in those strange times during 2020, when many of us went more silent and drifted away in our thoughts, perhaps as a result of the isolation we found ourselves in. This photo is sweet yet kind of sad. A child napping and being carried away on the waves of imagination and dreams. Being in this moment, yet being carried away from it, somewhere into happier places where anything is possible again...

KRISTÝNA ERBENOVÁ PRAGUE, CZECH REPUBLIC

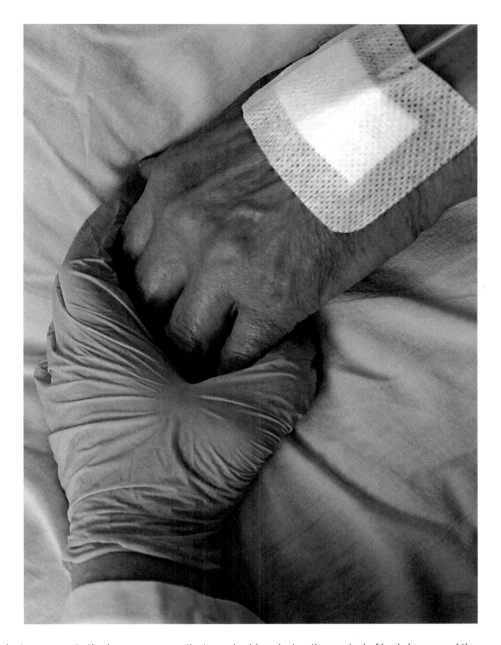

This shot represents the human caress that was lacking during the period of lockdown, and the abandoned and lonely, fragile people who died without the contact of loved ones.

I took this photo in my house during the lockdown period in Italy. The photo was born in a difficult moment, because I was at home with my father, who needed care, and we were alone with our fears. In this period, we still didn't know exactly how we could get infected. It was not easy to take care of a fragile person while trying to limit contact, which, although essential, left a trail of worries. The anti-COVID health provisions limited and still limit the presence of family members with a sick person in the hospital—this was my greatest fear, which fortunately did not happen.

So while I was assisting my father, holding his hand, I wanted to capture this moment. I realized the luck I had despite the discomfort we were experiencing, to be able to caress him in a moment of great fragility even if only while wearing a latex glove, aware that for many others this was not possible. I titled this shot of mine *The Human Caress*, which still seems difficult to exchange today.

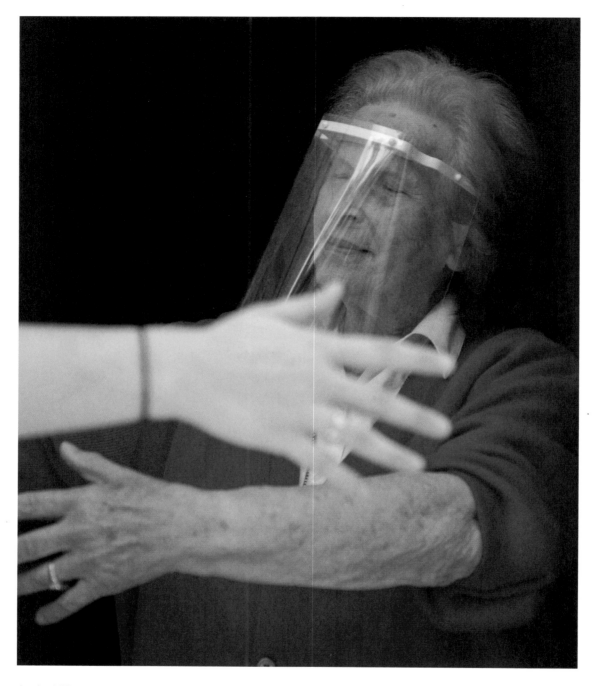

As the UK started to go into lockdown back in March 2020 and the severity of the pandemic unfolded, I embarked upon a yearlong photographic project to try to document this moment in time. I used our daily exercise allowance to photograph friends, family, and neighbors in our local community. As time passed, I focused on the younger and elder generations affected in similar ways by restrictions during the pandemic. They shared worries, anxieties, boredom, frustrations, and an endless longing to be with friends and family again. I spent many days photographing my elderly mum, who was isolating alone and fearful, but I took this photograph in May, when we were still advised not to hug our elderly relatives. This is a portrait of my 83-year-old mum giving my daughter, her granddaughter, an imaginary hug with their arms outstretched but not touching.

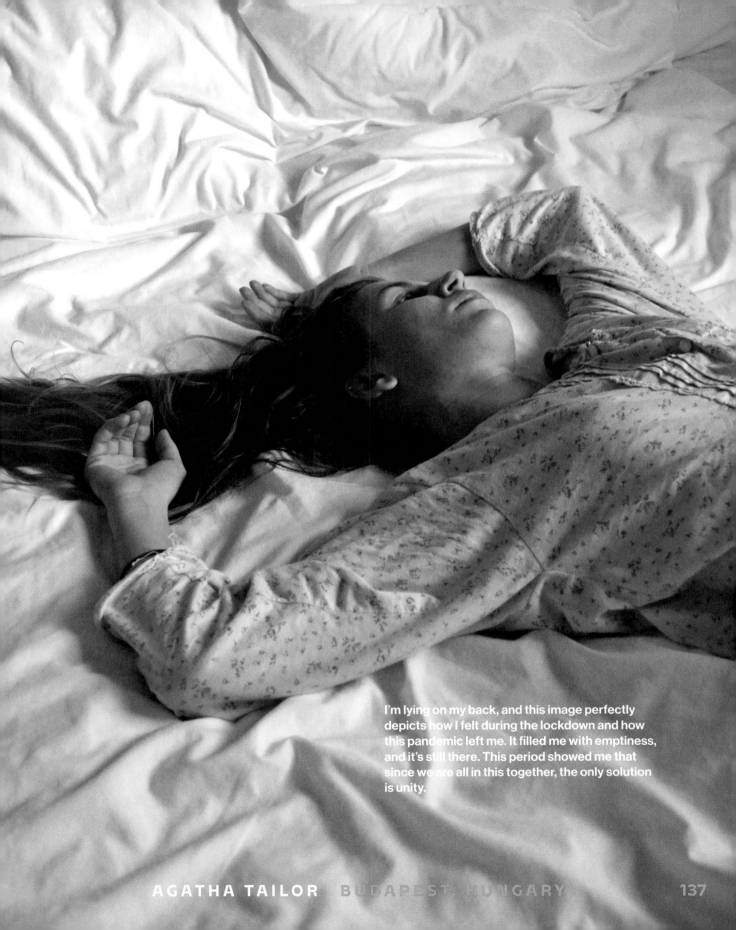

I'm lying on my back, and this image perfectly depicts how I felt during the lockdown and how this pandemic left me. It filled me with emptiness, and it's still there. This period showed me that since we are all in this together, the only solution is unity.

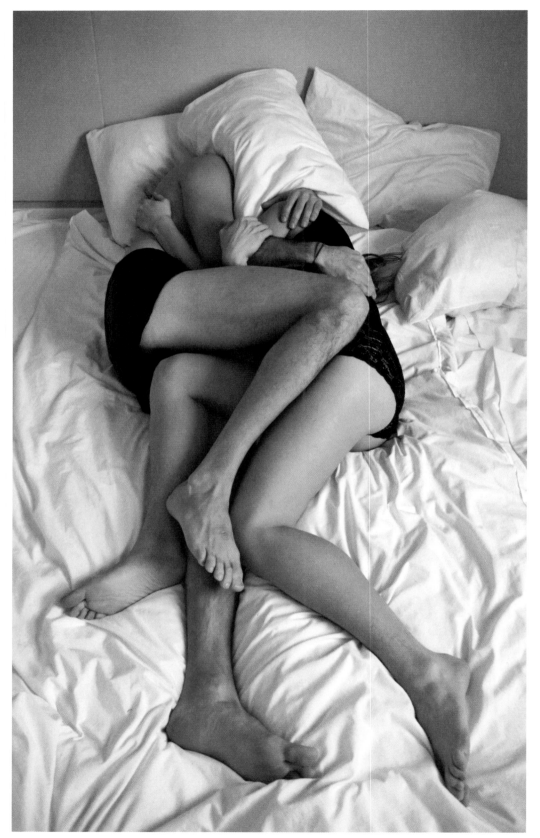

I captured this image of my husband and myself when the first wave of COVID-19 hit the world and we went under lockdown. I have never imagined that isolation could be so hard. As a traveling couple, we were used to being on the road all the time, full of energy and plans for the future, then suddenly everything stopped and we felt trapped in our own home. I think most people felt the same. Trapped, lonely, and insecure. We felt depressed too, and it is still hard to get back our motivation.

AGATHA TAILOR BUDAPEST, HUNGARY

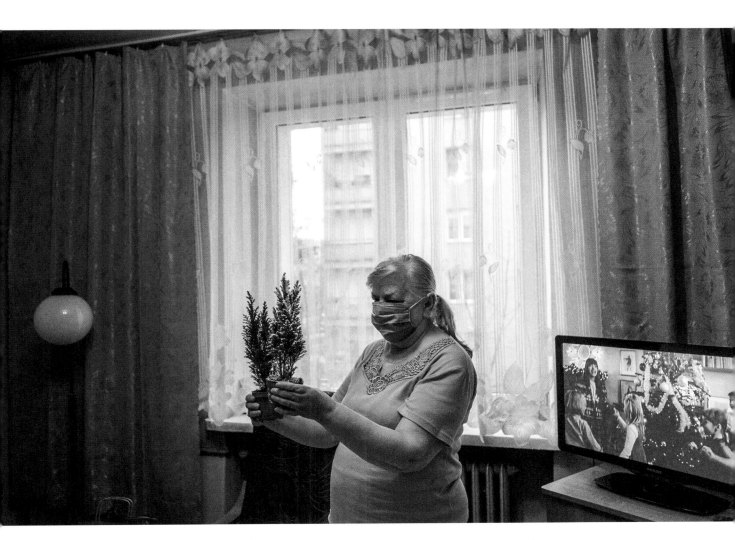

The photo was taken the day before Christmas Eve, which is, for a lot of people, the most important day of the year. Grazyna, photographed here, lost her husband and her son a few years ago. She lives alone. I found the scene of her looking at the little Christmas trees offered by the volunteers of the Senior in the Crown organization, with the television showing a happy family celebrating around the Christmas tree, quite metaphorical and nostalgic at the same time.

My mother, or Mamó ("Grandmother" in Irish), looks from her window in April 2020 during the first major lockdown in Ireland. The older generations were advised to "cocoon" and keep their distance from other people. I felt lucky to live close by so I could visit often. Just a couple of weeks before this photo was taken, my father, who was already in the hospital, contracted COVID-19. She wouldn't see him again in person until July, and he died the day after seeing her through the window of the nursing home.

CREATIVITY

People wanted to express themselves, many unlocking their inner child, and felt experimental. Creativity helped get them through the inescapable boredom they faced throughout the year. These images reveal how people expressed their feelings about the year and got creative, showed the new hobbies they picked up, and went out of their comfort zone in ways they never had before.

UNLEASHED

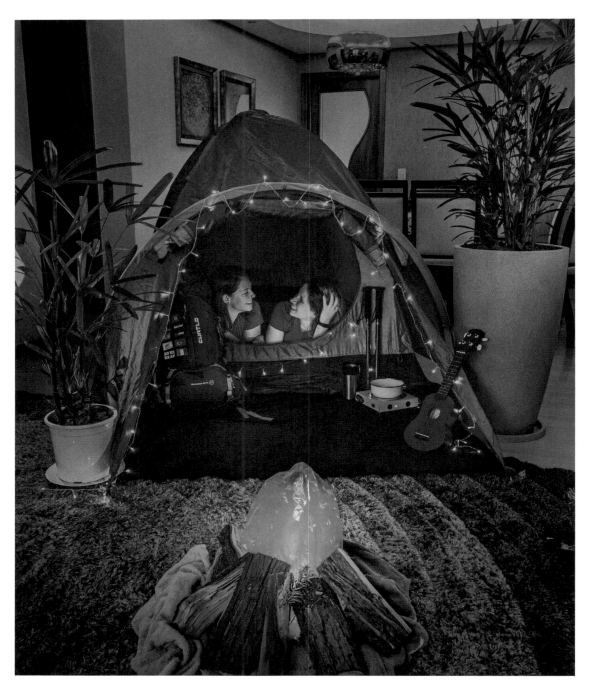

During a pandemic, we feel very much like being in nature and venturing out again. So we re-created this scenario at home, to remind us of the good times.

This photo was taken in the first months of the pandemic when we couldn't even imagine it would go very far. We set up the tent indoors to simulate the place where we really feel at home: in nature. Even facing such a turbulent time, we were trying to stay creative and productive within our work as content producers. And of course also to pass on the message so that people would stay at home in a lighter way, because the whole situation of COVID-19 was already too heavy.

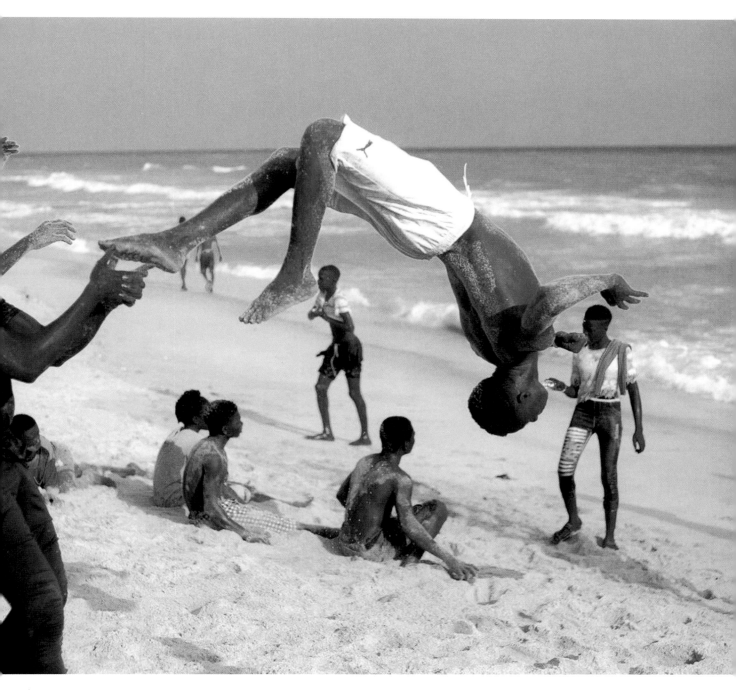

I was lucky enough to have had my camera with me at this moment on a public beach in Accra, Ghana. The feeling of brotherhood and a sense of community came to mind when I saw the boys playing together. Accra opened during the month of December—that's why there isn't social distancing in the image. It truly felt like a blessing and very refreshing to be able to just experience life like how we have always known it to be. The energy of the boys at the beach gave me an in-depth understanding of just how much they missed each other and how we need to appreciate all the small moments and things in life.

SIANEH KPUKUYOU ACCRA, GHANA

Ganga Aarti at Varanasi is one of my favorite sights. During the pandemic, the event was not performed for the public, so I had to wait till November to visit Varanasi and see this beautiful ritual again. And it was quite amazing to see the pandits wearing face masks while performing the Aarti. Although they were always at a distance from the spectators, they still covered their faces for the whole ritual and sent out the message that this was the "new normal."

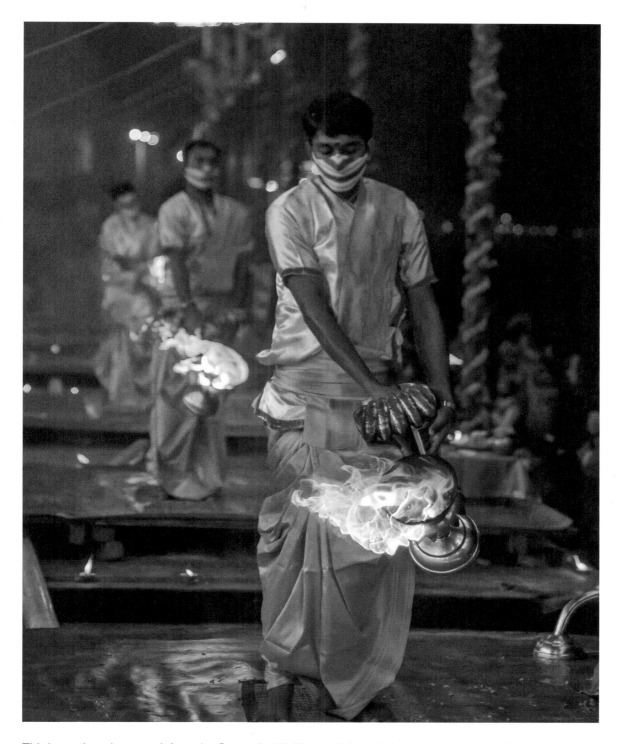

This is another photograph from the Ganga Aarti in Varanasi. As a photographer, one of my favorite subjects to capture is fire. It has such deep spiritual meaning. And what better place to capture it other than the City of Gods, Varanasi. With such synchronization and the music, these flames look nothing but beautiful.

RAGHAV RALHAN VARANASI, INDIA 145

I had the opportunity to take pictures of the children who are back to practicing skateboarding. They look happy and seem to enjoy the process of adapting, despite this very limited environment. Sarkara Laislana, 8, wearing a face shield, performs her ollie trick during a practice session at the Crooz School of Skate during the COVID-19 outbreak in Jakarta.

Whenever there is a box in my house, it will always be turned into something to either play with or color. This time it was big enough to play in. The pandemic has been especially hard on the kids. The constant closures of school and businesses really builds up kids' anxiety, and they, just like adults, have a difficult time understanding their feelings. After taking this photo of my daughter, I felt sadness, as it gave me a feeling of isolation, and that feeling has been a constant for the last year. Yes, we have each other, but we also feel very alone. Separation from friends and family, and missing human interaction, has taken a toll on us all.

LOVE AND

Having to be away from everyone else brought us so much closer. In our bubbles, we had to reinforce the bonds we already had and experiment with new ways of being together. Love reinvented itself in 2020 and took on all shapes and forms. Whether it was the love we felt at home when surrounded by our friends and families, holding them closer than ever and being around them more than we ever had before, or the warm glow of a video call from a long-distance friend who put in the extra effort to show us they care—the solidarity of a companion, just you and them against the world.

CONNECTION

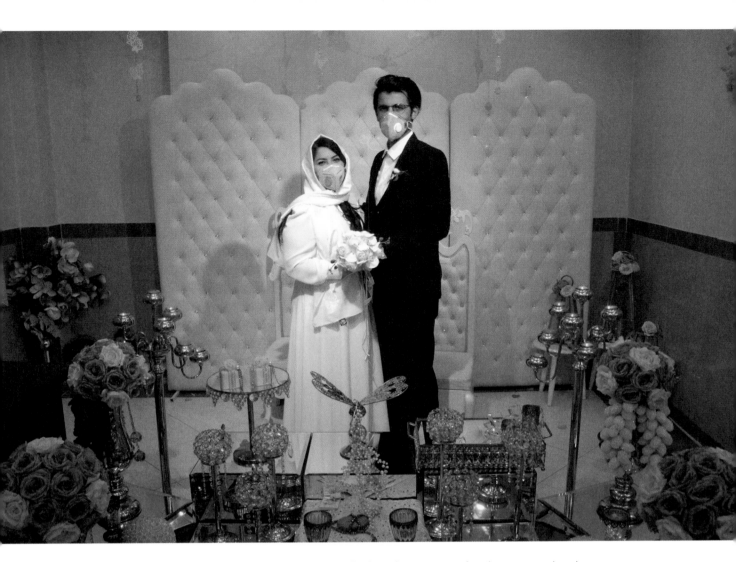

I have been working with Shayan as a photojournalist in a photo agency for six years, and we have become close friends.

The wedding of Shayan and his wife, Fatemeh, was scheduled at the beginning of the pandemic and it was not possible for them to change the time. Those days, Iranian people were so afraid of this new situation, so they decided to invite only twenty of their relatives and close friends. It made me so happy that I was one of the twenty important people in Shayan's life. I was not supposed to be the photographer of this ceremony, but a photojournalist always has a camera and is ready to take photos even as a wedding guest.

In those days in which people around the world were battling with COVID-19 and death, this masked couple stood in front of me and started a new life. So I took the camera out of my bag and took the photo. For me, this photo was the symbol of hope for the future, hope for happy days without COVID-19. However, in the following days and months, the country suffered heavy death rates, and as of this writing, more than 128,000 people have been killed because of this virus.

But hope is always there. Now that we have access to the vaccine, again we can imagine life without this coronavirus.

SOBHAN FARAJVAN TEHRAN, IRAN 149

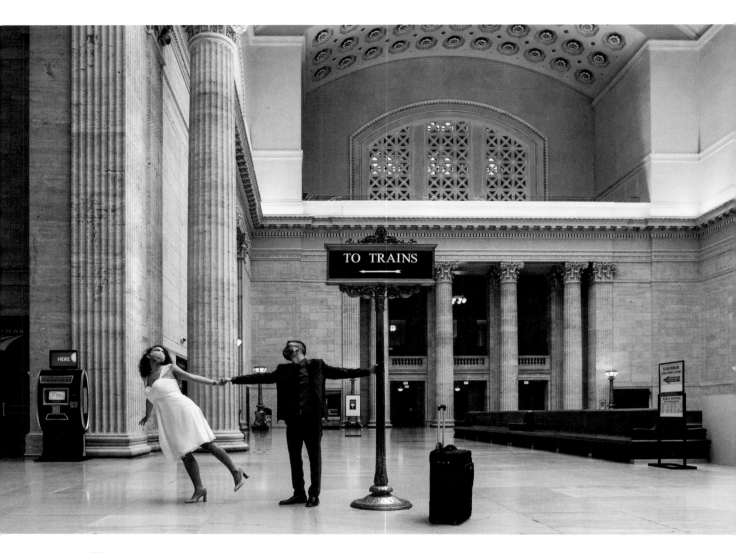

This is from an elopement that took place in Chicago in a subway station, Union Station and Lincoln, on the couple's originally planned big wedding day. Ashley and Josh chose not to postpone because the day was important to them, and in a year of things not going as planned, they wanted to at least become family. Turns out, COVID-19 was not the only thing that would be changing the day for them. It ended up raining as well, which normally isn't an issue in Chicago, except that most of the buildings were also closed. So they had their first dance in the subway, they had their photographer officiate, and they had to change plans while changing plans. The one constant is that they knew they wanted to be family.

Boyfriend and girlfriend at First School—lockdown kept them apart. When I started my photography project to document family lives "through the window," I thought it would be nice to surprise Bella with a visit from her boyfriend. The delight on her face says it all.

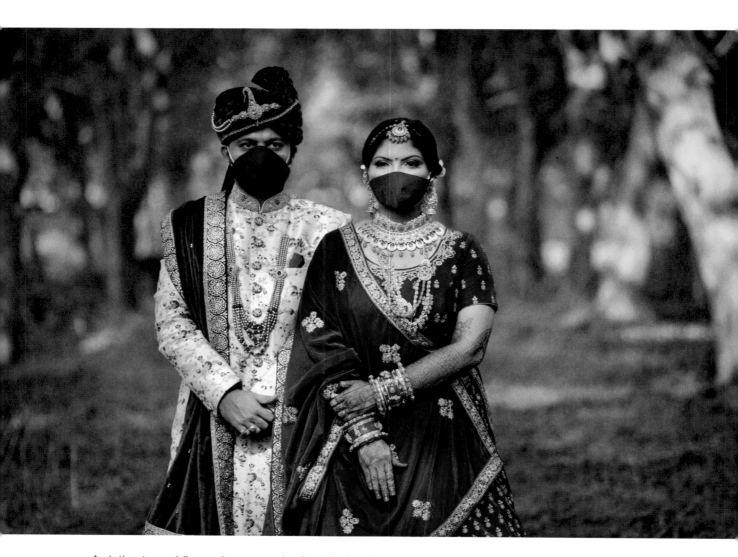

An intimate wedding makes memories for a lifetime. Love in the time of a pandemic: an intimate Indian wedding.

FORAM SHAH AHMEDABAD, INDIA

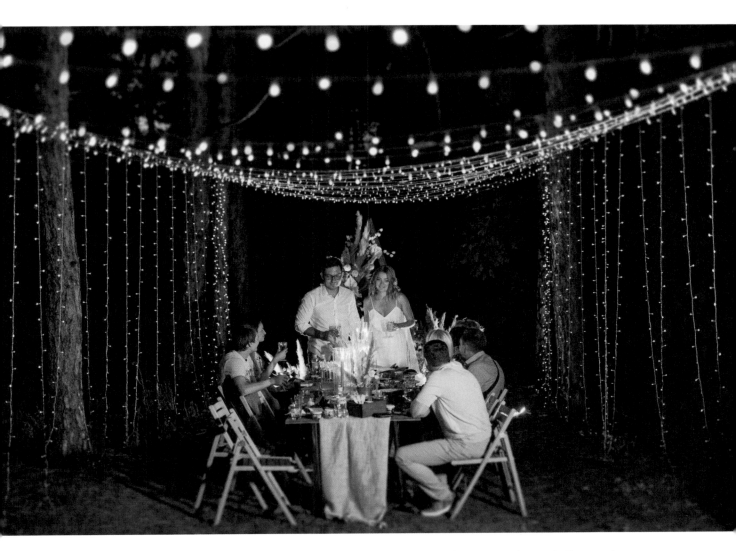

I am a wedding photographer living in Ukraine. The pandemic has made a strong change in the usual lives of people here. In terms of the industry I work in, it has changed completely. Wedding formats have become small and intimate. The number of guests at events has decreased to 10 or 20. And the impossibility of holding the event indoors has produced alternative options, such as in the forest! Like this photo! A forest wedding in a pandemic . . . Probably will never happen again, but the smiles and happiness of the people in the photo remain, as before, sincere. People, even in difficult conditions, will not stop enjoying life.

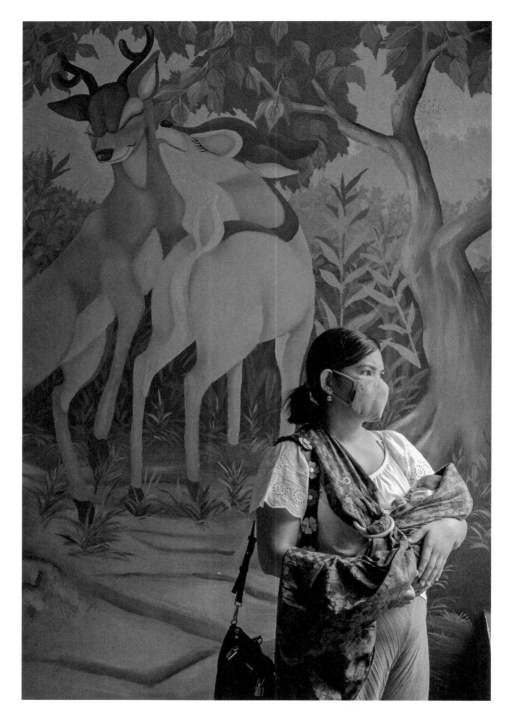

I named this shot *Pandemic Mom*, taken during the first COVID-19 outbreak in our country. We'd just had our third baby, and I was worried about going outside, especially to the hospital. It was time for our baby's first checkup, so we had to do it. We were waiting in the waiting room to see our doctor. Usually it's packed with parents and their kids, but on this day there was only us.

This picture will always be my most memorable moment during the pandemic.

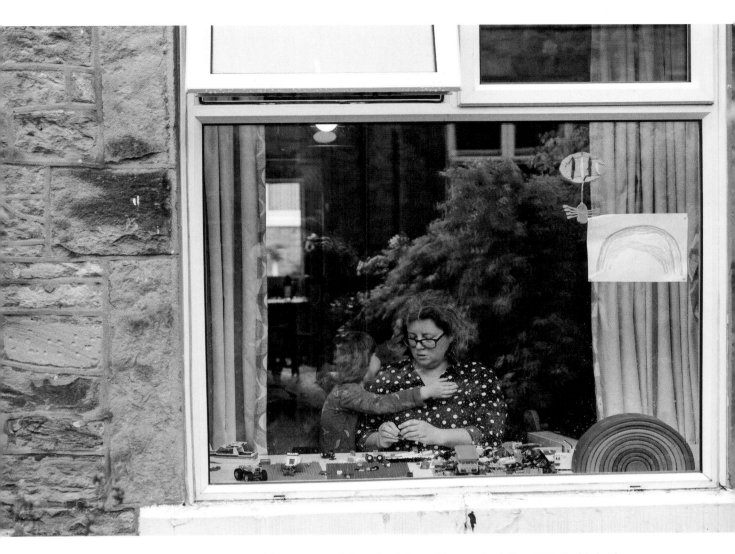

Helen and Teddy invited me to their home as part of my *Lockdown Story* project. Poor little Teddy had barely left home during the whole of lockdown. Helen told me how it was starting to take its toll and how she was concerned for his social development. Despite that, he was completely charming and playful. He clearly doted on his mum. The way in which he held her and lightly touched her while they played, you could see how much the time alone together had strengthened their bond. I observed them playing with LEGOs on the windowsill—a trusted toy to see them through isolation. The rainbow in the window, such a common sight in the UK during the pandemic. A sign of hope and solidarity.

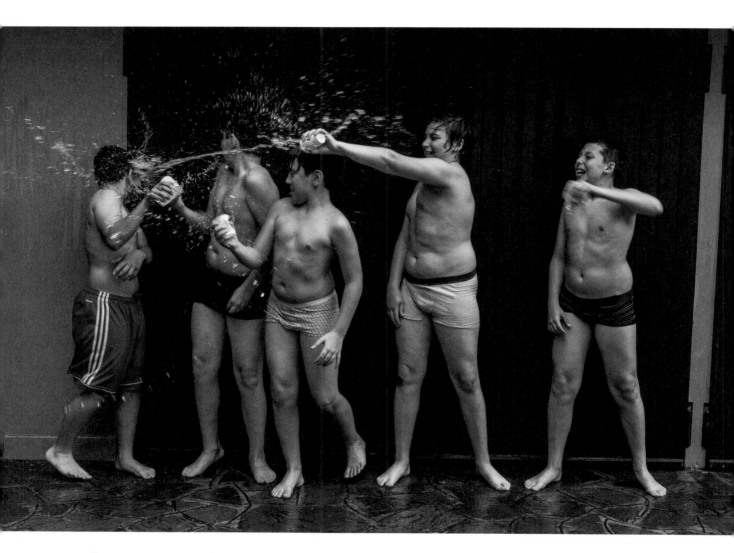

Summer was upon us. It was a sunny day in the Milanese heat. Unable to go out due to COVID-19 restrictions, these friends and schoolmates often hung out at one another's houses. Today it was up to Rick, the boy with the red shorts. We were in the courtyard of my house. It was his birthday, and his surprise was an impromptu barrage of water bombs. Fortunately, there was no shortage of laughter and jokes, people always trying to play down the difficult moments of a year that will go down in history: 2020. I often document the life around me; my children, family, and their friends are an excellent starting point to observe and immortalize in shots what life offers us.

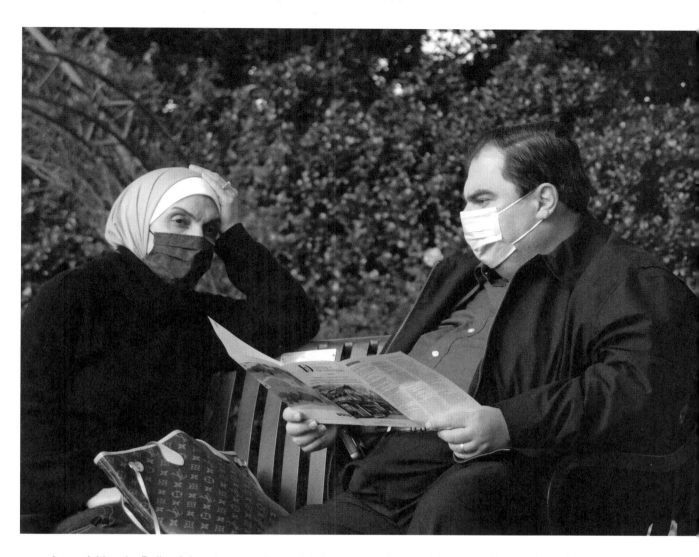

I was visiting the Dallas Arboretum one day and sitting on one of the park benches. I turned to the left of me and noticed a family of four settling down on a bench. What interested me about this family is the women were wearing hijabs, and that isn't something I see often. The two teen girls were talking to their mother, and the father was taking some time to look at the park map. After a few moments I saw the mom reaching into her purse to give the girls some money, and they both made their way to the nearby café. I noticed that the parents never took their eyes off of the girls and they scanned the girls' surroundings until they entered the café. As I looked at this woman from afar, I could tell she was a mother who would do anything to protect her children. I also could tell that a part of her worried for the safety of her children. Not only did she have the job of raising teenage Muslim women and protecting them in America, but now she had to also figure out how to continue to protect them from a virus we don't know that much about. Will there be more shutdowns, virtual schooling, proms and graduations missed? What is the new normal for raising your children during this pandemic? How can you be confident in knowing you're doing the right thing? I took this photo because it shows a sense of protection but also shows the underlying concern that I think everyone has.

NATALIE KELLEY DALLAS, TEXAS, USA 157

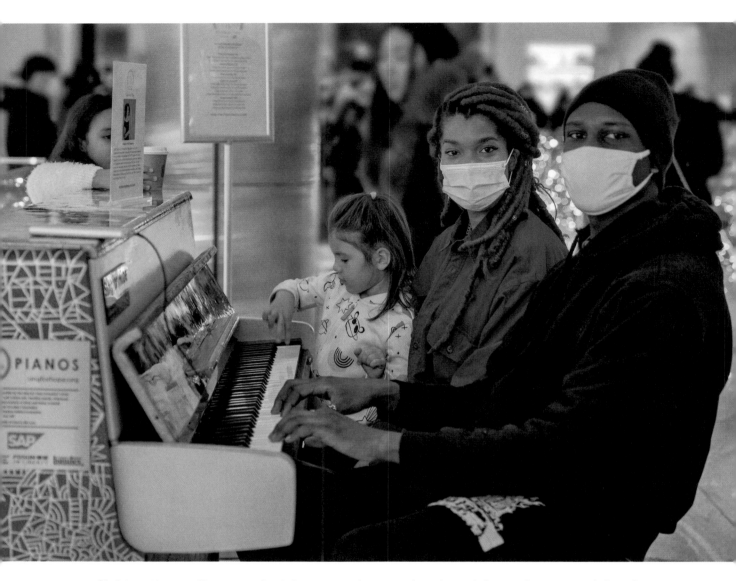

Christmastime, and it was pure joy to be among a large number of people in one place, unusual given the past year. The atmosphere at the shops in Hudson Yards was lively, and some people tried to take off their masks for those seconds they took pictures with the decorations.

I heard piano music, and when I approached, I couldn't be more touched by the picture of a young couple with two adorable kids playing the instrument. At this moment, I felt how having strong family values is a true blessing, how with that connection you can go any distance. I do believe that it's important to play your own loving music at all times, especially in those times that challenge us.

There's nothing more heartwarming than being together. When you're distanced from other people, family values can get more appreciated, needed, and enjoyed.

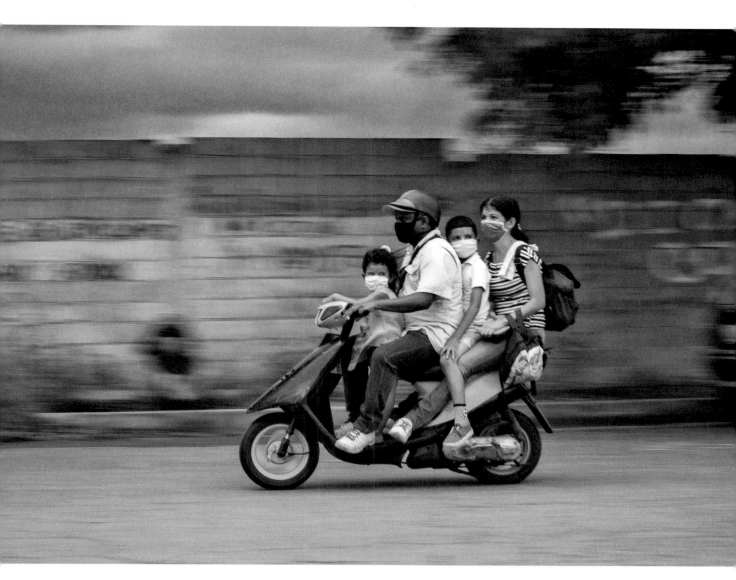

I was sitting on a sidewalk waiting to take a photo. I had thought about doing it, but I was waiting for the right moment.

It was then when a family of 4 people passed, riding a motorcycle in times of a pandemic. We can also see the moving background.

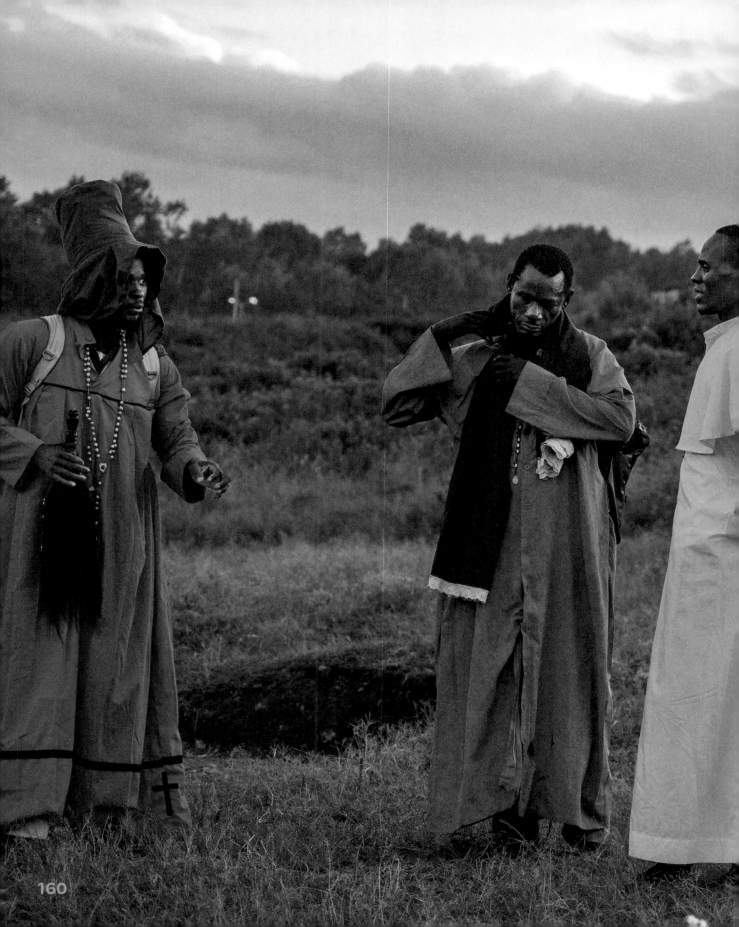

Members of the Legio Maria traditional religion in Kibera have a socially distanced conversation on the day of Easter. The church could not hold its annual celebratory ceremony due to government rules prohibiting gatherings to curb the spread of COVID-19.

This project explores the community I call home, Kibera, and how, amid the pandemic, different people from the community came together—designers, midwives, religious leaders, and local authorities—to curb the spread of the virus in this community, which, it was feared, could have been infected during the recent occurrences. This photo explores a community coming together and reinventing ways to fight during the pandemic.

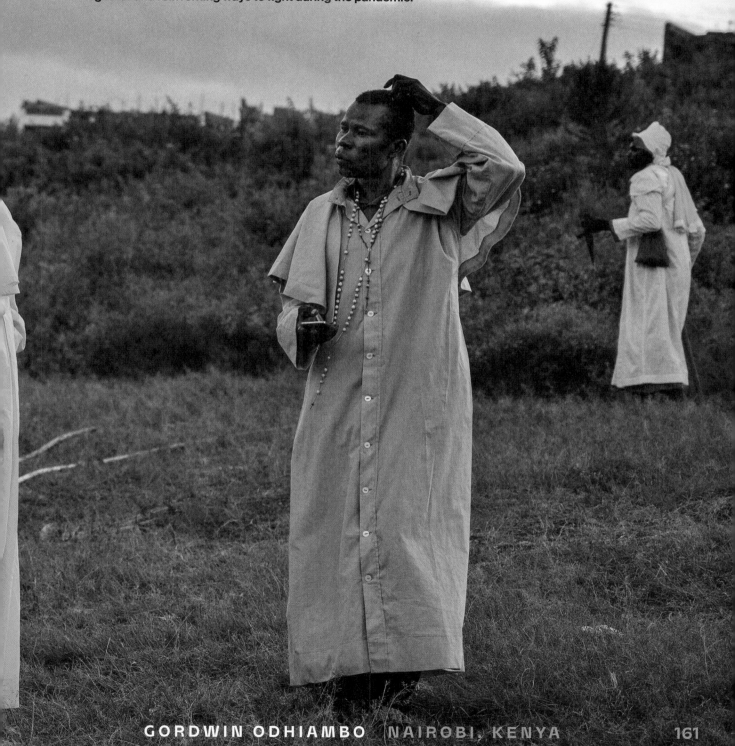

GORDWIN ODHIAMBO NAIROBI, KENYA

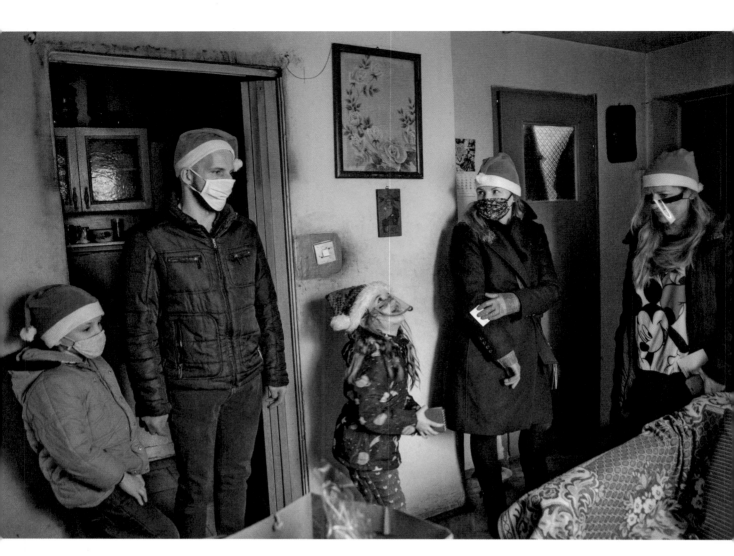

This image was taken the day before Christmas Eve. I followed the volunteers of the Senior in the Crown organization as they delivered parcels and gifts to the elderly in need. I loved how they all played the game and wore Santa Claus hats to make their beneficiaries laugh even a little.

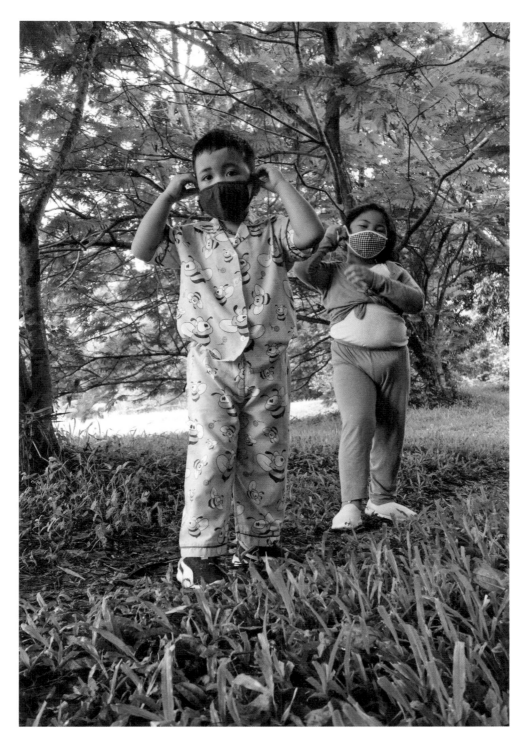

When no travel was allowed, no school was attended, so to get the kids into nature, I was lucky to find a bike park in my backyard. Having a quick morning trail walk in a mask and pajamas surely gave them a good break from all the gadgets.

To my kids, Papa loves you.

My friend Zahra and her fiancé, Samer, had planned to be at a resort in Egypt to celebrate their union. When they pushed the wedding date for personal reasons, a nationwide lockdown was suddenly ordered, with airports closing in order to contain the spread of COVID-19 here in Saudi Arabia. On March 26, 2020, 3 days after a 7 p.m. curfew, and 3 days before a 3 p.m. curfew, the couple celebrated quietly with 3 friends and 5 family members (plus me, the photographer friend, who tried to be a fly on the wall, and the officiant, who came briefly and left), as the government ordered that no more than 10 people could gather in one place at a time.

I was a bit nervous to go out there since this happened at the very start of the pandemic, when we did not know enough about it, and there was a curfew, but I've been documenting Zahra's life for 5 years now, so this would have been an important day to miss.

It was a joke at first to put on the gloves while wearing the rings, to remember this pandemic union, and they stayed in them when I continued shooting.

IMAN AL-DABBAGH JEDDAH, SAUDI ARABIA

PART 2

During this collective separation, the globe connected in more profound ways than ever before. At a time when people may have felt the most lost and alone, they also were confronting the injustices that had been wearing them down.

Being online in a global village made the world that much smaller, allowing some people to connect on the issues that mattered most to them. Being truly disconnected for the first time pushed us to reconnect with renewed purpose.

Individuals rose to fight for racial justice, closing class disparities, LGBTQIA+ rights, environmental justice, and human rights everywhere. This was the year to make a change. Problems that once were swept under the rug could no longer be ignored. The status quo was disrupted. Most lives changed overnight, and many people felt they had nothing left to lose. The fight for justice became universal where global populations saw with more clarity the intersections of race, class, gender, geography, and sexual expression, and accepted that oppressed people must unite and fight in solidarity in order to win.

TOGETHER

The damages didn't go unnoticed. The images reveal that the sacrifices made during these fights affected all those who sought justice. Though the world was not saved, and justice was not achieved overnight, it's clear that the fire will burn on for years to come. Being alone forced us to confront our own biases. People on social media posted videos of themselves crying for freedom and others confronting their own biases in front of thousands of people—asking, "Am I racist?" People shared old interviews of civil rights leaders, trying to understand complex terms we have been sheltered from or too busy to think about. The compression of information and our time alone was remarkable. One thing is certain: many people left 2020 forever changed, and with a fervent need to continue seeking justice.

Photographers bravely ventured out to document what they surely knew would be the beginning of a new global history.

SIGNS OF

Even though our mouths could not be seen through our masks, our words were louder than ever. The signs were all around. It was the year of getting messages across, and we needed to make sure we were seen at all costs. The images included here show the signs that packed the most punch from the year. This is what the people had to say. The signs came in all different forms, in different places, with different messages, but their purpose was consistent: changing the status quo.

CHANGE

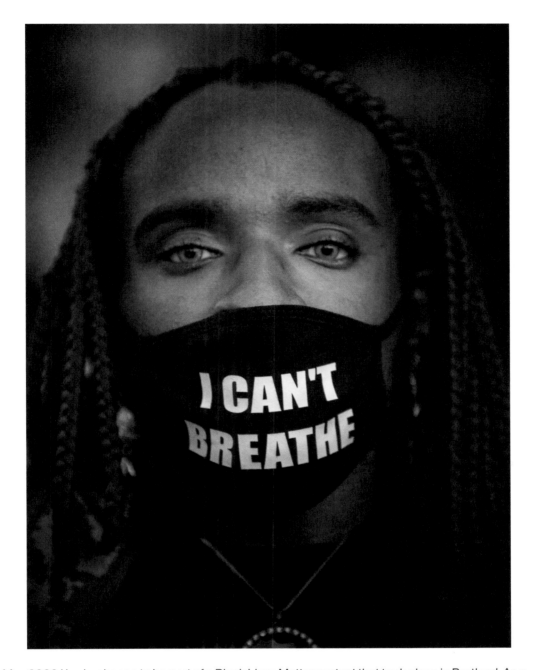

In May 2020 I had a chance to be part of a Black Lives Matter protest that took place in Portland. As a photographer, I decided to go with my camera to record that one moment in history.

The protest started on Congress Street and went all the way to Commercial Street. During that time, I was on my bike, taking pictures as well as being part of the protest.

After the peaceful protest, I reflected, by going through the pictures I took, on how we have been dealing with the many faces of racism and oppression for so many centuries that some people don't even know what racism looks like anymore.

The year 2020 was a year like no other—a year when all aspects of life seemed transformed. Everyone, including me, was so hopeful and excited, making proclamations that 2020 was going to be their year, before all of the obstacles and challenges.

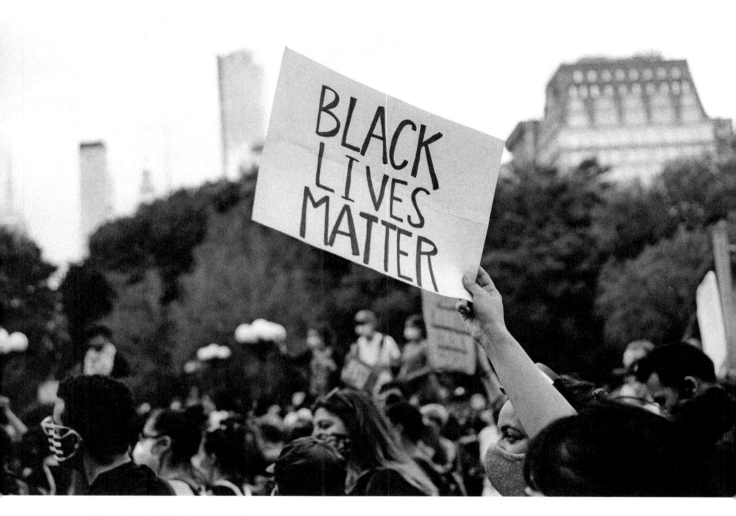

When I took this shot I was sleep deprived, despite New York City's newly imposed 8 p.m. curfew. The night before we had been marching in a protest on the Upper East Side that had started in the morning and continued until around the time when everyone was supposed to be at home. Around 8 p.m. we began to notice riot police with shields and body armor forming a line behind us, and as they advanced, the crowd began to chant: "Peaceful march." A little after 8:30 p.m. the police began to chase, tackle, and zip-tie the slower marchers at the end of our group. Seeing this action caused panic and started a stampede. My protest buddy was knocked down, and as the larger person, I guided us both to a traffic pole, where we waited out the panic. At some point one of the organizers yelled over the chaos, "Don't run! The people have the power! They should be afraid of us!" And then almost on cue, it began to pour rain. We managed to stumble toward the subway by quickly going down a side street. My shoes were full of water and sloshed as I walked, and our masks clung to our faces. It was 10 p.m. by the time we got home, but it felt like midnight, and even after a week of daily marches like this one, my sleep did not come easily. The shot included here was taken on my first roll of black-and-white film and on the day after the described events. To live in New York City during a global pandemic and this ongoing human rights movement was devastating and an incredible privilege.

In June 2020, racial tensions as a result of the murders of George Floyd, Breonna Taylor, and Ahmaud Arbery, among many other Black and brown men and women, were reaching a boiling point across the United States, including in Seattle. It wasn't that this frenzied tension was new or extraordinary to the populace. However, in this particular month of this particular year in the 21st century, the difference between June 2020 and the Junes of previous centuries was that millions of white people had witnessed the perpetual, malicious brutality plainly and publicly, and they too had had enough.

The milder temperatures of Seattle and the Pacific Northwest could not assuage the inflammation of racial tensions throughout the nation and other countries around the world in the summer of 2020.

For the sake of posterity and documentation, I felt it was paramount that I use the tools at my disposal to capture the anger, angst, frustration, exasperation, and motivation of people of multiple ethnicities crying, "Enough is enough!" with unified determination. Also claimed boldly in unison was a statement that only a few years ago had been deemed culturally taboo in America: "Black lives matter!"

For several days, the Hyatt Regency hotel illuminated specific windows along the eastern facade of its building with the letters "BLM," which could be seen from miles away in many directions. To me, it was one of the most conspicuous—yet extremely simple and effective—displays of solidarity with the Black Lives Matter movement in the city of Seattle without a single trace of equivocation. As a cityscape photographer by profession, I was deeply moved by the scene. Alas, it was imperative to capture this moment of such a grand gesture.

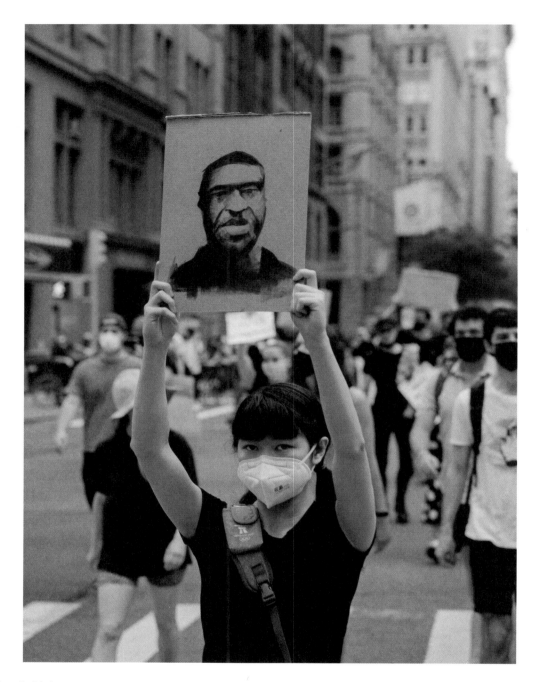

I took this image to capture the heartbeat of that moment in time in 2020 when the streets were rife with Black Lives Matter protesters of all races calling out the injustices and demanding change to protect and honor human life, regardless of the color of their skin.

To me, it was interesting that all this was happening in 2020, because 2020 helped me have a renewed outlook on life: to appreciate loved ones, friendships, and humanity, to recognize how we take for granted the simple freedoms we have in life, and to stand up and help one another.

A few months down the line, in 2021, fresh protests against the violence against Asian Americans were held in this same Union Square to demand justice and the protection of Asian Americans. "Divided we fall. United we stand."

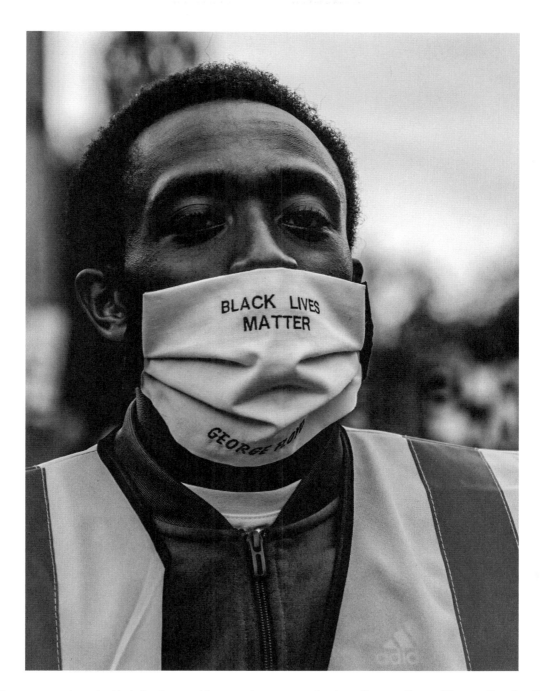

The message I wanted to bring forward from my images was to show the emotions of those attending the BLM protests in Oxford. This image is from the Cecil Rhodes protest, in particular, which was a march and occupation of Oxford high street outside Oriel College where the Rhodes statue was standing over the street, and you could feel the electricity in the air. All these people came to protest the systemic racism that has been and continues to be pervasive throughout British society. The image shows the real people who came out to show their support for the Black Lives Matter movement, and I captured their emotions at that time.

THOMAS ASTERIADES OXFORD, ENGLAND

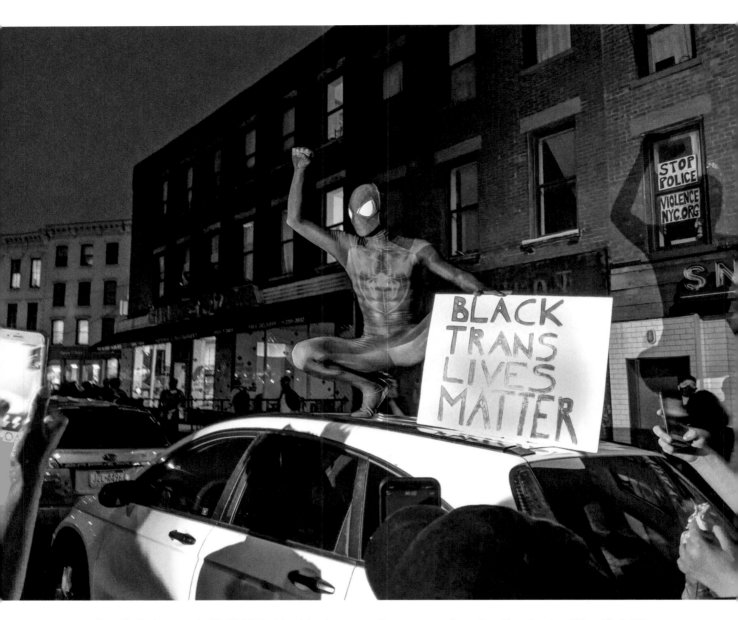

Despite being created in 1962, Spider-Man has never been more relevant on the streets of New York City than during the BLM protests.

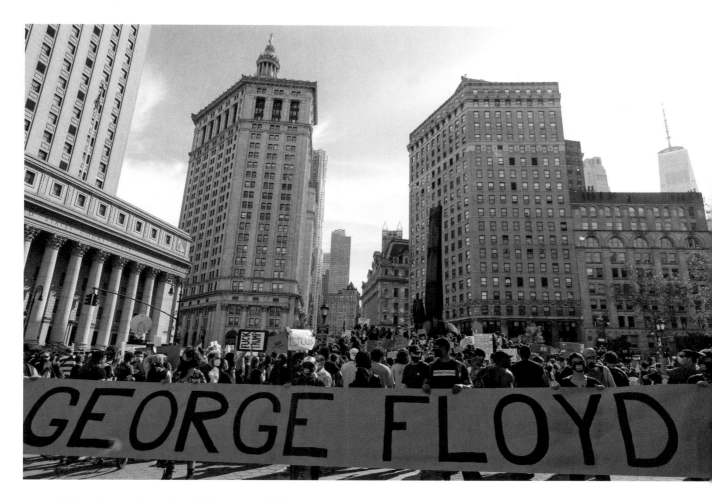

Taking photos during the BLM protests in New York City after covering the Lebanese protests in Beirut for the past decade made me realize many differences. In Lebanon they used onions and cola against tear gas, while in New York it was mainly milk used against pepper spray. But police brutality is similar everywhere.

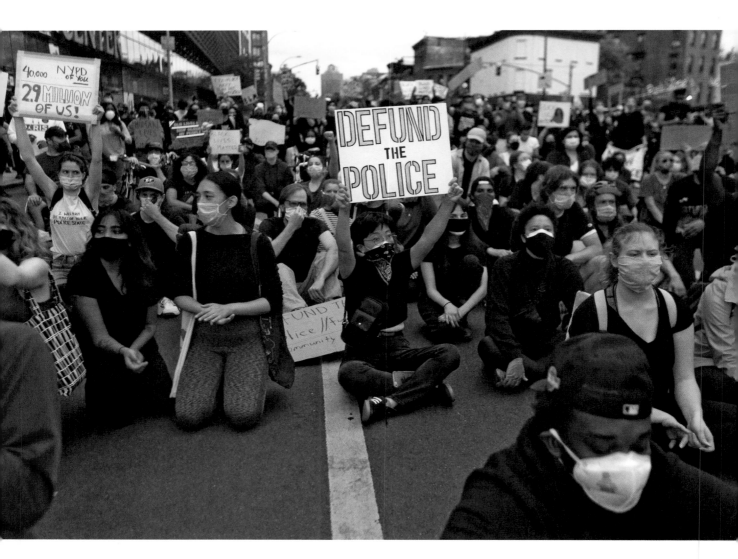

People were not idle in New York in the face of multiple ongoing threats. The protesters came out demanding protection from the dangers of out-of-control police and at the same time took measures of mutual protection against an out-of-control pandemic, like the masks seen here. One of the common chants was "Who keeps us safe? We keep us safe!"

I moved to a new city (Berlin) in January 2020 expecting big changes in my life. But I got much more than I expected.

Roaming the streets was unbelievable. Life under COVID-19 in another country was surreal, and the several months I was there changed me a lot.

I wanted to create and express myself visually so much, but my anxiety was through the roof on an everyday basis and depression got to me. It was a battle every time I wanted to get out of the room. Still, I wanted to see what was out there, and in the end, it was always worth it.

PEDRO RANGEL BERLIN, GERMANY 177

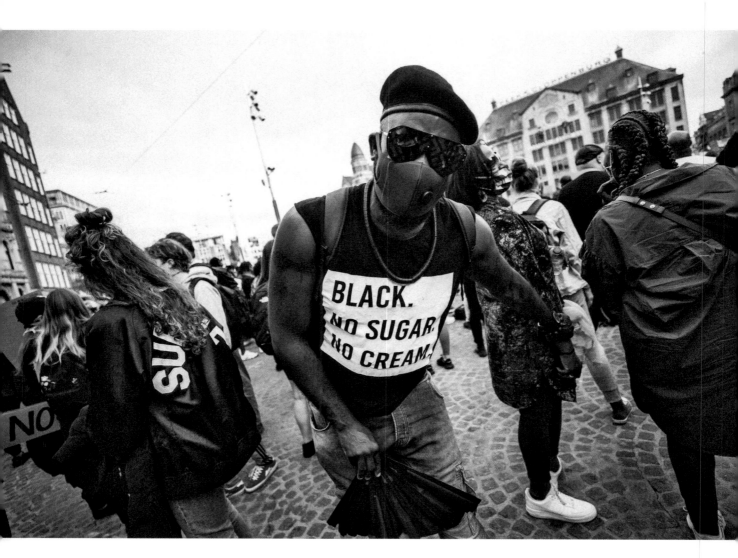

Both my parents are Persian, and they had to go through a lot to make sure their children had the best opportunities in life. While you're growing up, you don't realize that, being a child. You're busy with discovering how the world actually works.

When I was 19, I had a chance to travel to the States for my study. I moved to Greensboro, North Carolina, and spent a year there. Growing up in Amsterdam is a completely different story to what I experienced there. I feel blessed with my journey. It shaped me into the person I am today. I learned so much in North Carolina that I still reflect back on it on a daily basis.

The BLM movement created unity. It brought all cultures, beliefs, and people together. All over the world, people came together to show how connected we are, how strong we are together, and, most important, how we can unite. On June 1, 2020, we wrote history by all appearing on Dam Square in Amsterdam and showing our strength and unity.

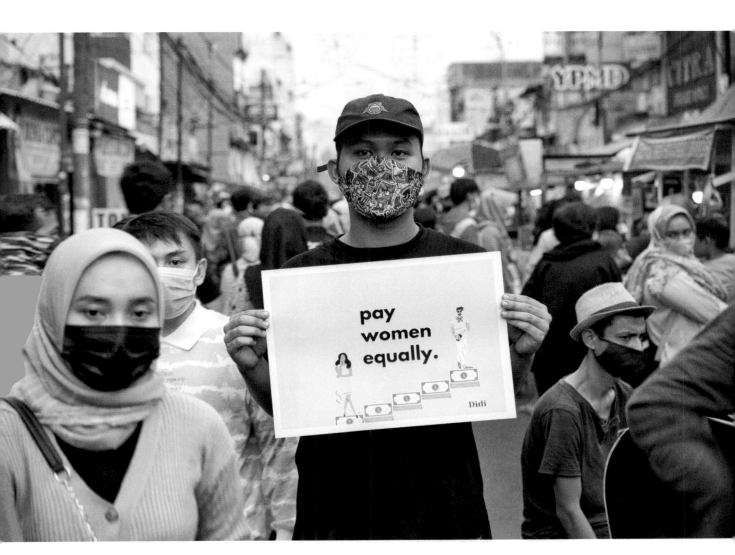

The Women's March is a global action to mobilize and assemble—the most impactful actions to defend women's human rights. In Indonesia, the Women's March commemorates the birthday of Raden Adjeng Kartini, the country's national heroine and women's empowerment icon. It is an everyday struggle for Indonesian women to fight for justice and gender equality.

The gender wage gap refers to the difference in earnings between women and men. Women consistently earn less than men, and the gap is wider for most women of color. In Indonesia, female workers earn 23 percent less on average than male workers, while also facing being undervalued and having inflexible working conditions.

During the photo shoot, we knew there was the potential risk of acquiring COVID-19 in public. We had to make sure that we were well prepared to minimize the risk and proceed as fast as we could. The pandemic has been an obstacle for us, but it will never break our spirit to speak up. In fact, we will be louder than ever.

DISTANCING

The year 2020 proved that even though we had to be separate, nothing could stop people from coming together in solidarity. Thousands banded together—remaining socially distant, wearing masks, and taking precautions while simultaneously fighting for their lives. Every event was now a risk to one's health in the face of this global pandemic, but it was a risk worth taking. It became obvious that we could not continue to live with the injustices that were killing many of us in ways worse than a disease could; this was a fight against the disease of humankind, one that we had to actively work against.

TOGETHER

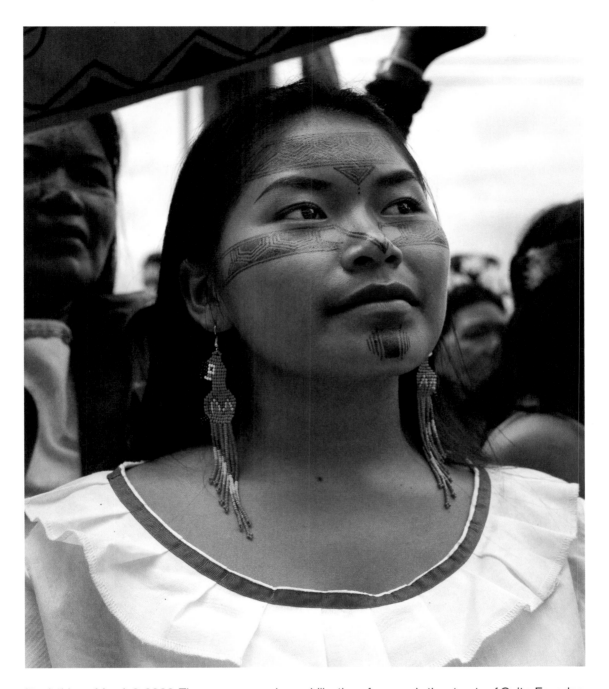

I took this on March 8, 2020. There was a massive mobilization of women in the streets of Quito, Ecuador. For the whole day, we wondered if the COVID-19 pandemic had already arrived to our country. This still seemed unreal, but after a few days the restrictions began.

This young woman belongs to the Collective of Amazonian Women that was formed by women from different Indigenous communities of Ecuador. They fight for the defense of nature and their territories against extractive activities, and against violence.

At that moment we were listening to the words of another Indigenous woman and I was deeply moved by the concentration and look of this young woman. As a woman and feminist photographer, I intentionally look at the stories of other women, strong, diverse fighters, because I am convinced that only we can change what is wrong in this world.

KAREN ALEJANDRA AGUILAR QUITO, ECUADOR 181

Getting out of the subway to see the Black Lives Matter crowd chanting in solidarity to defund the police sparked a flame in me. I joined the march, quietly observing through my lens. As a Black African immigrant, I understood the need to stand against injustice. It could be me, my brother, or a friend [who faces this injustice]. The crowd decided to march on to Times Square, and the move was on. It was a coordinated attempt to bring to the forefront the challenges that systemic racism and the role of a violent police force have in cutting short so many young lives, and to make it clear that we cannot keep quiet and let injustice continue to prevail.

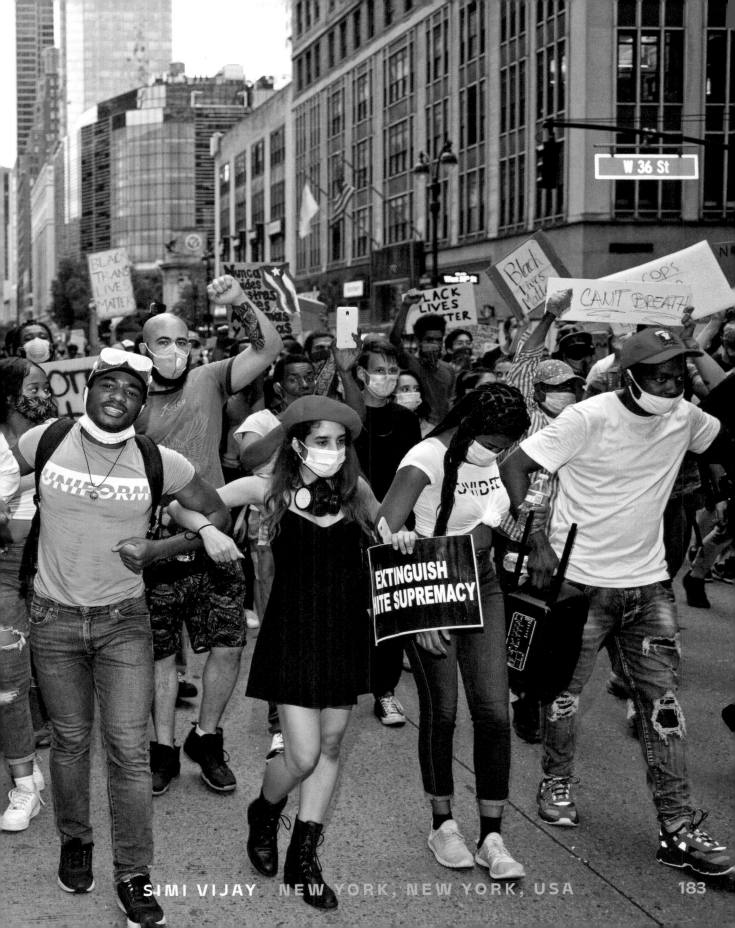

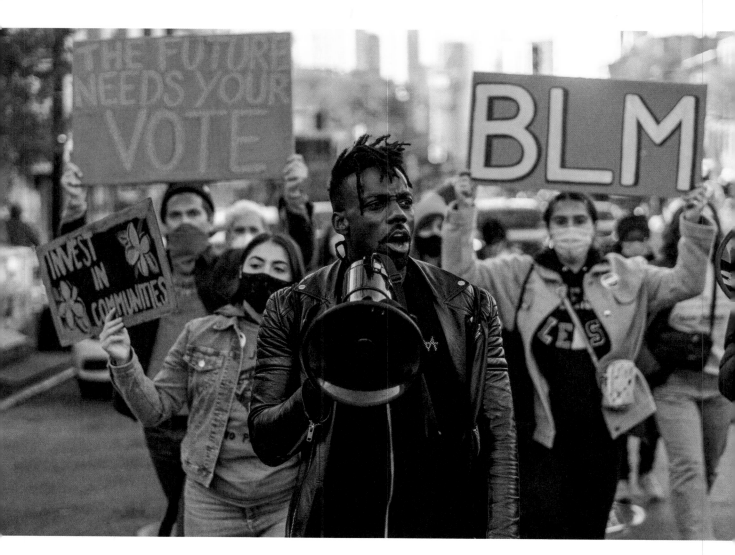

All the difficult, divergent paths that blazed through 2020 led to Election Day. Election Day was seen by many as a point where we could see the potential for real solutions lying ahead. Of course, there can never be certainty in things left in the hands of policymakers, but there was a measured optimism on the part of the people. In New York City, grassroots organization Unite NY organized a March to the Polls. A relatively small but energetic group marched from downtown Brooklyn to Prospect Heights, chanting throughout the entire journey.

At the halfway point and the endpoint of the march, various groups provided PPE, sanitizer, water, and food—everything from granola bars to empanadas. While such gestures were commonplace at marches held around New York City, November 3, 2020, just felt a bit different. There was an intimacy and buoyancy present that would have been harder to spot in the more massive actions that took place earlier in the year. Everyone left with a sense of communal support and a reinvigorated hopefulness, all tempered by a smattering of anxiety.

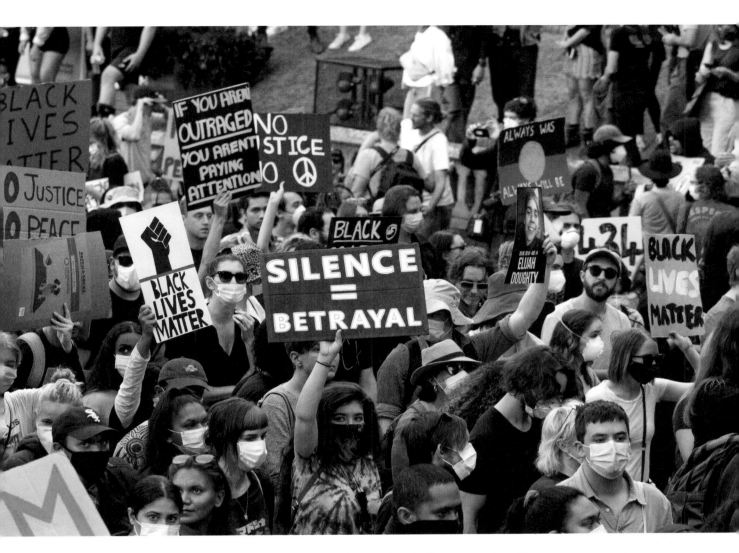

Australia is a nation based on immigrants and with a very long Indigenous history. For many years, racism has been ingrained in Australian culture, so it makes me very proud to see a new generation of inclusion and understanding growing up.

This photo was taken at a Black Lives Matter rally in my hometown of Brisbane. The racism ingrained in Australian history is very prominent among older Australians, so I wanted to highlight the support that younger, white Australians are giving to the Indigenous communities here. It's awe-inspiring and gives me hope for the next generation.

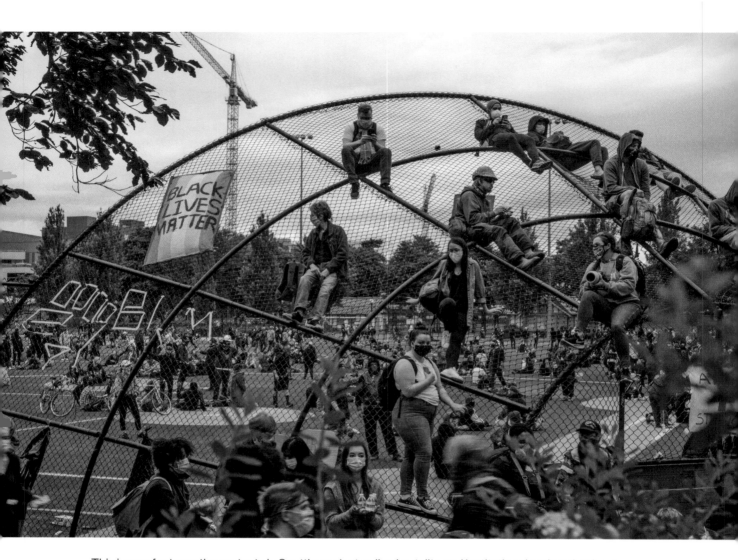

This image features the protests in Seattle against police brutality and institutional racism that have taken place since the recorded lynching of George Floyd in Minneapolis. The photo was captured at Cal Anderson Park in the late afternoon of June 3, 2020, just a few days after George Floyd was murdered by a white police officer in Minneapolis. There was so much tension in the air, and hundreds of people, of all ethnicities, gathered to protest their anger and anxiety regarding the idea of race relations in the United States. As a photographer, it was important for me to document the moment and witness how a tragedy, as extreme as it was, brought so many different people of various creeds together.

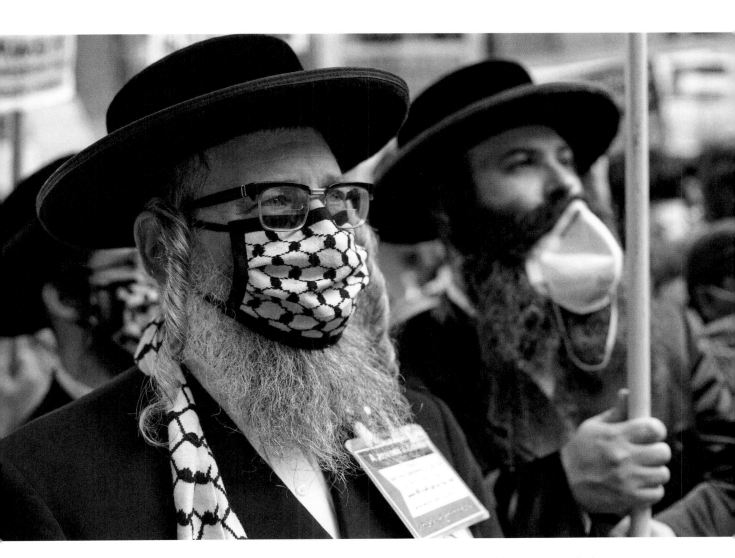

After Israeli prime minister Benjamin Netanyahu's declaration that Israel would annex occupied territory in the West Bank, Palestine, protests around the world erupted in opposition. I was in Brooklyn when this global outcry was taking place, and attended a massive protest on July 1, 2020. Different communities came together to express solidarity with the Palestinian people. Among the many community leaders in attendance was Rabbi Yisroel Dovid Weiss, an anti-Zionist Jewish leader. He was there side by side with secular Jewish folks, LGBTQIA+, Black, and Indigenous activists who came to support the Palestinian struggle for liberation. Never have I seen so many people from different walks of life united under one cause.

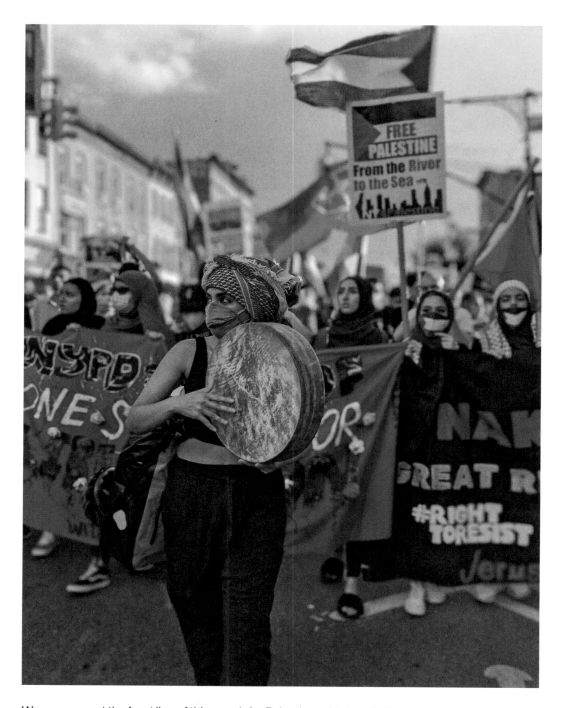

Women were at the front line of this march for Palestine, which took place in Brooklyn. Some were singing, others leading chants, and this particular person had brought a drum and was accompanying them.

Witnessing the events unfold over that week felt almost surreal. It seems like the world collectively awoke from a trance, and people are finally naming years of ethnic cleansing and violent colonialism for what they are. I took this photo at a rally in support of Palestine. The shift in public discourse in the US about Palestine is palpable, though there is still much work to do, and we hope that this is the beginning of a change in the status quo.

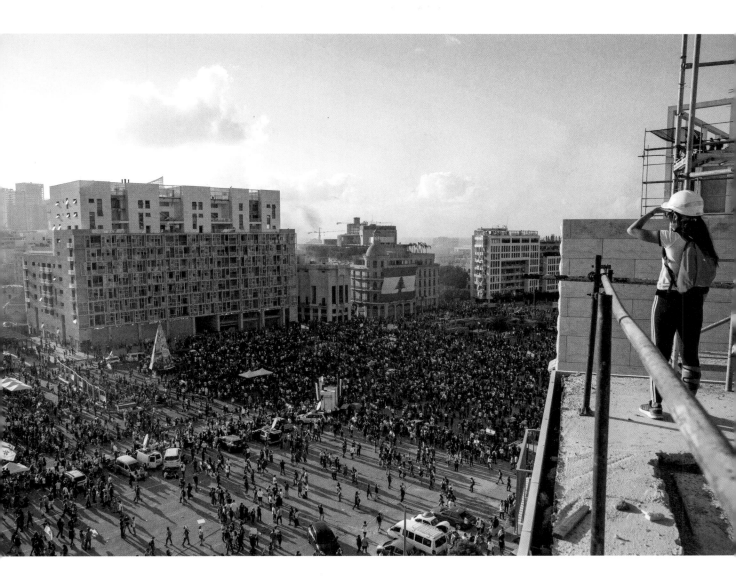

"The Lebanese revolution": when people of all beliefs, ages, genders, united to shout in the face of those in charge of dragging the country down. Capturing the moment and freezing a second is what street photography is all about. Intimate moments such as praying and family time reflect exactly those honest feelings.

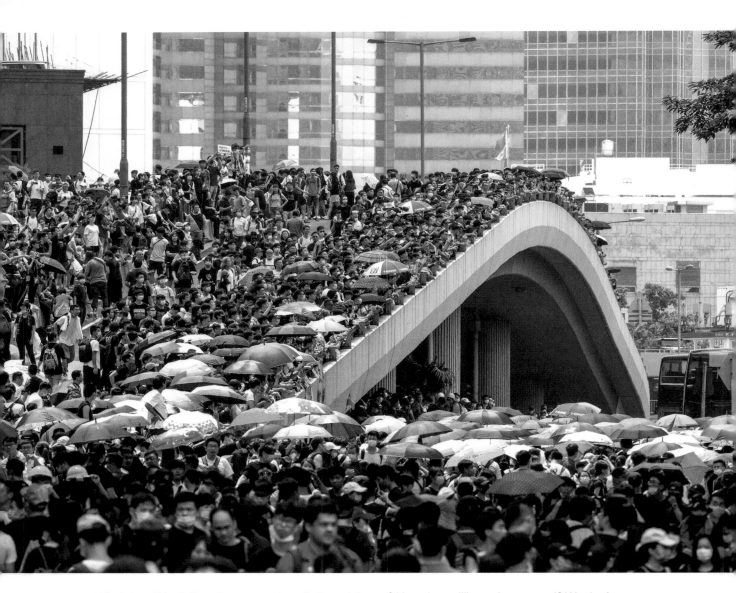

What does it look like when a people unite in resistance? How do a million voices sound? Week after week in the summer of 2019, the streets of Hong Kong swelled with pro-democracy protests until the crowds formed a righteous mass, an unstoppable organism that roared with the voices of everyday people prepared to join history. International observers searched in vain for apt descriptors. Were these people brave? Vigilant? Indomitable? When you're standing to protect your home and your way of life, these words are helpful but ultimately insufficient: This is Hong Kong. These are Hong Kongers.

Behind each of the photographs I took is a different story, but all the photographs are connected by a strong belief in freedom and democracy. I witnessed, as a foreigner photographer, from day one the fight for a better future without the control of the Chinese Communist Party. During my time, I saw horrible things but also beautiful things, such as how humans can really stand together even against their worst enemy and still never lose their feelings of belief and compassion.

RAISE YOUR

A raised fist is a universal symbol of power, solidarity, and a desire for change. In 2020, we saw many raised fists. They were held high for causes of all types. Our photographers captured this universal gesture all across the globe, in all different contexts, whether it was a fist raised for Black Power, for a cause unique to a community, or in celebration. The fist became a symbol uniting people throughout the year in a universal language of strength and togetherness.

FIST TO . . .

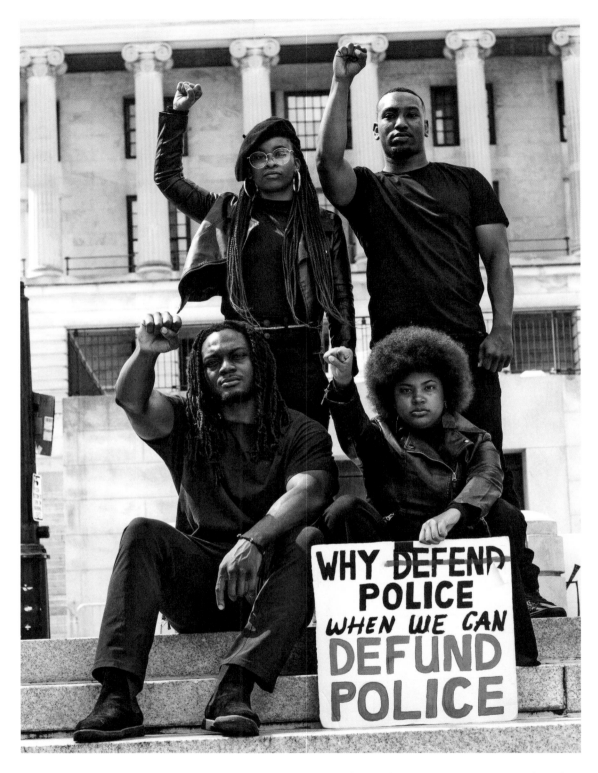

This photo was taken in downtown Nashville, at our capitol building, where state troopers were placed in front of the building to protect it from the protesters. My motivation behind the image was the BLM movement and how whites and Blacks came together to show we are stronger together. Throughout the day, there were people driving back and forth, yelling racist slurs and throwing things at the protesters. But we stood together.

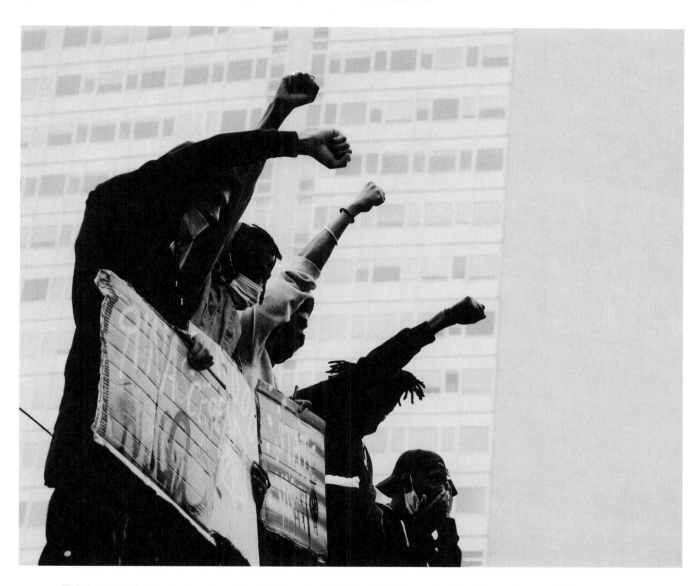

This image is from a series about the BLM protest in Milan, Italy. It was the first time when we felt a sense of unity and power all together—we were there for one reason. What is still happening in America happens also in Europe, even though the media prefers to not talk about it.

DANILO BORGHI MILAN, ITALY 193

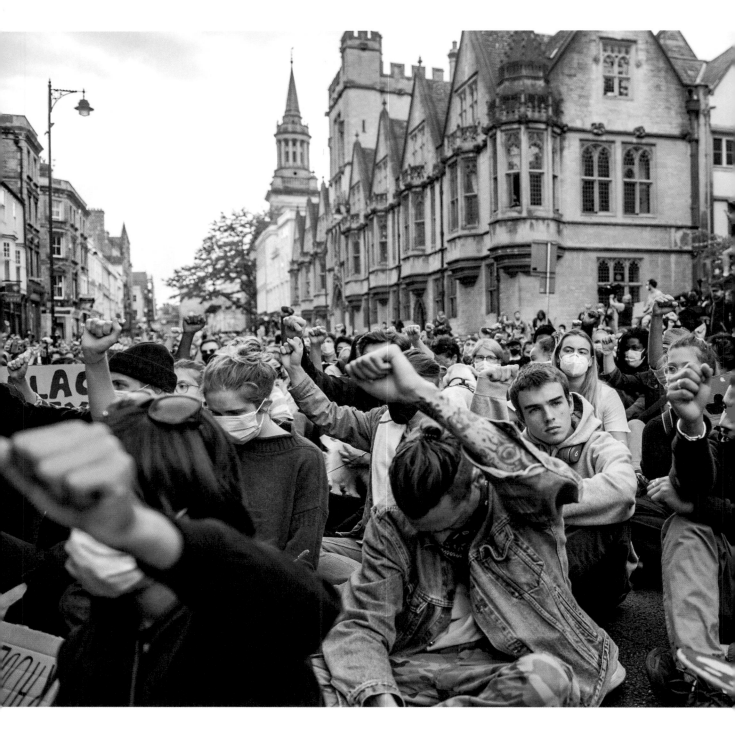

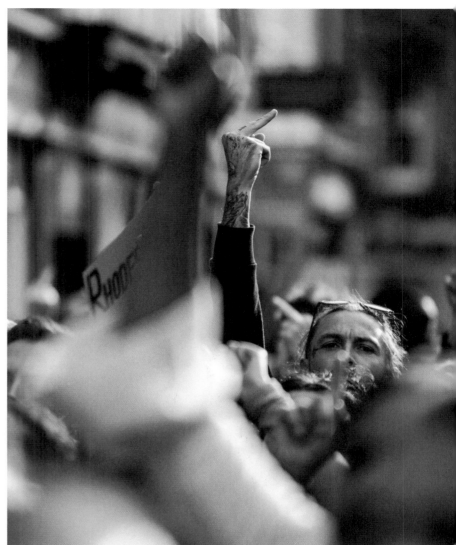

These images were taken on a hot day in Oxford in June 2020, when I participated in the various Black Lives Matter protests to stand in solidarity and gain a clearer understanding of how truly devastating, systemic racism has destroyed countless lives. Even though it was mid-lockdown in the UK, people were protesting in the thousands on the streets outside Oriel College the university's contentious relationship with its statue of the infamous colonialist and racist Cecil Rhodes. I wanted to truly represent the crowd's emotions through a series of intimate portraits interspersed with wider shots of the sheer number of people crowding this historic street. After photographing for three hours, I was taking portraits at the front, by the speakers, when I was called forward by the two men who were holding up the loudspeaker. I stepped forward, and they asked if I could help hold it with them, as the toll of balancing it on their shoulders for most of the demonstration had become too much. I took the speaker from them and held it on my shoulders alone, as I was significantly taller than the two men, and it became a truly humbling experience, to stand there in front of this crowd of thousands as the leaders of the protest spoke their moving words.

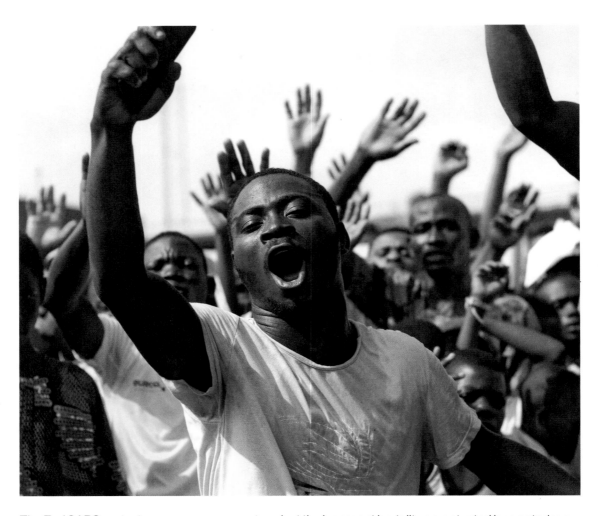

The End SARS protest arose as a movement against the incessant brutality perpetuated by a notorious police unit called SARS (Special Anti-Robbery Squad), formed in 1992 to combat armed robbery and serious crimes in Nigeria. The majority of those engaged in the protest were youths, mainly because they were the most affected by the incompetence of the unit, becoming victims of extortion, criminal profiling, robbery, and more. The protest officially began on October 8, 2020, led by musical artists like Runtown and Falz, before it gathered momentum nationwide and globally.

Three days into the protest, the inspector general of police, Mohammed Adamu, announced that the unit would be disbanded, but the youths did not back down, because it was the same old tune: words without action. I myself had gotten into an encounter with the police before. I was beaten before I even was put into the police vehicle. I felt the need to join voices and also document the protest, which represents the might of the average Nigerian youth.

On October 20, 2020, the Lagos State government invited members of the Nigerian military to ensure a newly imposed curfew. Two hours before the curfew began, the Nigerian Army opened fire on peaceful protesters singing the Nigerian national anthem and waving the Nigerian flag at the Lekki toll gate. Eyewitnesses reported seeing dead bodies being carted away in trucks by the Nigerian Army as they tried to cover up the evidence.

In the early hours of the next day, the Nigerian Army denied any report of its involvement, branding it as fake news and calling any visual evidence "Photoshopped." The latest report on the atrocity involved the Lagos State government and the Nigerian Army shamelessly pointing accusing fingers at each other.

October 20, 2020, will always be remembered as the day the Nigerian government murdered its citizens.

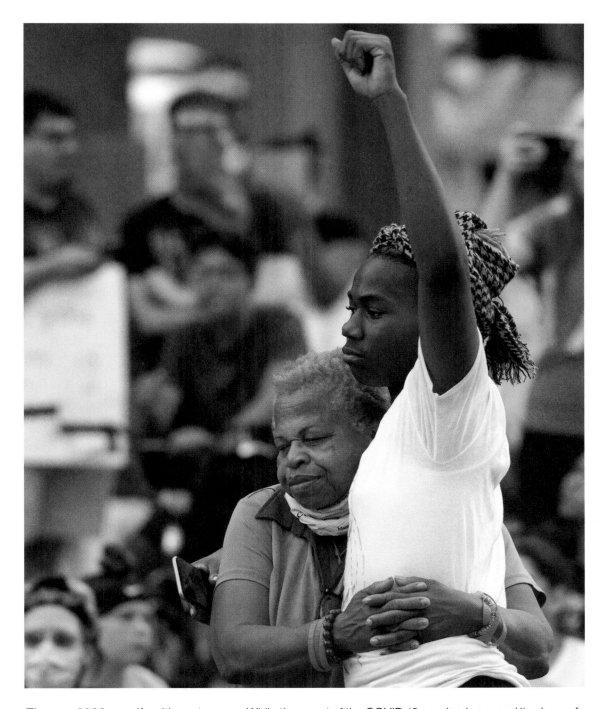

The year 2020 was rife with controversy. While the onset of the COVID-19 pandemic caused its share of unrest throughout our nation, the murder of George Floyd in Minneapolis, Minnesota, ignited a wildfire in the African American community and among its allies. Mothers, sons, daughters, and people of all ages and ethnicities marched all across America, and even around the world, to let everyone know that Black lives matter. In this photo, a mother embraces her son in a heartfelt moment during a BLM protest.

I am a Black man. I am privy to and, to a degree, affected by all the issues that plague Black America. On any given day, I could be any one of the men murdered by police, and my name would be denigrated in the media. This is my way of expressing that concern.

CLAYTON JONES WICHITA FALLS, TEXAS, USA 197

BREAKING

In these moments, it all came to a head. When staring directly into the face of all the injustices threatening their lives, their communities, and all humanity, people chose to fight back. These images captured only a fraction of the feelings experienced during that choice made to rise up. The pure energy, emotion, and anger had been building and building, only to finally be released, like after the opening of a floodgate. All across the world this same strong current was felt, empowering people to make their voices heard, whatever the consequences.

POINT

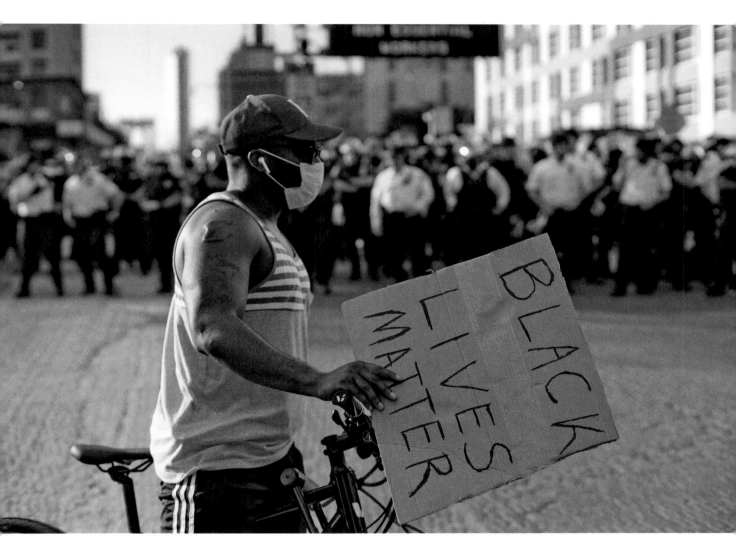

It was in the heat of June 2020, and we were marching in the Black Lives Matter protest in Brooklyn, on our way to Manhattan. Suddenly we saw the NYPD form a barricade between us and the Manhattan Bridge, barring our path into the city. The police presence was a reminder of the structural racism and inequality that are so embedded in the US, even against the backdrop of a deadly pandemic.

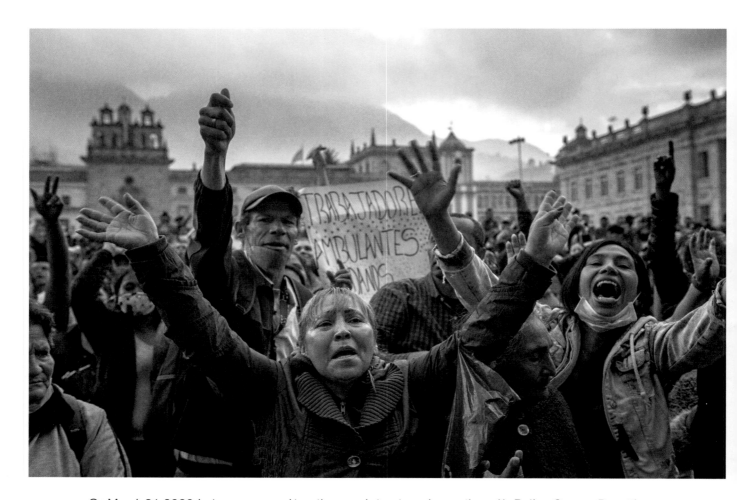

On March 24, 2020, between one and two thousand street vendors gathered in Bolívar Square, Bogotá, to ask for help to survive the lockdown that was going on all over Colombia. As their work is informal, they earn day-to-day money that allows them to buy food for their families. "We're hungry!" they shouted. Their placards said, "Help us" and "We are displaced [by violence], support us with any help . . . God bless you." It was during this protest that I realized the danger of the social consequences of the pandemic. For most of these already precarious workers, the danger was not this invisible thing, but the risk of having nothing to eat at night. I had to tell their story, to help them to be taken into account. As I approached the Plaza Bolívar, after the deserted streets, I could hear the rumor of their shouts getting louder with each step.

OPPOSITE: During a protest against police brutality in front of a police station in the center of Bogotá, someone waves a flag in the color of a former political movement, with the inscription "COVID-19." The capital of Colombia was then coming out of five months of quarantine. Although it was arranged, the continuous presence of restrictive measures became heavy. It was at this moment that police abuse took place, which ended with the death of Javier Ordóñez, a law student. Three days of mobilizations in working-class neighborhoods against the police centers followed. This image, for me, evokes a general feeling of people being fed up with the increasingly precarious conditions in working-class neighborhoods, as well as an explosive situation of social restraint already existing before the pandemic, now exacerbated.

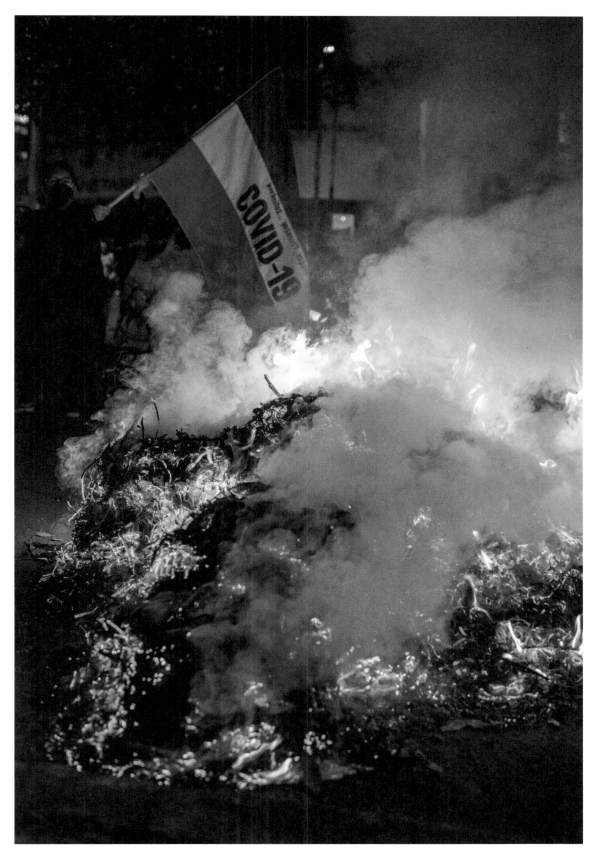

NADÈGE MAZARS BOGOTÁ, COLOMBIA

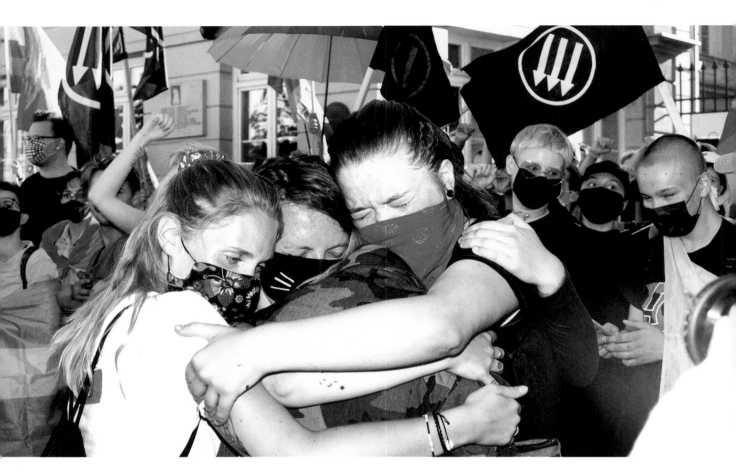

This photo was taken in July 2020 in Warsaw, Poland, during a wave of protests supporting the LGBTQIA+ community. The moment captured a group of friends hugging one another. The photo is significant, as on the opposite side of the street there was a nationalist rally against the LGBTQIA+ community. This photo represents a very heartwarming moment for me—it shows the need to create a community and a safe space in Poland, which has become an antagonistic environment for LGBTQIA+ folks.

During August, a series of assaults toward LGBTQIA+ people took place in Poland—arrests of activists, etc. The Polish far-right government uses rhetoric to objectify and dehumanize the queer community and gives permission to the alt-right movement for its violence and hate speech.

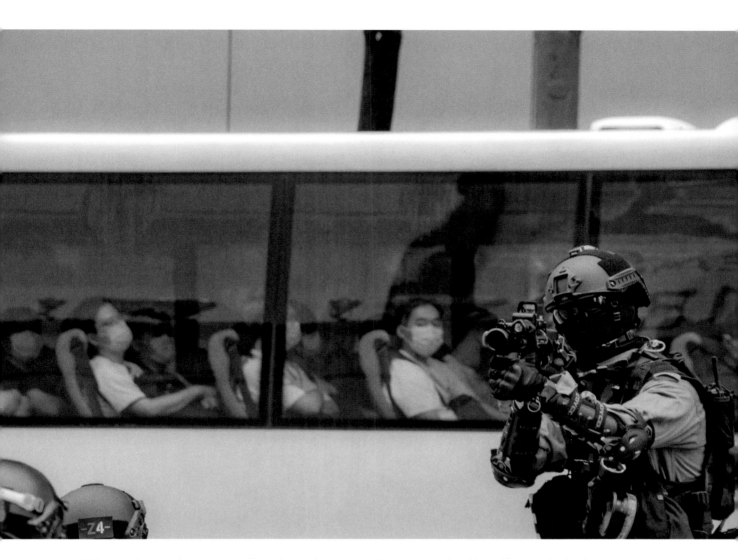

When resistance becomes routine, danger is your constant companion. Hong Kongers looked on as armored police made their threat known daily, emerging from clouds of tear gas to reclaim the streets. Scenes of violence spilled from televisions across Hong Kong, telling stories of pitched battles from the night before, and of the bleeding, disfigured victims who were left on the pavement. But absent from those images was the basic truth that all violence starts from a choice made. A choice to raise a weapon, to silence a voice, to take a life. Posterity will be the judge of these decisions.

CARLOS ALBERTOSI HONG KONG

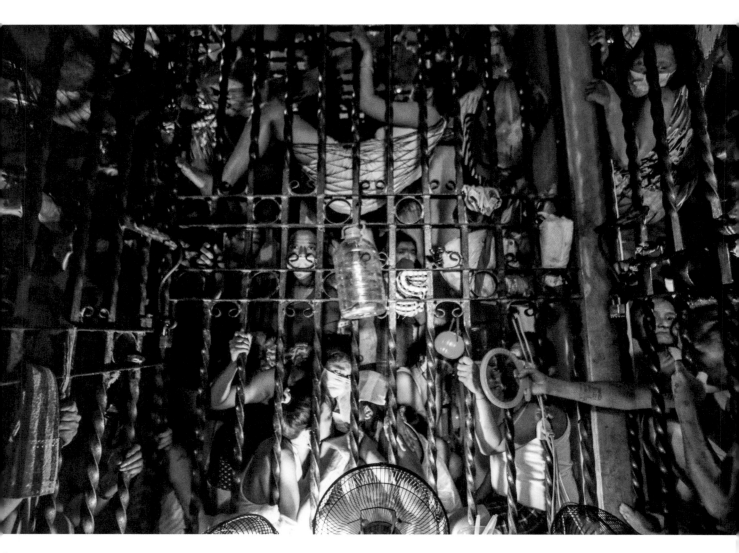

This is a photo of "persons deprived of liberty" (PDL) crammed up in a small cell at Biñan City Police Station, Laguna, south of Manila. I went there since the local chief of police was asking if we could document the condition of their prisoners on the risk of their being exposed to meningococcemia, since one of them allegedly died from the infection. They were hoping that the local government would extend some help to lighten up the conditions in their police station.

The atmosphere there was so gritty, heavy, and damp. All of the female prisoners pressed inside this small cell were crying for help.

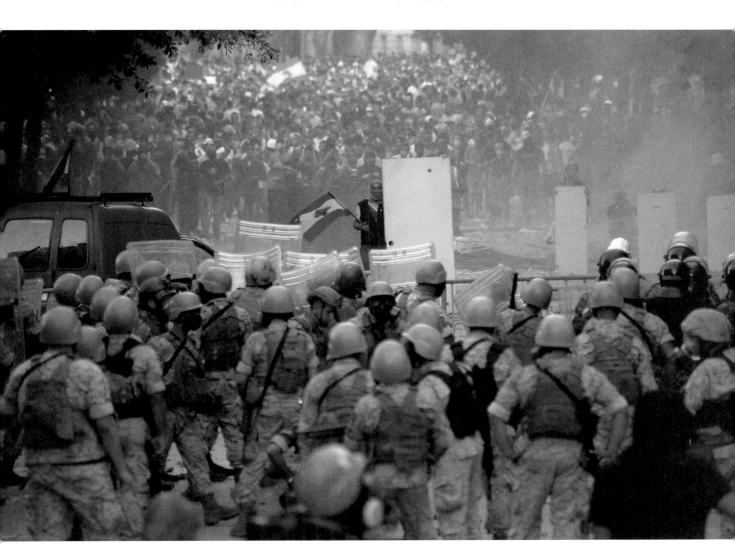

Almost one year after the October 17 Revolution and four days after the Beirut port explosion, the Lebanese people found themselves still trapped and helpless under the continuing economic and political failure of the government. After months of lockdown and stagnation, the deadly blast was the last straw and pushed massive crowds to take to the streets and demand a new democratic regime, free of corruption. At this point, a lot of people demanded justice even if it would cost them their lives. The status quo was not an option anymore. That day ended in a lot of people injured from police brutality, the police showing little mercy for people's suffering. The country passed through the toughest series of events it has seen in decades.

RAMZI HAIDAR BEIRUT, LEBANON

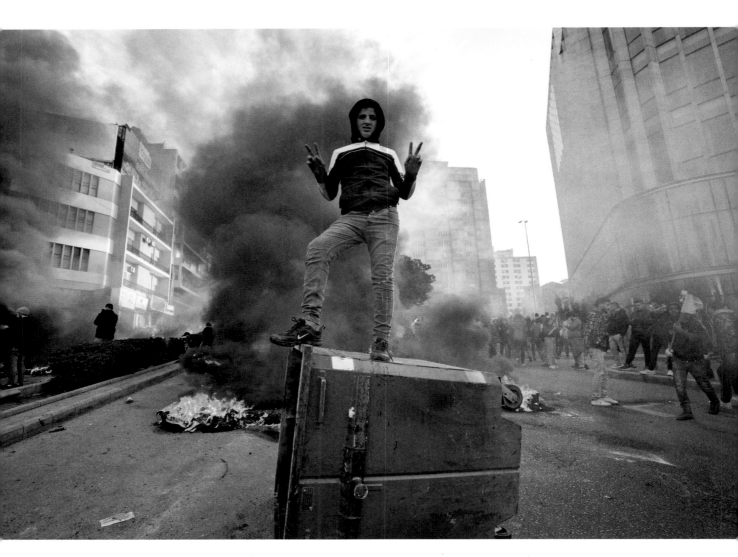

Lebanon's 2019 October Revolution carried through to the following year, when the nation experienced an uprising against the political elite and widespread protests throughout the country. On January 14, 2020, day 90 of the revolution, protesters in Beirut blocked major roads by burning tires and using dumpsters as barricades. On this specific day, underprivileged kids and teenagers showed up in numbers. Some were running between the burning tires, some were chanting, some were sitting in line on the pavement. In a split second amid the smoggy chaos, I captured this young gentleman flashing a peace sign at the camera.

LYNN CHAYA BEIRUT, LEBANON

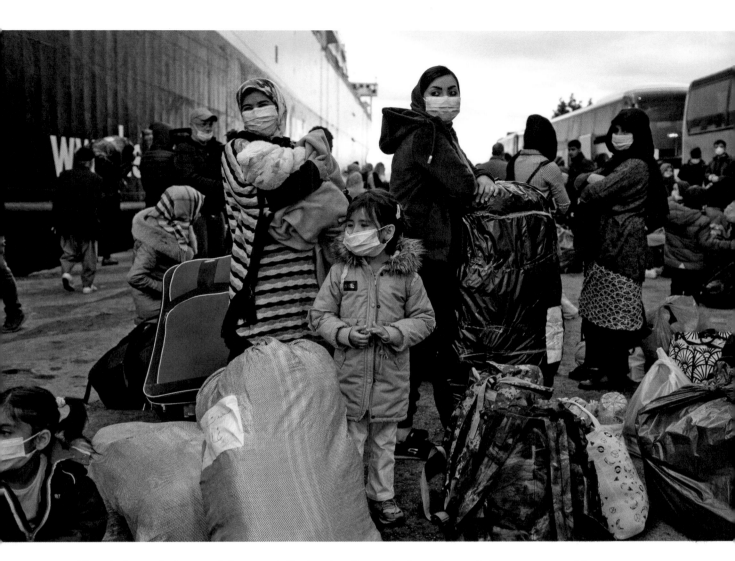

The photography I present documents the immigration and refugee issues in Greece, some of the long-term issues I have been working on in the last years. I am dealing with these issues through my own personal history of immigration, as my family and I came from Albania to Greece in 1998. Coming here, I faced both the dark side of the immigrant situation, such as racism and poverty, and the beautiful feelings of freedom, hope, and solidarity. This led to my curiosity to record the daily lives of refugees and immigrants in Greece.

Refugees and migrants wearing masks, to prevent the spread of the coronavirus, wait to get on a bus after their arrival at the Port of Piraeus, near Athens, on Monday, May 4, 2020. Greek authorities are moving 400 migrants, mostly families, to the mainland to help ease overcrowded conditions at the Mória refugee camp on Lesbos island.

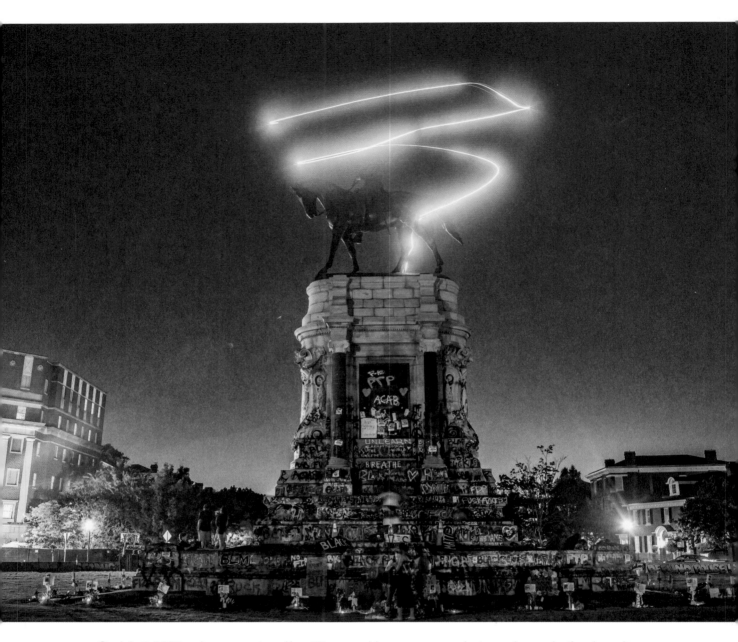

On July 9, 2020, a drone—captured in a 30-second-long-exposure photograph—marks the sky as it spirals downward, enveloping the 60-foot monument of Confederate general Robert E. Lee. Thousands of citizens made their marks of protest and solidarity on the pedestal for the statue. The plinth became a canvas that documented the private cumulative actions of BLM protesters using loud voices and colorful paint to declare themselves against racist acts of police violence and against Richmond's collusion with the Confederate "Lost Cause" narrative that perpetuates systemic racism. The *New York Times* recognized the space now known as Marcus-David Peters Circle as the most influential protest art since World War II. Midway through the flight, the drone crashed between the legs of the horse and landed on top of the plinth. The drone was never recovered, which felt oddly symbolic of the sacrifice and risk it takes to confront these injustices. A local street musician blew long-winded notes through the air, received by quiet bystanders lighting candles and reading the handmade memorial placards of people murdered by police around the country. I hope this collaborative piece can remind people that racism must be illuminated before it can be undone. It's best we all work together.

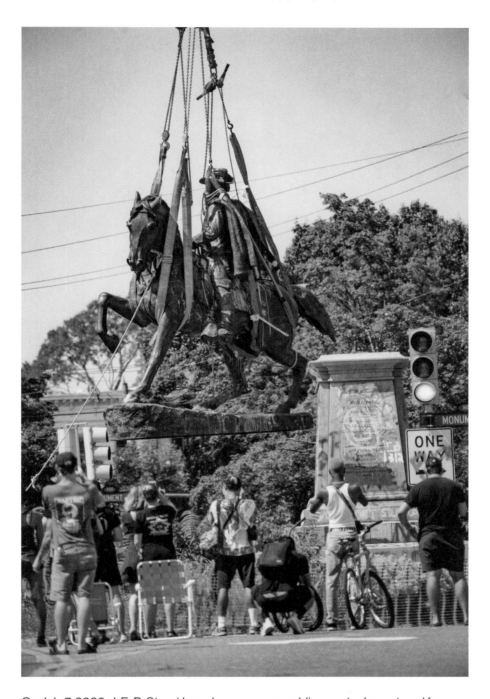

On July 7, 2020, J. E. B. Stuart hung by ropes as a public spectacle captured for social media posts, private photo records, and journalistic reports. I waited for the traffic light to turn green before taking this photo of one of the most prominent Confederate monuments being lifted from its plinth—113 years after its installation in Richmond, Virginia (the former capital of the Confederacy). The traffic light turning green in combination with the One Way sign felt symbolic of the mayor granting the request of the people of Richmond to remove the monument from the public space as the only way to move forward. The monument was transported to a nearby wastewater plant for temporary storage that day.

CHRISTOPHER RISCH RICHMOND, VIRGINIA, USA

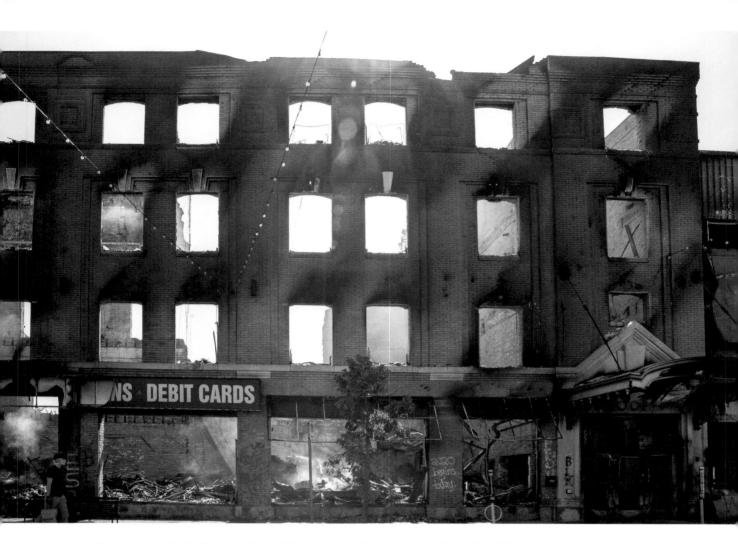

I live in a suburb of Minneapolis, and like so many others, I was saddened and sickened over what happened to George Floyd. This photo I took was from the aftermath of rioting on Lake Street in downtown Minneapolis. I had to see for myself the damage that was done to our beautiful city. Nothing could've really prepared me for what I saw as I walked along Lake Street. Most of the buildings were still burning that morning, and I felt like I was actually walking in a third-world country, not a city located in the northern state of Minnesota. There were people all over with brooms and trash bags in hand, ready to help clean wherever they could. Nothing was off-limits to me, and I was able to walk into Target and see the damage done to the exterior as well as the interior. Whatever nonperishables that weren't damaged were free for the taking for the community. What happened here was truly heartbreaking.

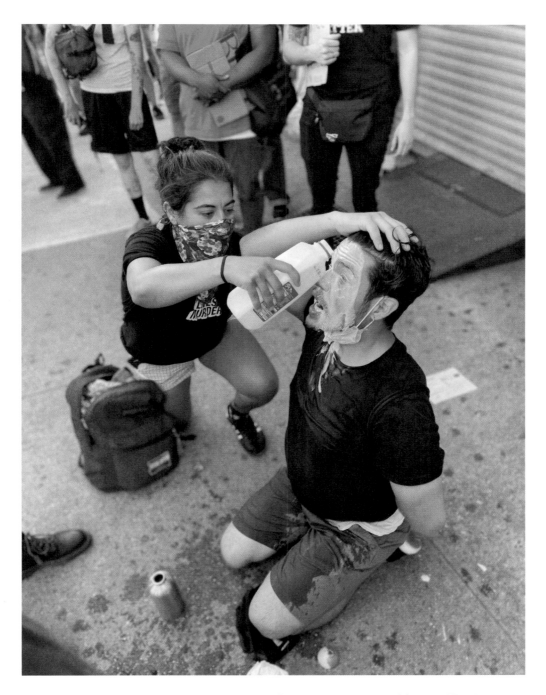

It was the first weekend of protests in New York City after the murder of George Floyd. Tensions were high, and police officers were using excessive force against protesters. That day my friends had been providing first-aid help to people and were treating those who had been pepper-sprayed by the police. Unfortunately, the police deliberately targeted them for their work as medics, and they were beaten, shoved, and eventually arrested during the protests that unfolded over the weekend. This photo is of one of the protesters receiving first-aid help by getting milk poured onto his face, commonly considered to be a street remedy for the pepper spray used by police.

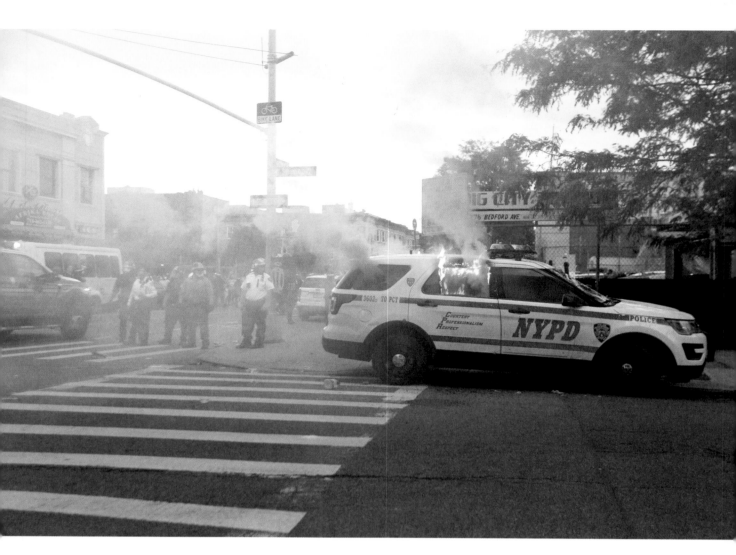

As the protesters and the police clashed in this Brooklyn BLM protest in May 2020, a police car was set on fire, while a Christian prayer van parked in the middle of the intersection, its powerful speakers amplifying the preacher's chant, "Jesus, Jesus, hallelujah, Jesus," over and over.

ALIA HAJU BROOKLYN, NEW YORK, USA

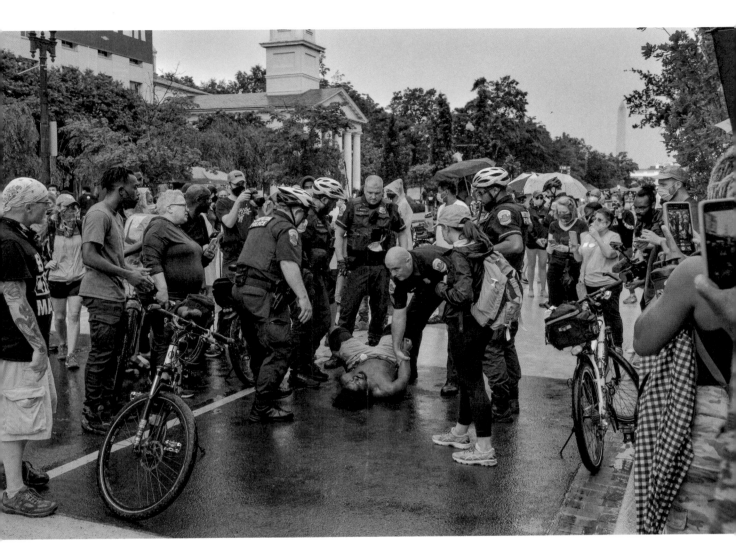

I got this shot in Washington, DC, during the months of protests. I went there to document when they changed the name of part of 16th Street in front of the White House to Black Lives Matter Plaza NW. We need to remember that first we are humans. No matter what we are fighting for, we can always find ways to do it in a respectful manner. I can relate to the pain, as no matter the reasons, the pain feels the same for everyone. Yet a lack of education can result in such aggressive behavior that takes us further from peace and harmony in the world.

IDO SIMANTOV WASHINGTON, DC, USA

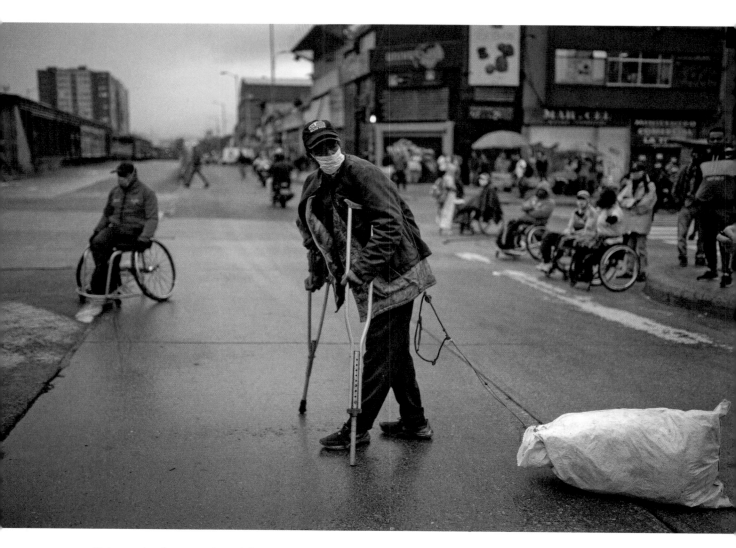

This pandemic exacerbated the social inequity in which Colombians have lived for decades, and besides being a medical emergency, it has become a social one.

Dozens of people with disabilities and their caregivers blocked one of the main streets in downtown Bogotá to ask the government to include them in aid programs. In a year and a half, thousands of Colombia's inhabitants—this kind of vulnerable population included—had lost their incomes due to economic closures. This was one of the first protests caused by the COVID-19 restrictions in the country, which now has scaled up into the country's longest national strike, which started on April 28, 2021, and is still going on.

ESTEBAN VEGA BOGOTÁ, COLOMBIA

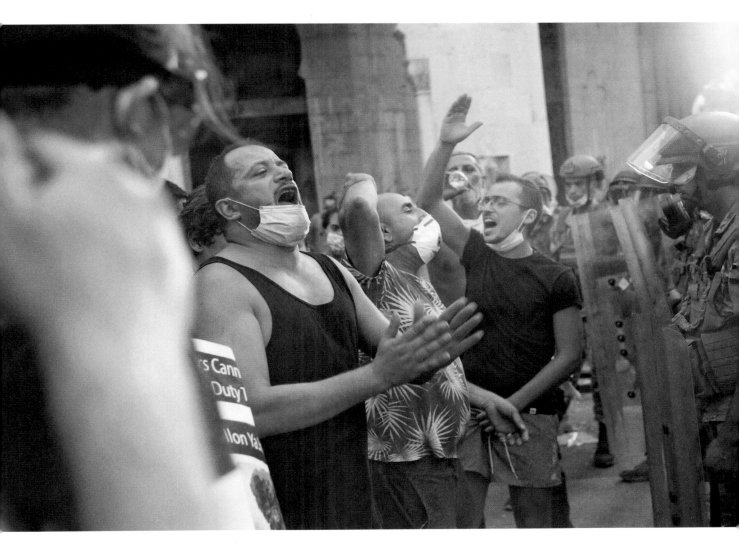

Lebanon during the summer season was always known for its joy and glamour, on the beautiful beaches and in the green mountains. This year, in the wake of the terrible explosion in the Beirut port on August 4, 2020, and the deteriorating political-economic situation, the Lebanese people had a sad, and angry, summer. The heat mixed with anger and bitterness in the streets in the face of the corrupt regime.

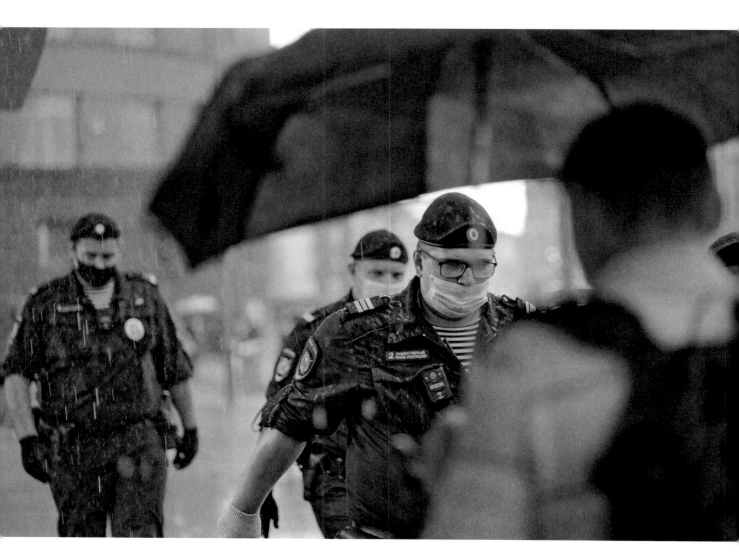

The requirement to wear masks during the pandemic has given additional benefits to both police and protesters. This was taken at a rally in support of arrested Russian journalist Ivan Safronov, July 7, 2020. It was the first protest during the pandemic in Moscow, and due to restrictions, it was mainly between journalists and police. Hopes of democratic changes in the country were beaten due to heavy rain.

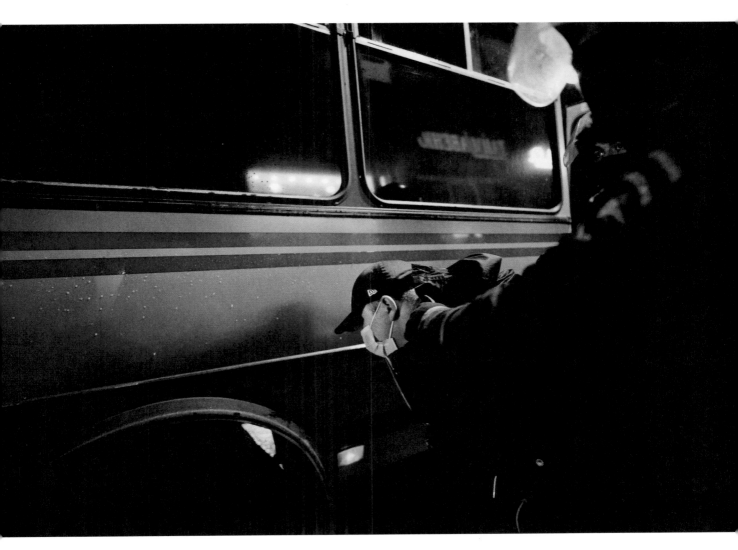

I've been shooting rallies for almost 10 years, and I didn't think this one would be a turning point, but it was for me. The protest was divided through the streets until the police trucks became filled with a few hundred unlucky protesters. Police randomly arrested those who looked like protesters. However, the protesters did nothing against the law, maybe just shouted too loud. I was a journalist that day, but it was a big risk for me to be pushed into the police truck, because police often don't care about the journalist ID when they catch somebody.

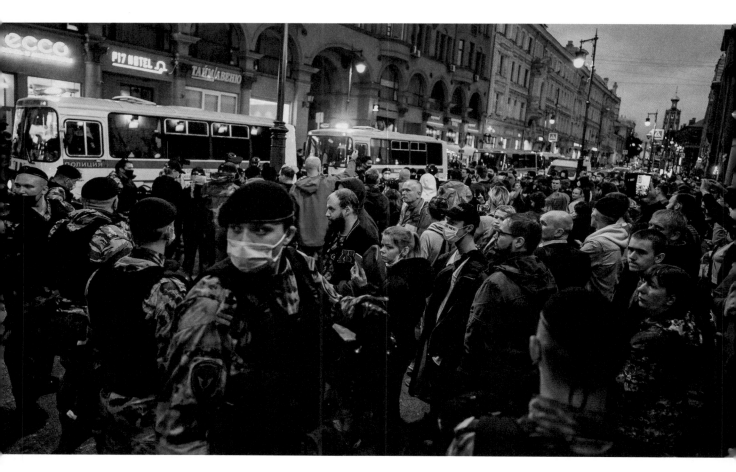

This was taken at a rally to collect signatures to cancel the results of voting on amendments to the Constitution in Moscow, Russia, July 15, 2020. It was the first mass rally in Moscow during restrictions due to the pandemic. Many people came, despite the fear of contracting the coronavirus. I worried about being in the crowd, of being infected by the virus. I also thought that due to the lockdown, a large amount of protest energy would be released as it was in the USA during the BLM wave. None of my expectations were fulfilled.

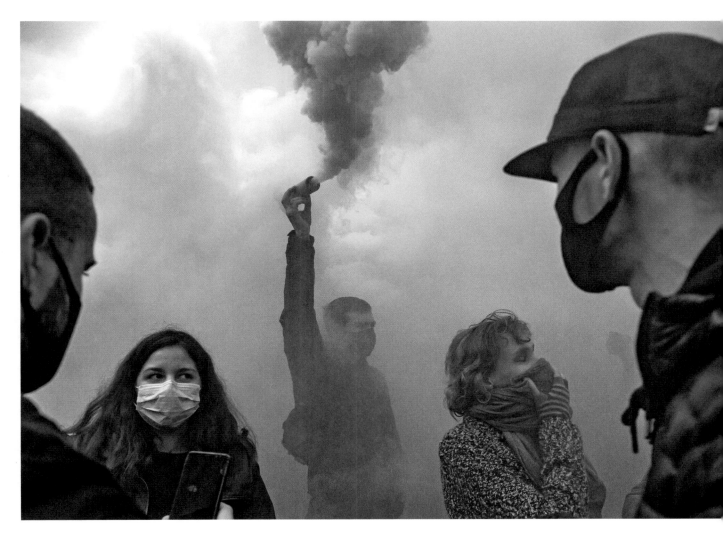

On October 27, 2020, the Constitutional Court of Ukraine declared the powers of the National Agency on Corruption Prevention to be unconstitutional. The NACP imposes penalties on anyone who doesn't truthfully declare their assets, which affects the loans Ukraine receives from the International Monetary Fund. This decision ultimately jeopardized visa-free movement between Ukraine and the EU.

Calls for protest began to be heard on social networks. As a photographer-reporter, I decided that such an action deserved attention and support. There were quite a lot of people, mostly young people, out in these strange quarantine times. Most of them wore protective masks on their faces. Some tried to keep a social distance, although it was not an easy task. When smoke bombs were used, masks became even more useful. At one point I just saw this picture and managed to capture it. The action did not last long. Several speeches, chanting, the smoke of different colors, and it all ended quickly and peacefully, on October 30, 2020.

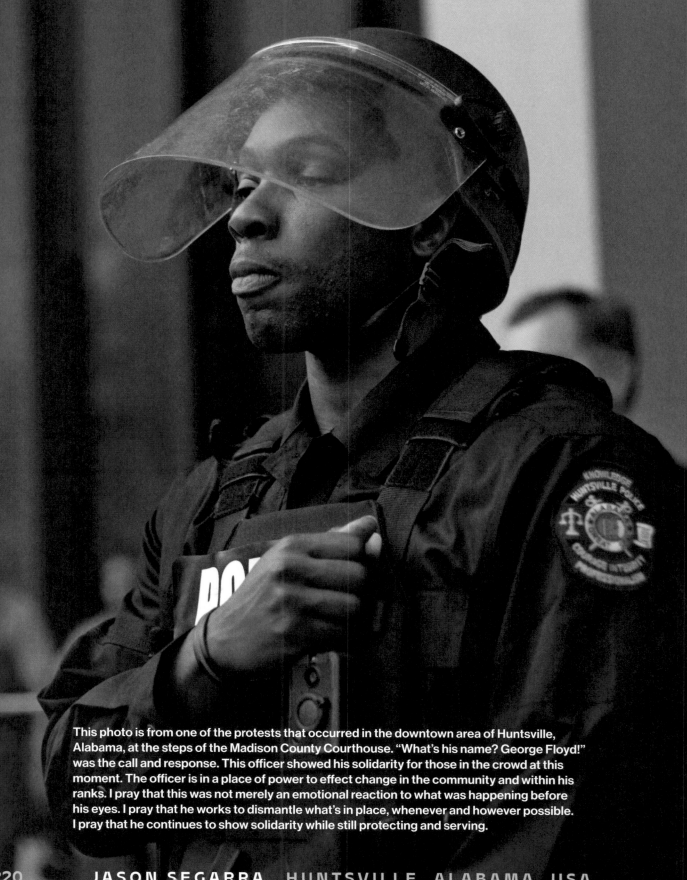

This photo is from one of the protests that occurred in the downtown area of Huntsville, Alabama, at the steps of the Madison County Courthouse. "What's his name? George Floyd!" was the call and response. This officer showed his solidarity for those in the crowd at this moment. The officer is in a place of power to effect change in the community and within his ranks. I pray that this was not merely an emotional reaction to what was happening before his eyes. I pray that he works to dismantle what's in place, whenever and however possible. I pray that he continues to show solidarity while still protecting and serving.

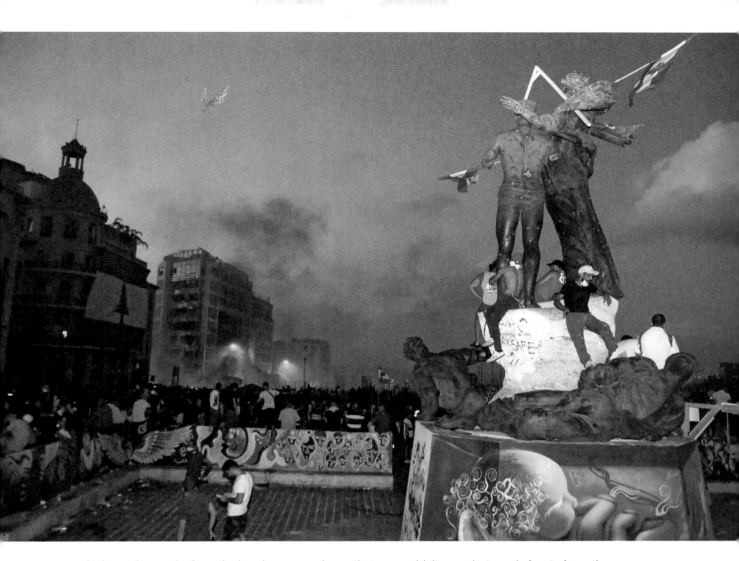

At times, the smoke from the bombs was so dense that we couldn't see what was in front of us—the streets, the protesters, our friends, not even the sky. But there was always the statue of the Martyrs of Liberty on the right and the flag of Lebanon on the left, to give us hope and strength, and to remind us why and how we started and went through our October 17 Revolution, and our insistence on moving forward until we reach our goals.

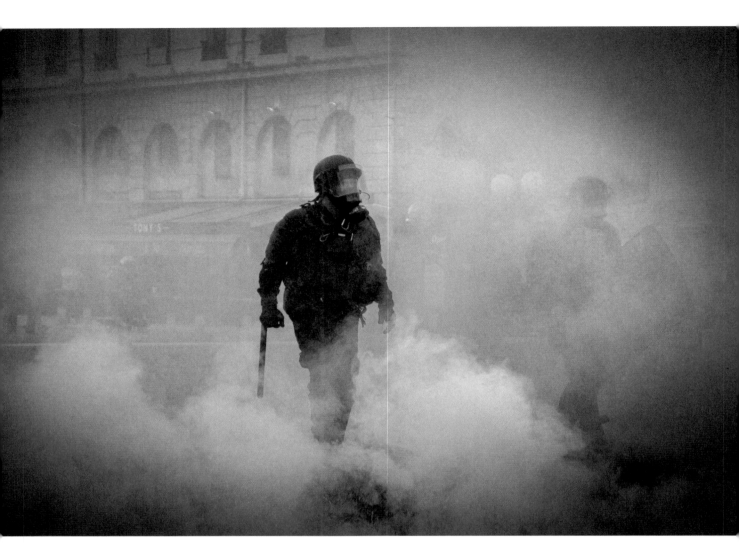

During a BLM march in the French town of Lyon, as the police used tear gas and water cannons to push antiracist protesters out of Bellecour Square, I and a few other photographers were left behind in between the police line and the protesters. As the tear gas was getting thicker, we could only hear what was happening: on one side, the screams of the people suffocating in the cloud of chemicals, and on the other, the sound of the boots and the water truck rapidly approaching. I was both terrified and fascinated by this dreadful spectacle. Then, out of the blue, an officer pushed me, telling me to get with the others. This was one of the first major protests since the beginning of the lockdown in March 2020.

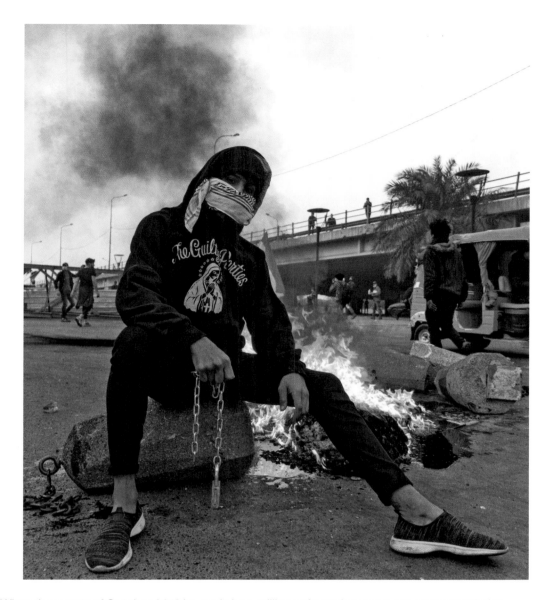

When the events of October 2019 began in Iraq, millions of people went out to start a revolution against injustice and corruption. Five months after the start of the revolution, shooting and tear gas increased indiscriminately, and there are approximately 800 dead and 23,000 wounded as a result of assassinations and random and approved killings.

This photo was taken in Tahrir Square, Baghdad, in the midst of the shooting, in the midst of the rebellious crowds that felt the spirit of defensive patriotism for a land in which freedom was violated. Despite the danger, I took this picture of my friend Saif, whom I met in the midst of smoke and bombs flying in the sky, with a steel chain in his hands to defend himself, as the arrests by riot police were many. He wears the yashmagh (the head covering of the Arab dress) on his face so that his face did not appear and the militias in control of the government would not recognize him. Saif fell about three hours after I took the picture, due to difficulty breathing with the smoke and tear gas, and he was transferred to the existing camps to be treated.

This is one of the pictures I took during my participation in the Iraq demonstrations, which killed many in front of me. The protests held in Iraq kept going until the COVID-19 lockdown. This image shows only a small bit of what happened in Baghdad.

GHAITH ALSARDAR BAGHDAD, IRAQ

LOSSES AND

The year came with a cost. All over the globe, the traces of 2020's tragedies were both evident and subtle. Photos show the rubble, the hurt, the pollution, and the indescribable loss. We may not even know the full extent of these tragedies or ever comprehend what has happened to others. It is important to remember that healing takes place, even when we are most weakened. The year 2020 reminded us that no matter how bad the damages are that we sustain, there is always hope that we will come together again. Photography sheds light on the extent of the damages and attempts to capture the emotional cost.

DAMAGES

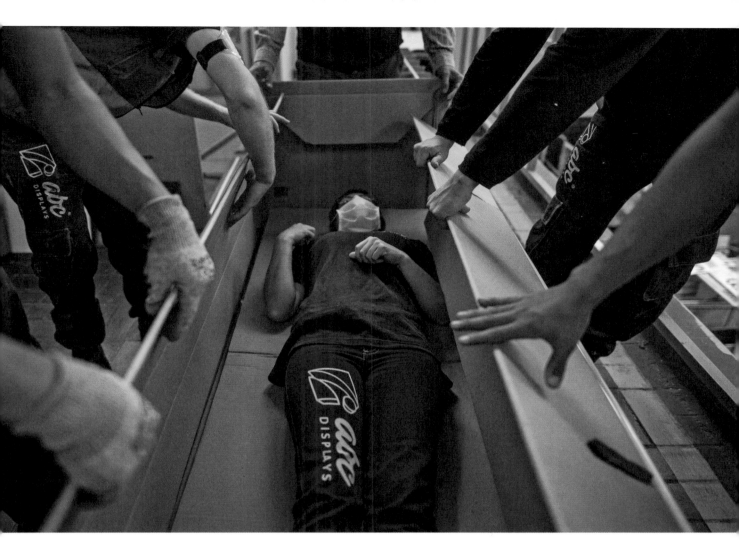

An advertising company in Colombia created a cardboard bed as an alternative for patients with COVID-19, since by that time neighboring countries, such as Ecuador, were running out of hospital beds. The cardboard bed holds up to 150 kilos and costs 40 percent less than a standard hospital bed. But it has an extra purpose, which shocked me a lot: it can become a coffin if the patient dies. In such cases, the body is placed on a lower level of the bed and the frame is moved to close the casket, thus reducing the chances of contagion between healthcare professionals and funeral home workers. So far, the company has donated part of its inventory to the places most affected by the pandemic in Colombia, such as the Amazon forest.

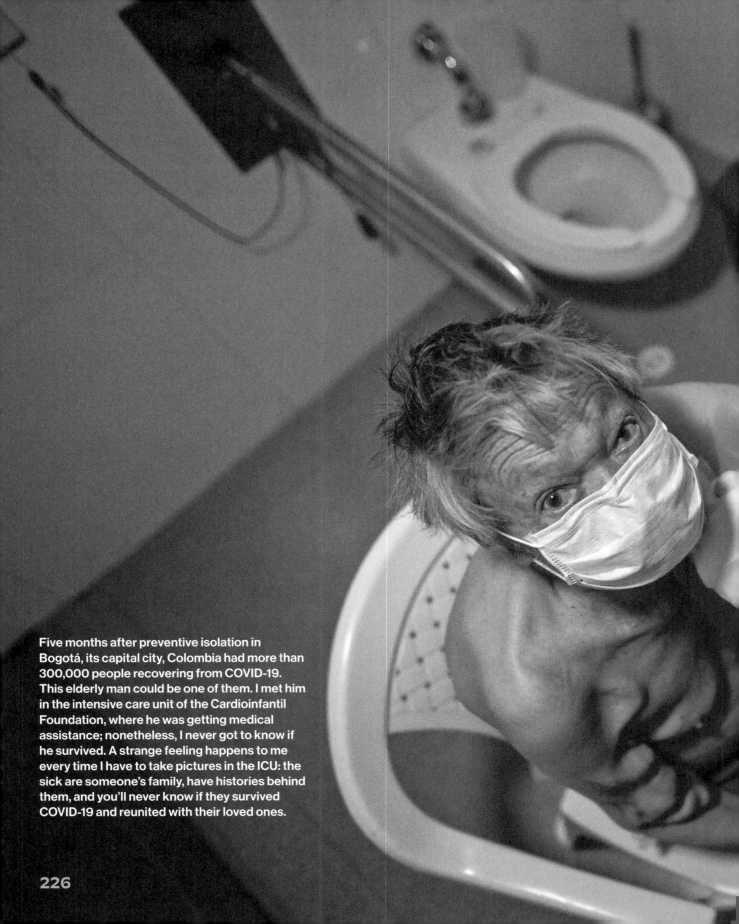

Five months after preventive isolation in Bogotá, its capital city, Colombia had more than 300,000 people recovering from COVID-19. This elderly man could be one of them. I met him in the intensive care unit of the Cardioinfantil Foundation, where he was getting medical assistance; nonetheless, I never got to know if he survived. A strange feeling happens to me every time I have to take pictures in the ICU: the sick are someone's family, have histories behind them, and you'll never know if they survived COVID-19 and reunited with their loved ones.

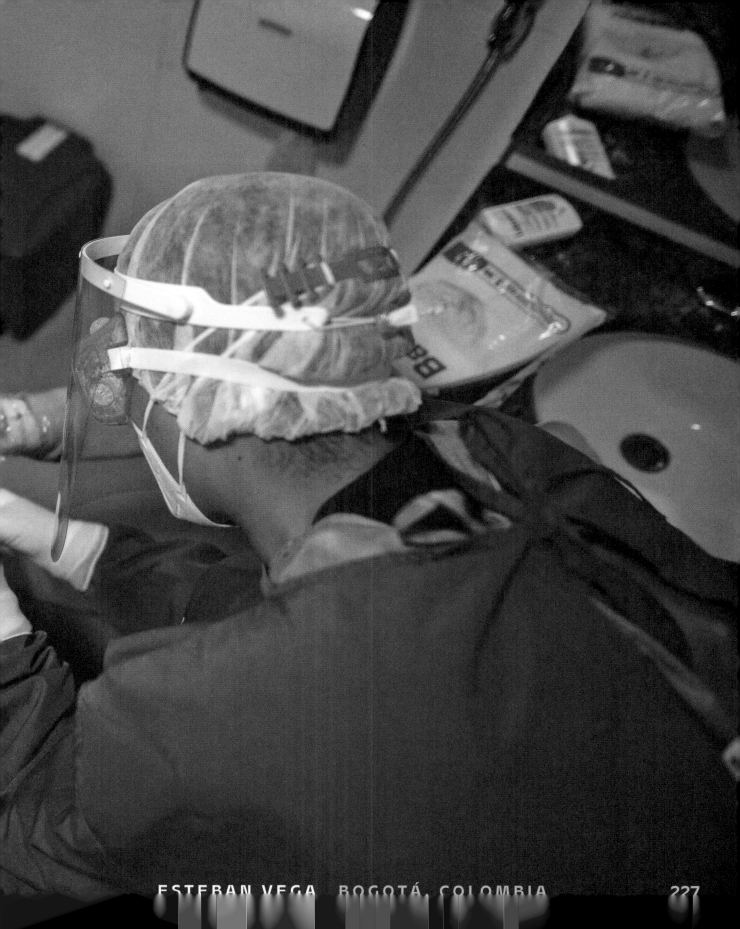

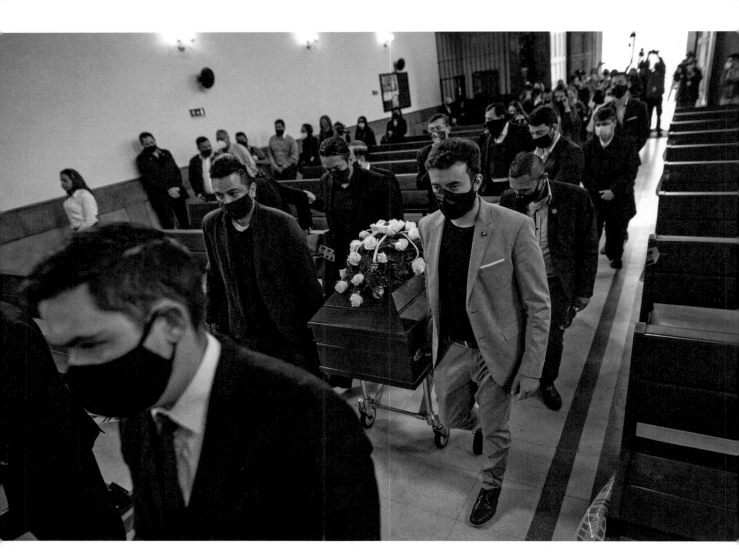

In Colombia, violence never stops. Not even when there is a virus killing us. Six months after COVID-19 arrived in the country, Javier Ordóñez—a man pinned to the ground by Colombian police officers, who shocked him repeatedly with a stun gun for more than two minutes and then beat him to death—is mourned in Bogotá. According to the autopsy, Ordóñez died from 40 blows that ruptured his liver. However, he had previously received 13 stun-gun shots that the police officers gave him in the middle of the street and that were recorded on video. Within 24 hours, thousands of Colombians had taken to the streets of Bogotá, in protests against police violence without caring about getting the virus.

ESTEBAN VEGA BOGOTÁ, COLOMBIA

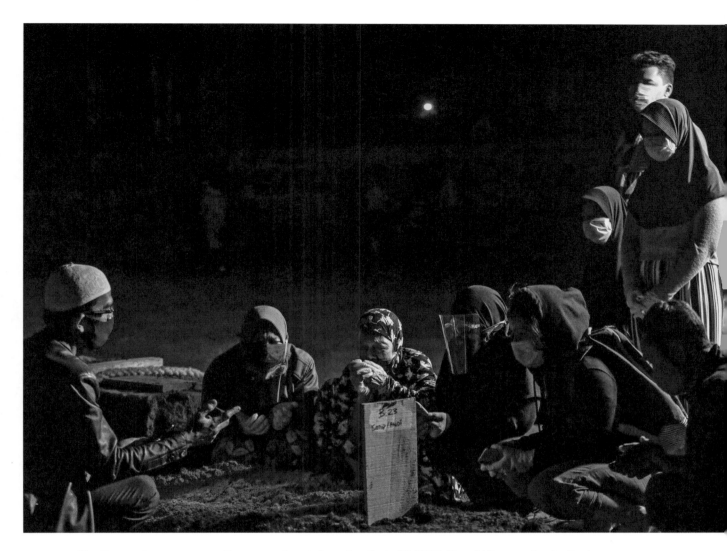

Family members pray near the grave of a relative who died of COVID-19 amid the pandemic. East Jakarta's Pondok Ranggon Cemetery ran out of space for COVID-19 graves late in 2020, because of the increase in the number of deaths, and began stacking burials.

A dive site known as the Breakwater in Monterey, California, is a great place to observe and photograph sea lions from above and below the water as they play and pirouette. With lockdowns in place across California, places like Monterey have been favorable destinations for state travel due to large outdoor spaces with plenty of wildlife. In the world of social media, it is common to see people taking off their masks for selfies at the end of the wharf, oftentimes forgetting them. Vistas and tourist destinations have been clogged with abandoned masks.

Breakwater is the outer wall that protects the harbor. The area is home to some 1,200 sea lions, which attract swarms of tourists, fishermen, and divers. I had heard reports that the day before the area was absolutely packed with jellyfish, and I was hoping they were still around. I quickly found out that the sea nettles were no longer there and also that conditions had turned really bad. It was literally one of the worst dives I had had in my life. It had rained the night before and the water had turned really green with tons of particulate, and it was really surgy. But with all the sea lions out, I figured I would give it a go. After having almost zero luck with the sea lions and using most of my air, I decided to call the dive.

As I was swimming in, I noticed a small group of sea lions diving down and playing with something white. It looked like a piece of trash, but sea lions are notoriously curious, and you see them playing with all sorts of things. It wasn't until I was closer that I realized that it was a mask.

Honestly, it was very quick and the conditions were so tough that I was mostly trying to make sure I didn't completely miss the opportunity to document it. It's one of those experiences that you're fortunate to have—being presented with a moment that helps sum up a huge environmental issue and you really want to capture it. Obviously, the pandemic has been extremely hard on people across the world and we are encouraging everyone to wear masks, but at that same time, we have created another problem. Another environmental externality.

With an estimated 129 billion disposable face masks and 65 billion throwaway gloves being used each month through the pandemic, we are likely to be seeing the effects of COVID-19 on our oceans for the foreseeable future.

I have been a social justice activist for years, and 2020 was a tough one, especially for activists. I'm from Atlanta, where John Lewis was a representative and was someone who showed me how to stand up and fight for what you believe in. I was shocked when he passed but also grateful that I was in the city where I could go pay my respects in person. It was a very emotional and personal experience. I felt like I knew him. I took some time there and knelt at the steps for about 10 minutes and just thought about his contributions and vowed to continue the fight. Rest in peace, John Lewis.

I took a self-portrait protesting police brutality with my fist in the air. At the US Capitol, I ran into young kids with their grandma who had signs supporting John Lewis. Then I walked to the Black Lives Matter Plaza to take a photo of the street sign. Then I walked to the Lincoln Memorial, where I saw people holding signs supporting Black Lives Matter. I was fortunate enough to then visit Seattle and go to the zone where the police station had been taken over by protesters. This is where I saw a man dressed as Darth Vader with the words "I can't breathe" on his mask while he was holding a book by James Baldwin. While I was there, I took my Black Lives Matter mask off and placed it on the ground and took a photo of it. It was a year of protest for me, and that is the best way for me to remember 2020.

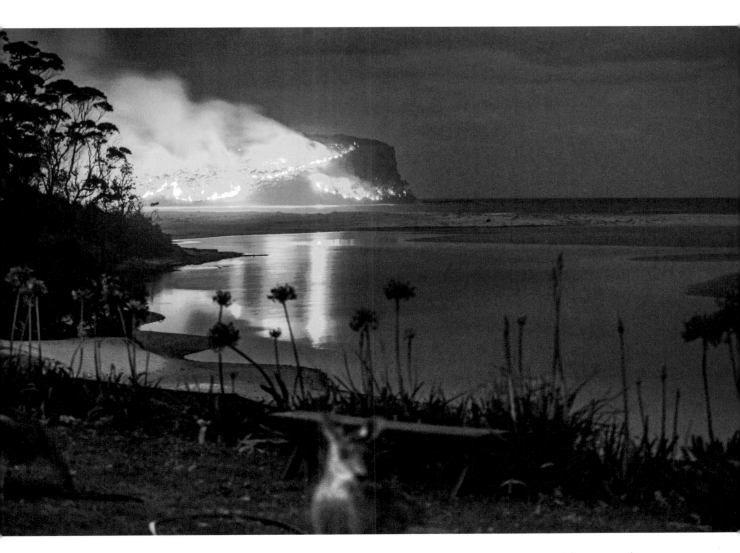

Here in Australia, on the South Coast of New South Wales, we experienced the worst bushfire season in history. It was one of the hardest times in my life, not knowing what was going to happen over the three months in 2019 to 2020 when my town was heavily affected by the fires. Not knowing when food was coming to town and more, as the roads were cut off. Seeing friends and family have their houses burnt to ashes was so disturbing. All I could do was be there for them when they needed me. Even half a year on from the fires, it's still so raw for me and many others.

Fueled by a combination of high temperatures and an August lightning storm that included approximately 12,000 strikes across the state, California's 2020 fire season shattered records, leaving more than 4 million acres scorched. Normally I spend June through December photographing wildfires across California for the Associated Press, sometimes venturing north for larger fires in Oregon. Producing strong images while staying safe requires a robust set of skills, tools, and knowledge accumulated over many years in fires. It is common for me to live out of my SUV for days and even weeks at a time while covering fires.

This photo is from southern Oregon, where the Almeda fire destroyed more than 3,000 structures. I drove up from San Francisco specifically to capture the scale of the loss. Since Oregon does not have laws allowing press access to evacuated areas, a drone was the most effective way to capture the scale of the destruction. Unlike ground images of ruined homes, an aerial image like this brings home the hundreds of lives affected by fire and the concept that an entire community could be leveled in a matter of minutes.

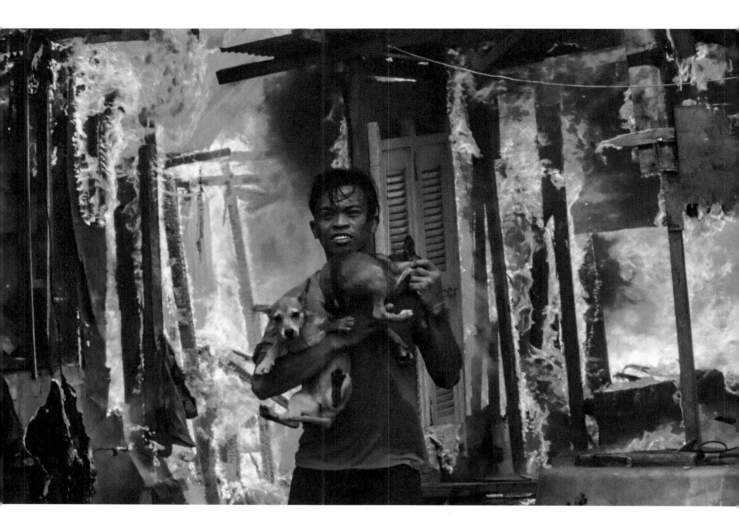

This was taken during a huge fire that razed shanties near the Port of Manila. The fire victims were scrambling to salvage their belongings, plus there was the danger of COVID-19.

Adrenaline was rushing in me as I felt the heat on my skin of the huge fire burning the houses. But I tried to stay calm and framed in my viewfinder this man rescuing his pets.

Alleyways between intertwined shanties in Manila are difficult to enter, especially if there is a fire. Some of the photojournalists that day stood on footbridges near the area to get a general shot. However, I felt I could tell the story with a stronger photo if I got inside the burning shanties.

The place was damp, filled with scrambling firefighters and residents fleeing from the scene. In scenarios like this, I feel a bit scared, but I always have the mindset that a photojournalist can't make strong photographs if he/she is not connected to the community/subject.

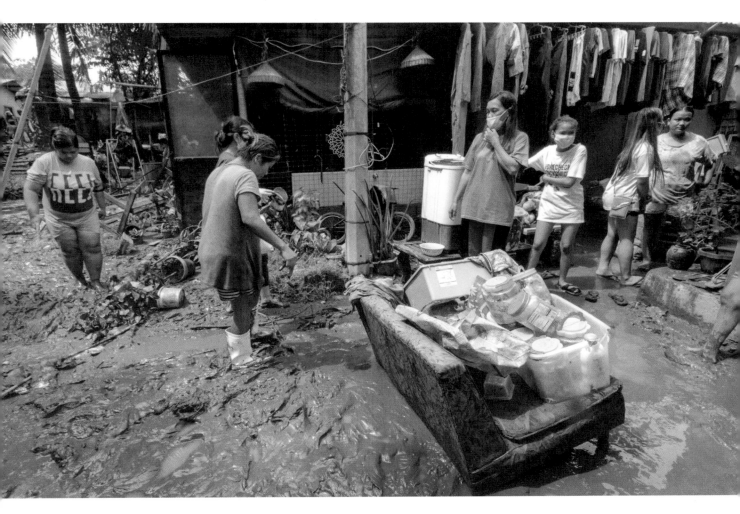

As COVID-19 hit the Philippines, Filipinos start to adapt to a "new normal" while facing the old problems encountered in the country, like typhoons and poverty.

The most difficult part for me, I think, was when my wife got the virus because I constantly go out and shoot. During that time, I really thought about which is more important: the photos/stories being brought out to the people or the safety of my family. The support for media people is not that great during this time.

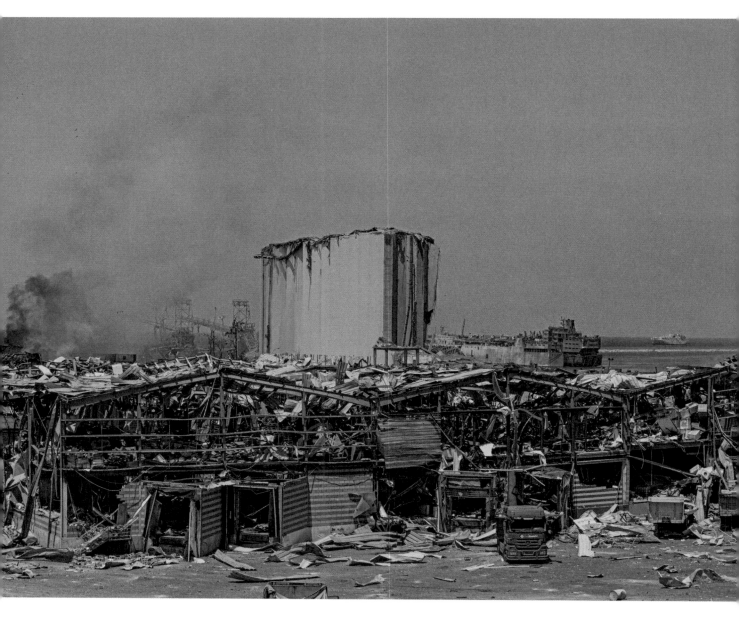

I was in my apartment in Mar Mikhael Street, sitting on the deck, while my friend was on the street waiting for a delivery guy. Then we heard the first explosion. After that, everything started flying, and people were screaming everywhere. We rushed into the house, and the glass was flying and the walls were falling.

We quickly got out of the house and we saw the street. My car was smashed. I went crazy, with blood running from my hands. I tried to call another friend, but the network was not working. But then she came toward us and she was fine, but she was bleeding.

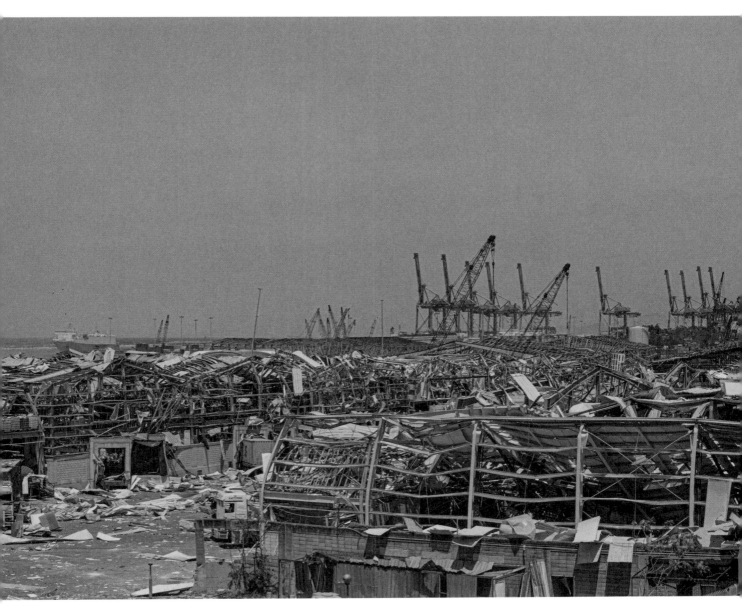

We went to the Al-Roum Hospital near the house, and the city was in ruins. We were walking on glass, smoke was everywhere, and people's screams resounded through the place.

When we arrived at the hospital, there were many dead victims around it. The medical team was treating the wounds of the injured. But despite the explosion and the panic, the racism did not stop. I saw the domestic workers of Ethiopian nationality bleeding in front of the hospital, and the medical team did not help them.

It was a day when we saw death with our own eyes.

Still, even now, when I see the pictures or even when I pass near the port, my heart breaks.

ZAKARIA BADDOUR BEIRUT, LEBANON 239

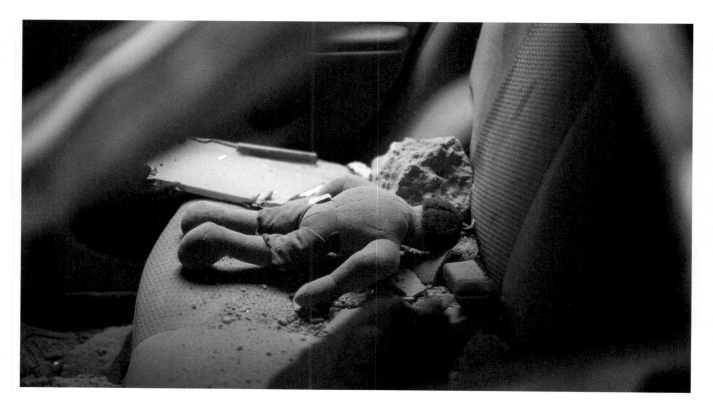

This was taken a day after the August 4, 2020, port explosion, in Beirut. A car, destroyed, glass everywhere, building walls on top of it, and in it lay a child's Hulk toy.

This image struck home. Hulk and superheroes were a big part of my childhood. They were able to achieve everything we dreamed of. But this hero? He lay there facedown, beaten and defeated.

This is what happened to childhood in Lebanon. This is what happened to strength in Lebanon. No matter how hard we have been fighting, somehow the oppressive government seems to always find a way to bring us to our knees.

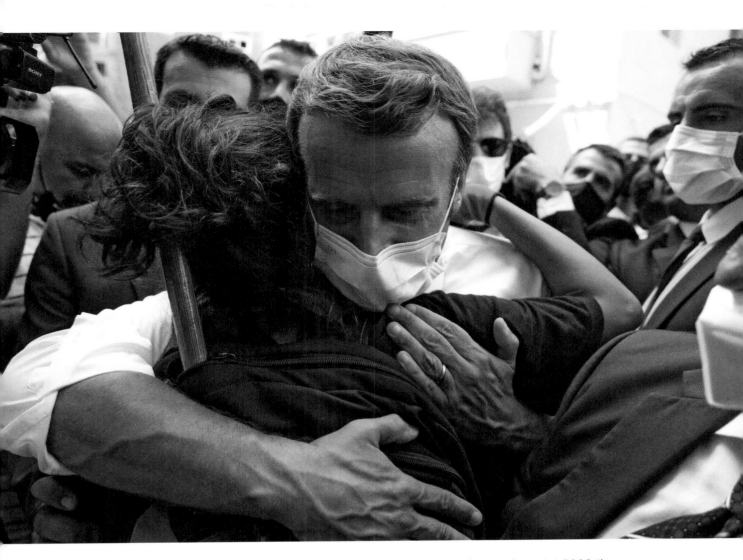

A few days after the devastating port explosion in Beirut that took 215 lives on August 4, 2020, the French president, Emmanuel Macron, visited Lebanon to support the country. When he arrived, he had the emotional support of the Lebanese, who desperately wanted their corrupt government to hold the people responsible for this negligence accountable. I captured him embracing a woman who came up to him while he was walking through the neighborhood most affected by the blast. It was a very emotional moment, where a lot of people saw in Macron a savior-like figure because of the promises he made to support Lebanon in its formation of a new government. Ultimately, he failed to deliver on his promises, like most politicians do.

IBRAHIM DIRANI BEIRUT, LEBANON

FUTURE

The younger generation understood that, in the face of one of the greatest obstacles of their time, they could have a voice in the fight. Many future leaders were born, as great injustices increasingly were brought to light over the course of the year. They creatively found ways of expression through online and physical activism. The children in these images show us that there is a future worth fighting for. They show us that their generation deeply cares about the planet and all human life, and that not much can stand in the way of these ingrained beliefs that will course-correct the mistakes that the previous generations made.

LEADERS

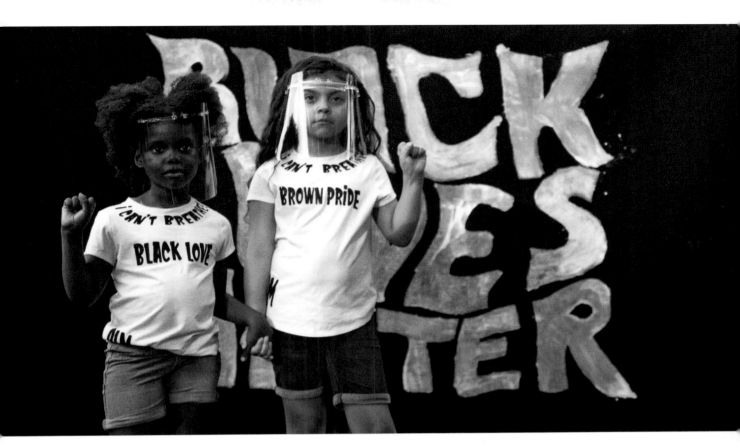

Protesters traveled from all over to meet at Washington Park to show solidarity and speak out in the aftermath of George Floyd's death. Social unrest in Chicago was at the highest I've seen it in the past seven years living here, with the tension between the police and the community at a fever pitch. These two children held hands and looked on amid the chaos.

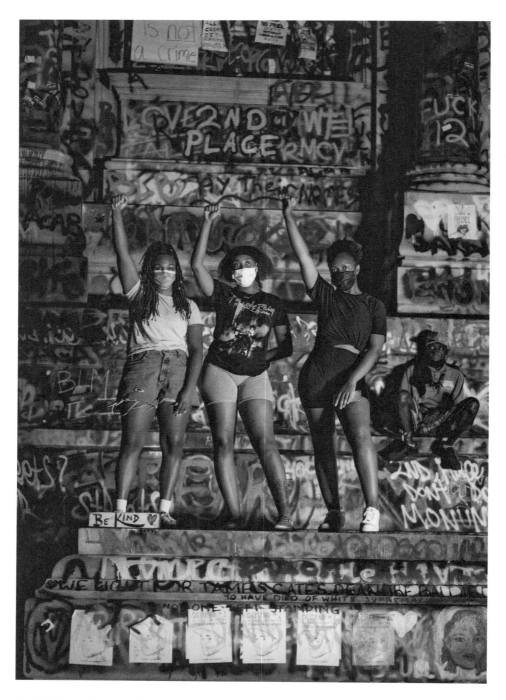

On July 28, 2020, participants Kelsey, Lauryn, and Maria stand victoriously at the plinth of the Confederate monument of Confederate general Robert E. Lee at the place now known as Marcus-David Peters Circle in Richmond, Virginia. Thousands of people took to the streets to reclaim this monument of white supremacy as a space that now commemorates all the Black lives murdered by police.

This photo represents the collective power of the people of Richmond who risked their lives during a pandemic to stand up in defense of Black lives. I took this photo at the end of the George Floyd Hologram Memorial Project event, where hundreds of people gathered at the Robert E. Lee statue on Monument Avenue to hear the family of George Floyd and their attorney, Benjamin Crump, speak.

CHRISTOPHER RISCH RICHMOND, VIRGINIA, USA

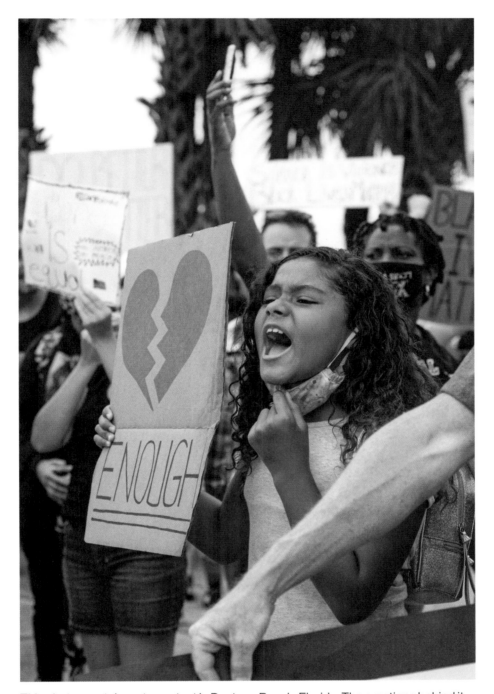

This photo was taken at a protest in Daytona Beach, Florida. The emotions behind it come from a deep place that only minorities can deeply relate to. The movement was so powerful and the moments were so gravitating. I love to capture emotion, so the feeling of this moment has meant the world to me.

In Poland, in recent years, the fights for women's rights and LGBTQIA+ community rights have become some of the most important triggers dividing Polish society. These issues are also on the agenda of the currently ruling conservative party Law and Justice, which the government has clearly proven by almost totally banning abortion in 2021 and permitting "LGBTQIA+-free zones," adopted by almost one-third of Polish communities and towns. The scene in the photo summarizes it all. A woman, wearing a jacket with a red lightning bolt, the symbol of the International Women's Strike movement, and carrying a rainbow-colored bag, a symbol of LGBTQIA+ rights, is standing in front of a police cordon acting on the behest of the state apparatus.

ACKNOWL-EDGMENTS

For many, the COVID-19 pandemic brought our lives and societies to a grinding halt. Many, perhaps rightfully so, seek to forget the devastation inflicted by the pandemic. This book is dedicated to visual storytellers around the world who documented the events that unfolded in 2020. Many of them put their life at risk to capture these powerful images that will forever be chiseled in our collective memory. To the brave essential workers, healthcare heroes, and all those fighting for justice on the streets, or just fighting to stay alive, this book seeks to ensure that your courage and sacrifice will be documented for generations to come.

We owe this opportunity to our publisher, HarperCollins, Judith Curr, and Rakesh Satyal for giving us the creative freedom to give you this historical record. Hala Hawatmeh, our editor, worked with us to tell the story of the pandemic in a way that will send chills down your spine as it did with us. The talented Wael Morcos and Rouba Yammine, in collaboration with the HarperCollins design team, designed the cover and interior pages of the book in a way that speaks to the present time. Sarah Aoun and Mai Masri lent their expertise to advise on the curation process of the photographs. Yuchen Zhang, Crystal Tong, Hana Chamoun, and Hala Hassan gave great feedback on the creative direction. Marwan Shousher perfectly captured our author photo in New York, where we built Scopio over the past decade. To our families at home and in the diaspora, who taught us that telling stories is essential to the preservation and continuity of our communities, we owe you our deepest gratitude. And to our friends who have guided us by giving their time and love for the success of the book, thank you.

To the Scopio team of creatives, builders, and hackers, who are passionately committed to creating the largest international community of photographers, and visual storytellers that move and inspire the world, we thank you for making Scopio's vision a reality. Finally, we'd like to send our gratitude to everyone who opened a door and made it possible for us over the years to embark on this path of providing a platform for anyone to share their images and stories from every corner of the planet.

ABOUT THE

AUTHORS

CHRISTINA HAWATMEH

Christina is the founder of Scopio. As the daughter of immigrants, Christina recognized her passion and drive to make the world a better place and change perceptions at an early age. In launching Scopio, her dream of making an impact and creating a ripple effect of good has become a reality for thousands of people around the world. Christina has been featured on CNN, in Yahoo Finance, and in *Forbes*, in addition to being named a Top Entrepreneur to Follow by *The New York Finance*. Christina holds her undergraduate degree from George Washington University and her master's degree from Columbia University, where she proudly began Scopio.

NOUR CHAMOUN

Nour is the cofounder of Scopio. Her background in design and her long-standing passion for photography and storytelling are at the core of her drive for Scopio. Much of her work is influenced by her social and political environment, which led her to create several digital products before launching Scopio, such as an Arabic font-sharing platform. She has been featured in *Forbes* 30 Under 30 and *WIRED* magazine, among others. Nour holds an undergraduate degree from the Lebanese American University and a master's degree in Design + Technology from Parsons School of Design.

ABOUT

SCOPIO

Christina and Nour cofounded Scopio, which stands for "Scope It Out," a community-based platform where anyone can share images and stories from around the world. It is a digital space with the primary goal of elevating human stories told by people from underrepresented communities and regions. The vision of Scopio is to distribute the world's images so they can make their place in history. The pair wants this book to serve as a historical record and time capsule for the year of the pandemic, so it can be shared with generations to come.